NETHERLANDISH PAINTING
FROM VAN EYCK TO BOSCH

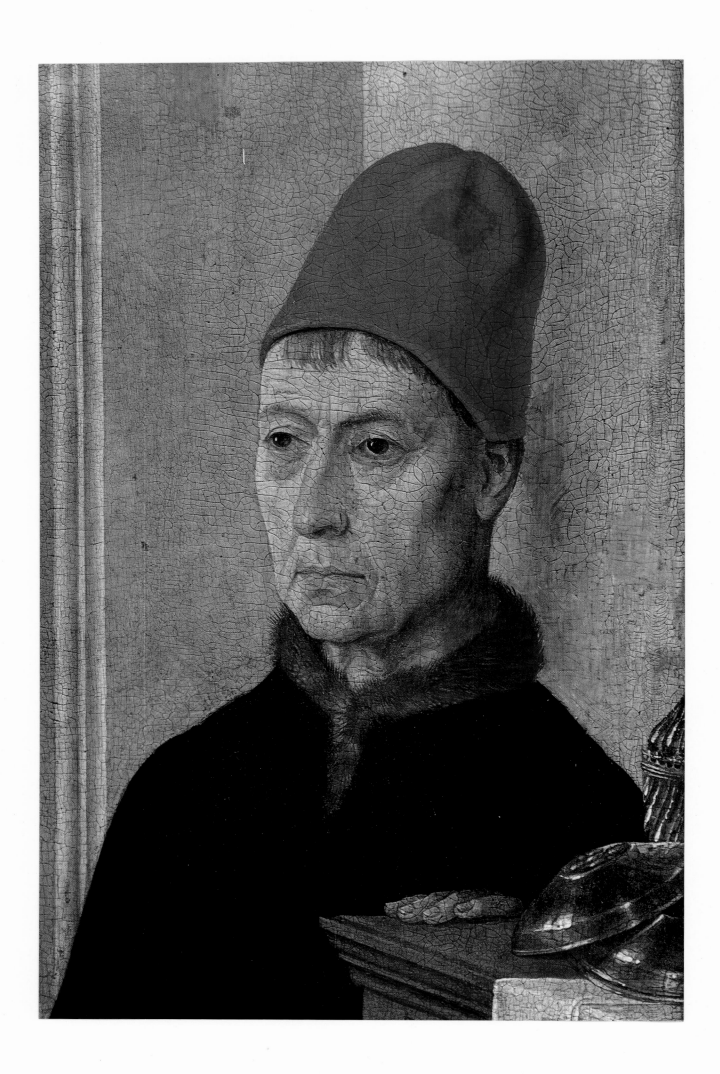

NETHERLANDISH PAINTING FROM VAN EYCK TO BOSCH

by H. T. Musper

Translated from the German by Robert Allen

Harry N. Abrams, Inc., *Publishers*, New York

Frontispiece: Dieric Bouts. *Altarpiece of the Sacrament.*
Detail of the center panel: *The Servant.*
Saint-Pierre, Louvain

Editor: Lory Frankel

Library of Congress Cataloging in Publication Data

Musper, Heinrich Theodor.
 Netherlandish painting from Van Eyck to Bosch.
 Translation of Altniederländische Malerei.
 Bibliography: p. 131
 Includes index.
 1. Painting, Flemish. 2. Painting, Gothic—Belgium. 3. Painting,
Renaissance—Belgium. 4. Painting, Dutch. 5. Painting, Gothic—
Netherlands. 6. Painting, Renaissance—Netherlands.
I. Title.
ND635.M813 759.9492 76-149849
ISBN 0-8109-0096-3

Library of Congress Catalog Card Number: 76-149849

Printed and bound in Japan

Contents

COLORPLATES

Introduction

At the end of the Middle Ages the Low Countries were ruled by a number of potentates who differed greatly from one another. A vast area was subject to the duke of Burgundy, whose seat of government was Dijon. Under Philip the Good it comprised virtually all of modern Belgium and Holland, the Franche-Comté, and parts of Alsace and Lorraine. Other areas belonged to the duke of Holland and Bavaria, who lived at The Hague. At the same time the rich city republics of Flanders and Brabant continued to gain in power and culture in their constant struggles with the counts of Flanders. Chief among them were Ghent, Bruges, and Brussels, as well as Tournai which, though situated in the French-speaking zone, was politically a part of Flanders. Thus diverging political, ethnic, and linguistic elements existed one next to the other, or rather one within the other, and even incessant armed conflicts were not a serious obstacle to the achievement of the economic prosperity without which art cannot flourish. Paris and Cologne were major centers of influence. The exiled pope, whose retinue included such great artists as Simone Martini, had taken up residence at Avignon. But that was not the only facility for contact with Italy; sea trade was another. What an extraordinary age it must have been, in which the innocent girl, Joan of Arc was cruelly burned at the stake while in the churches splendid altarpieces were donated depicting Bible stories in the most beautiful colors, with saints clad in silks and satins and adorned with precious stones, as if no price were too high to pay for proof of faith and piety!

It would be quite wrong to say that the west and south of central Europe produced all that is best in painting, even if the south can claim the glory of having given birth to a new order with Giotto. The right bank of the Rhine made an enormous contribution, which has been preserved in better condition. In the fourteenth century there was a first heyday in Cologne, while, among other outstanding painters, Theoderich of Prague worked in Bohemia and Master Bertram in Hamburg. At the same time important altarpieces were produced by anonymous artists in virtually all the provinces of the Holy Roman Empire. The English and Spanish contributions too are far more significant than is generally believed. Nor should we forget that in virtually all these countries mural painting and, still more, glass painting had attained a very high level.

The first generation of early Flemish painters seems to have found its inspiration not so much in altarpieces and panel pictures as in jewel-like miniatures, which owe a great deal to Italy. They were produced less in Flanders than in such centers as Paris and Dijon, though the artists who painted them were mostly Flemish emigrants employed by patrons like the Duke of Berry, an enthusiastic artlover and collector of fine illuminated manuscripts. Like Philip the Good, he was an uncle of the mad French king, Charles VI, for whom he served as regent for a time.

In Paris, at the beginning of the fourteenth century, Jean Pucelle still confined himself to small pictures and garlands in which one perceives, here and there, elements taken from Duccio di Buoninsegna. In the Book of Hours in Brussels attributed to Jacquemart de Hesdin, an outstanding artist who can be traced back to the fourteenth century, there are borrowings from Simone Martini's *Carrying of the Cross*. In *The Flight into Egypt* (fig. 7) we find mountains—the so-called "Phrygian caps"—resembling those in Robert Campin's *The Nativity* in Dijon (colorplate 4) and in his small panel of *Saint George* (fig. 10). The miniatures in the Boucicaut Hours (1414–16) preserved in the Musée Jacquemart-André in Paris display an advanced perspective and a central arrangement which were apparently studied by Jan van Eyck. The same may be said of the miniatures painted by that brilliant painter from the Dutch-Belgian-German borderland, Paul of Limbourg—his brother also lent a hand—which are now the most precious treasure of the Musée Condé in the castle of Chantilly near Paris. These little pictures of the months of the year and scenes from the Passion (1411–16, fig. 3) are among the finest miniatures of all time, a glory they share with those painted in all probability by Jan van Eyck for John of Holland between 1422 and 1424, some of which were tragically destroyed by fire in the Turin Library in 1902. Paul's works, which must have been known not only to Campin but also to Van Eyck (both of whom were attracted by the shepherds in *The Nativity*), reveal obvious Florentine influences (compare fig. 3 with *The Presentation of the Virgin in the Temple* by Taddeo Gaddi, fig. 2).

Those who make the rise of early Flemish painting dependent on the invention of oil paint attach far too great an importance to what was a purely technical matter. In fact, although its discovery was formerly attributed to the Van Eyck brothers, the technique is now believed to have been known at least a century earlier.

Among the precursors in the Low Countries, the most outstanding panel painter was Melchior Broederlam. His only known work is the wings of the *Altarpiece of the Crucifixion*, which was commissioned for the Champmol Charterhouse in 1392, delivered in 1399, and can now be seen in Dijon (fig. 4; colorplate 2). The huge carved center

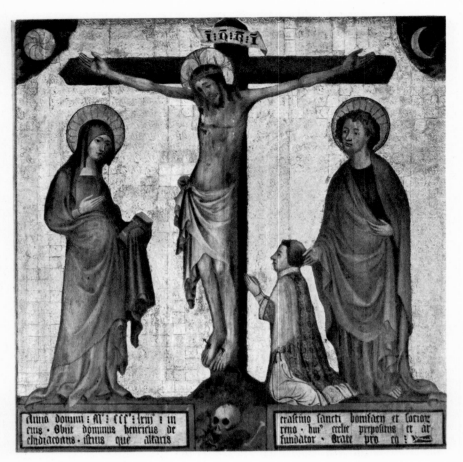

1. Utrecht Master. *The Crucifixion.* 1363. 52 3/8 × 51 1/8″ (133 × 130 cm.). Koninklijk Museum voor Schone Kunsten, Antwerp

panel (a Crucifixion flanked by a number of saints) was executed by Jacques de Baerze, but the painted frame and the gilding must be ascribed to Broederlam. When he died his possessions included the little Rotterdam altarpiece with a *Coronation of the Virgin* (above a Man of Sorrows in the center field; on the wings, male and female saints in two registers). There were also the slightly larger panels of a small altarpiece, parts of which are preserved in Antwerp's Museum Mayer van den Bergh (fig. 6; colorplate 3) and in Baltimore.

Robert Campin

It is futile to search for Robert Campin's name on the tablets at the entrance to the Prado on which all the great painters are mentioned. Adverse fortune robbed him of the glory he so well deserved. For many years no clear distinction could be drawn between his works and those of Rogier van der Weyden, and consequently it seemed impossible to compile a definitive catalogue of his oeuvre.

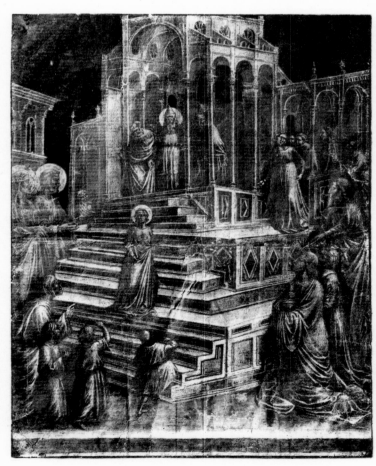

2. Taddeo Gaddi. *The Presentation of the Virgin in the Temple.* 14 3/8 × 11 1/8″ (36.4 × 28.3 cm.). The Louvre, Paris

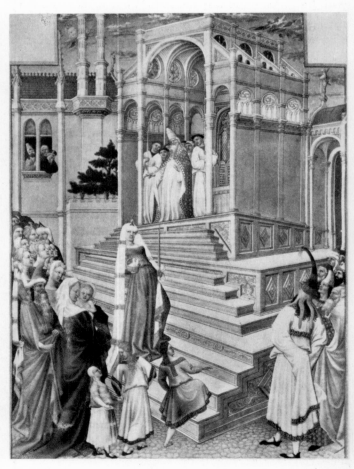

3. Paul of Limbourg. *The Presentation of the Virgin in the Temple.* 7 3/8 × 5 1/4″ (18.7 × 13.3 cm.). Musée Condé, Chantilly

4. Melchior Broederlam. Wings of the *Altarpiece of the Crucifixion*. Left: *The Annunciation* and *The Visitation*; right: *The Presentation in the Temple* and *The Flight into Egypt*. 1394–99. 5′5 3/4″ × 8′4 3/8″ (167 × 255 cm.) each. Musée des Beaux-Arts, Dijon

It is true that a great deal of information on him can be gleaned from primary archive sources, although we do not know for certain if he was born at Tournai. Be that as it may, he is mentioned there already in 1406 as a master painter and in 1410 as a citizen, and there he lived until his death in 1444. In 1427 he took Rogier van der Weyden, who was born at Tournai, into his workshop, where Jacques Daret had already been working for almost nine years. In 1432 both were admitted to the painters' guild as free masters. In 1423 Campin took part in a re-

volt of the artisans against the patriciate, and he held a position on the town council until his dismissal in 1428. It is not surprising to learn that during the next decade he came into conflict with the authorities because he lived with a woman who was not his lawful wife. Thanks to the intervention of the reigning sovereign, Countess Jacqueline of Holland and Bavaria, the penalty (a pilgrimage to Saint-Gilles and a year's banishment from the town) was remitted.

Robert Campin must have been an energetic character

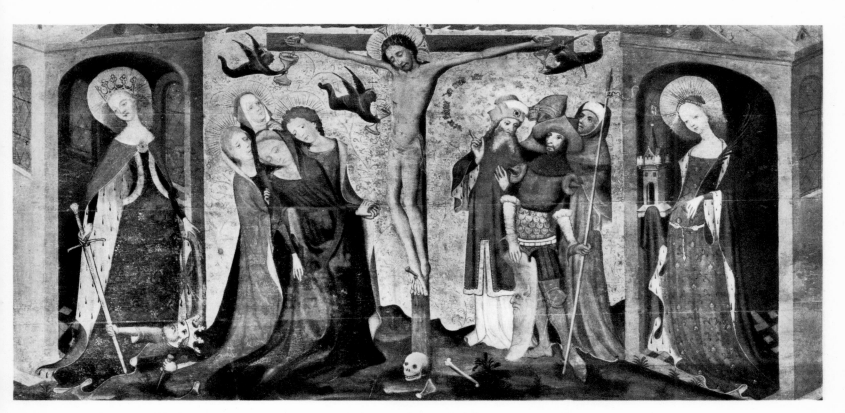

5. Unknown Master. *Huitefeld Altarpiece*. 28 × 55 1/8″ (71 × 140 cm.). Musée de la Cathédrale Saint-Sauveur, Bruges

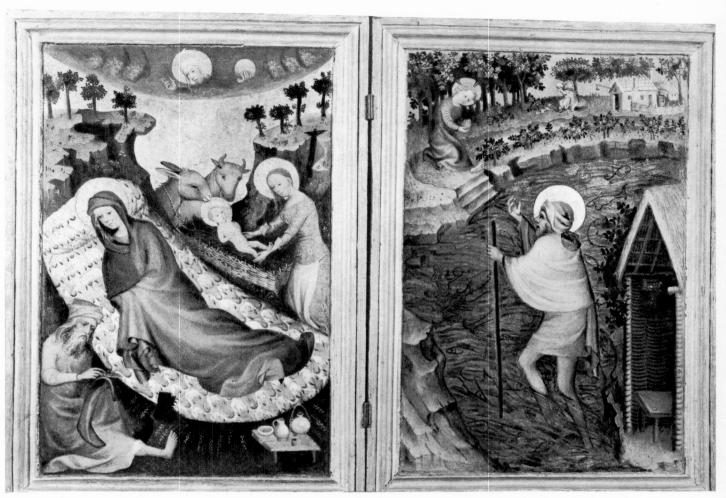

6. South Netherlandish Master. *The Nativity* and *Saint Christopher*. 13 × 16 3/4″ (33 × 42.8 cm.). Museum Mayer van den Bergh, Antwerp

7. Jacquemart de Hesdin. *The Flight into Egypt*. 6 5/8 × 4 3/8″
(16.8 × 11 cm.). Bibliothèque Royale, Brussels

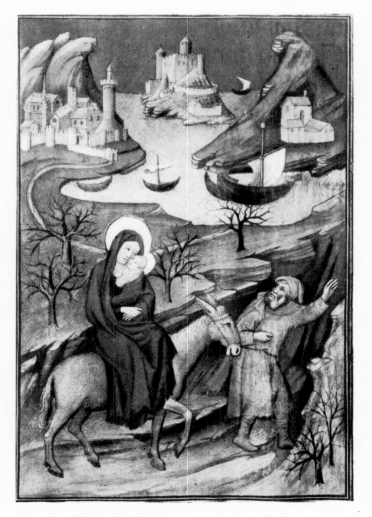

and, particularly as a young man, ruthless in the achievement of his aims. He wanted to rediscover the visible world and interpret it anew. What interested him was the representation of plastic volume in space. This interest may be viewed as typical of a romantic southern nature (and was shared by Campin's greatest pupil, Rogier van der Weyden), in contrast with the painters of the northern provinces. Thus he brought to an end what has been called the "International Style" (the rigid trecento mode in which human figures were painted silhouettes). In Campin's painting, shades of color and tonal values suggest volumes and link them with the environment. Though Campin lacked an exact idea of central perspective, he thrust space farther back perhaps than any of his contemporaries. Unlike the Italians, whose thinking has always been in terms of the harmonious, he did not shrink from exaggerating spatial projections; the most cogent examples of this are the benches against which his Virgins or saints lean. He was also fond of enveloping his female figures in a superabundance of drapery. Another vivid experience was that of the open air—a landscape, a street, or indeed a crowded square in the middle of a town. A third essential experience was the plasticity of the human figure, both nude and clothed. Nowhere is this so impres-

sive as in *The Bad Thief Gesinas* in Frankfurt (fragment of a large *Deposition*) which imprints itself indelibly on the mind by the extremely naturalistic treatment of the armor-clad captain and his beturbaned companion, as well as by the stark realism of the thief's dead body hanging with broken shins on the cross (colorplate 7).

Campin's art is founded on a faith in miracles and the tradition of Christian dogma that was not ruffled by the slightest breath of doubt. The very idea of questioning the existence or probability of angels and saints or of the Virgin and her Son was quite alien to him. The keenly observed drapery and architecture, which are usually those of the painter's own day or, more seldom, of the Romanesque style, give the spectator the impression of witnessing an actual, contemporary event and not something that occurred in the distant past.

The presumption that Campin first engaged in painting miniatures is supported by the fact that the earliest work that may be attributed to him, the triptych of *The Entombment* in Count Seilern's collection in London (fig. 8), is of relatively small size and that his oeuvre includes not only very large but also very small works. Features of that panel that still call to mind Jean Pucelle are: the definition of space, despite the gold ground, by the ar-

rangement of the figures with some close up, some farther back; the way those figures are grouped around the twisted body of Christ; and the movements and actions of all the dramatis personae. The disparity between the right wing (with the Resurrection) and the left wing (with the donor in the foreground and the crosses in the distance) reveals, for all their vivacity, a certain indifference to the demands of a closed composition. This confirms the assumption that *The Entombment*, which some authors ascribe to the second decade, is an early work, and perhaps even the first of those we know.

The Betrothal of the Virgin in the Prado (fig. 11) also shows signs of being an early work. But the division of the picture into two parts, justified by the subject, is not the only cause of the rather incongruous, oddly oriental-exotic impression the panel makes and for the rather unbalanced composition, whose center of gravity is quite clearly located on the right-hand side. A glance at the reverse, on which Saint James the Great and Saint Clare are painted in grisaille in niches after the manner of Claus Sluter's sculptures, shows that the work was probably part of the right wing of an altarpiece whose center panel (a carved or painted Coronation of the Virgin or Adoration of the Magi) was flanked by four scenes—two

8. Robert Campin. Triptych: *The Entombment.* 23 5/8 × 39 3/8″ (60 × 100 cm.). Collection Count A. Seilern, London

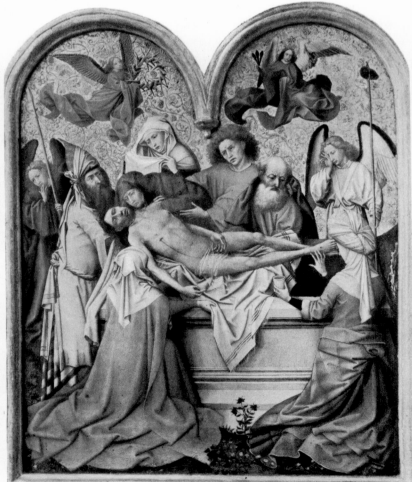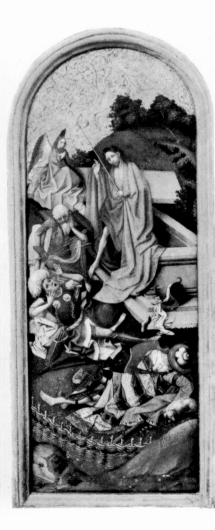

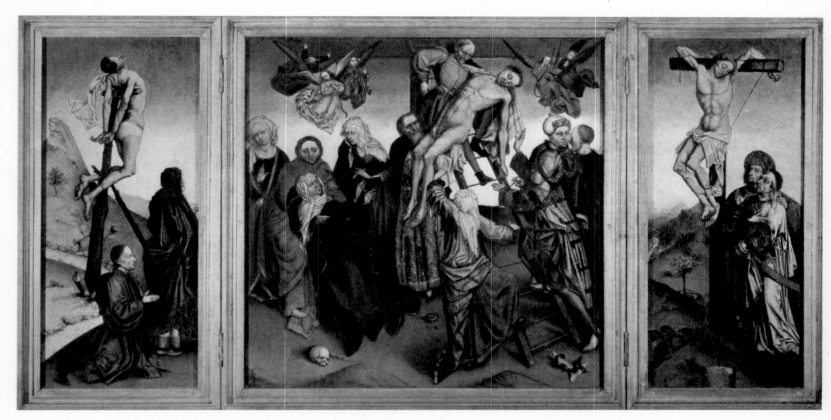

9. Robert Campin. Triptych: *Deposition* (copy). Center panel 23 1/4 × 23 3/4" (59 × 60.2 cm.); wings 23 1/2 × 10 1/2" (59.6 × 26.5 cm.) each. Walker Art Gallery, Liverpool

above and two below—from the life of the Virgin Mary.

One is struck by the throng on the right-hand side of the picture, but the other side is very lively, too. What is going on there? According to the Protevangelium of Saint James, all the widowers of the tribe of David were convened when the question arose of who should marry the twelve-year-old Mary. Each was told to bring a rod, "and to whomsoever the Lord shall show a sign, his wife shall she be." The priest took the rods, prayed over them, then returned them to their owners, giving Joseph the last, "and lo, a dove came forth . . . and flew upon the head of Joseph." There is not a trace of this in the picture; Campin merely shows the rod blossoming. Joseph attempted to conceal it, but the high priest said: "Take Mary into thy keeping." Some of the Jews are obviously preventing the unwilling Joseph from evading his mission by leaving the temple, in which the high priest Abiathar (surrounded by widowers with rods in their hands) kneels before the high altar. One of them wears one of the diagonally striped materials Campin used often in his early period to designate Jewish or oriental characters. The exotic impression of the left-hand side of the picture is enhanced by the variously sculptured pillars and the mingling of heterogeneous stylistic—Romanesque and Gothic —elements. The capitals are embellished with reliefs, as are the pointed arches of the spandrels above the semicircular arches that link the pillars.

10. Robert Campin. *Saint George*. 6 × 4 5/8" (15.2 × 11.8 cm.). National Gallery of Art, Washington, D.C.

11. Robert Campin. *The Betrothal of the Virgin.* 30 1/4 × 34 5/8″ (77 × 88 cm.). The Prado, Madrid

Erwin Panofsky has made a decisive contribution to the interpretation of Campin's themes (as he had already done for Broederlam's). He says that the Gothic narthex on the right-hand side symbolizes the New Testament, while the oriental-like domed building on the left stands for the Old Testament. Though all attempts to identify the unfinished church with a known edifice have failed, it is treated in a very realistic manner down to the slightest detail. Outside the door the high priest performs the ceremony before a fashionably dressed gathering. Attired like a Christian bishop—his mantle, which ranges in color from turquoise to vitriol blue, gives a typically archaic impression—he lays his stole over the clasped hands of the bride and groom. The bald-headed Joseph holds his miraculously blossoming rod, while an angel gives the bashful Virgin a gentle push toward her spouse.

The brilliantly colored *Nativity* in Dijon (colorplate 4) has certain details in common with the Seilern *Entombment*. Its scenic setting marks the very beginning of landscape painting in central Europe.

Campin's artistic activity reached its highest point in three important panels in Frankfurt—*The Virgin and Child*, *Saint Veronica*, and the grisaille of *The Holy Trinity* that was originally the reverse of the latter. It was these three works that gave rise to the makeshift name of "Master of Flémalle" because they were presumed to have come from Flémalle Abbey near Liège.[1]

The Virgin (fig. 14) stands before a panel of Lucca silk (sealing-wax red patterned with Saint Mark's lions in gold) on a greensward dotted with lilies of the valley

and dandelions. She wears a silvery-gray mantle (bluish and dark gray in the shadows) with a gold pattern, under which one can see a vermilion robe and hints of a white shift. A naturalistic detail that was unheard of at that time—it even preceded the Adam and Eve of the *Ghent Altarpiece*—is the Infant suckling at His mother's breast. His right hand clutches a corner of her intricately pleated white kerchief. His deep lapis-lazuli blue frock is tied with a narrow vermilion belt. This is typical of the 1420s; later the frock developed into a shirt and only after that was the Child depicted in the nude.

Saint Veronica (not illustrated), in brandy-colored mantle with gem-studded border along the lower hem, is depicted as a matron and treated as an individual (probably after a drawing from life). She holds the sudarium (a veil) with the dark imprint of Christ's countenance. The silvery-gray backdrop is patterned with gold leaves and white flowers. The lapis-lazuli blue sleeves of a

patterned undergarment can be glimpsed under her grass-green robe. The greensward on which she stands resembles that in the picture of the Virgin.

A very large *Deposition* painted about the same time is known only through a small copy in Liverpool (fig. 9). All that is left of the original is a very fine fragment in Frankfurt (colorplate 7).

The Virgin and Child Before a Fire Screen in London (colorplate 6) with her large, moonlike face is an outstanding example of a proto-Renaissance trend in early Flemish painting, which can be observed repeatedly.

Other works of Campin's early period that deserve mention are the small *Madonna in a Niche* in the Thyssen-Bornemisza Collection, Castagnola (near Lugano), and the no less miniature-like *Saint George* (fig. 10), as well as *Christ Blessing, and the Virgin in Prayer* in the John G. Johnson Collection, Philadelphia.

There is little doubt that it was Robert Campin and not

12. Robert Campin. *Portrait of a Woman.* 15 3/4 × 10 5/8″ (40 × 27 cm.). The National Gallery, London

13. Robert Campin. *Robert de Masmines.* 13 3/4 × 9 1/2″ (35 × 24 cm.). Collection Thyssen-Bornemisza, Castagnola (near Lugano), Switzerland

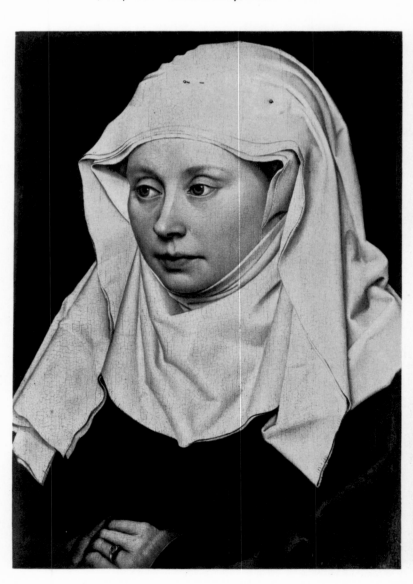

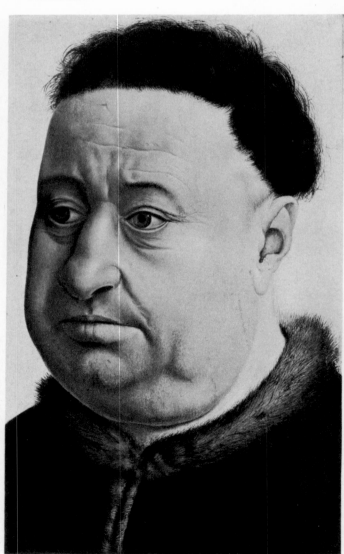

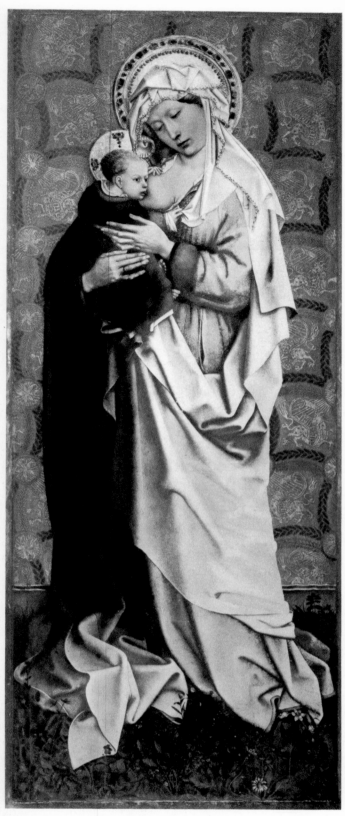

14. Robert Campin. *The Virgin and Child*. 63 × 26 3/4″ (160 × 68 cm.). Städelsches Kunstinstitut, Frankfurt am Main

Jan van Eyck who initiated the independent portrait. His *Robert de Masmines* (killed at the Battle of Bouvignes) gives an impression of plasticity that one cannot forget. It exists in two virtually identical versions, one in Berlin, the other at Castagnola, formerly in Ponthoz Castle

(fig. 13). Another peak achievement is the married couple in London (fig. 12 and colorplate 5). The splendid, crystal-clear figure of *Woman with a Kerchief* in Berlin displays a taut plasticity that one finds only in Campin's work.

The Mass of Pope Gregory and *The Annunciation* (colorplate 8)—the latter is important as a preliminary stage of the *Mérode Altarpiece*—were erroneously considered as copies until a few years ago; both works are preserved in Brussels.

In the *Mérode Altarpiece* (fig. 15) Campin took over the toilet recess from Van Eyck's *Ghent Altarpiece*, thus admitting the latter's superiority, but kept the type of Joseph we know from the Seilern *Entombment* and *The Nativity* in Dijon (colorplate 4). On the right wing he has represented Joseph as a mousetrap maker. The explanation of this scene is to be found in Saint Augustine, who says it was the devil who first set traps but now traps are set to win Christians. Joseph is busy boring holes in a plank. This is typical of Campin, who tended to think up novel genre motifs.

A change set in with the *Mérode Altarpiece*, which represents a *terminus ante quem* for the works mentioned above. In fact, from now on the boldness, defiance, and aggressiveness that had formerly been Campin's chief characteristics are either subdued or disappear entirely. *Madonna in a Glory* at Aix-en-Provence and one of the small panels in Leningrad[2] that originally belonged to a little folding altarpiece show the Virgin with the same face. They are generally viewed as being earlier than the *Werl Altarpiece* of 1438 (fig. 16), Campin's only dated work, but might just as well have been executed during the last years of his life, like the *Annunciation* in the Louvre whose shortcomings writers have not failed to point out.

Typical in the Paris picture is how the angel's brocade mantle spreads out along the ground into the distance. Campin appears to have adopted the difficult task of painting brocade from Jan van Eyck, but he never attained that artist's mastery. This can be seen, for example, in the gown of the maiden in his small *Saint George* (fig. 10). The *Visitation* on the right wing in Turin was painted after the one in Leipzig (formerly at Lützschena); the donor on the left wing has been given a more recent head.

Whether the painter curbed his impetuosity owing to advancing years or because he was overwhelmed by the *Ghent Altarpiece*—particularly the part with *The Annunciation*, which might be termed an organized plane—is a moot question. To ascribe it to the influence of his pupil Rogier van der Weyden does not make sense. Nor is the assertion convincing that the small *Madonna Standing Before the Throne in a Niche* in Vienna (with Saint Catherine on the reverse) derived from Van Eyck's *The Madonna at the Fountain* of 1439 in Antwerp. In fact, it was painted earlier.

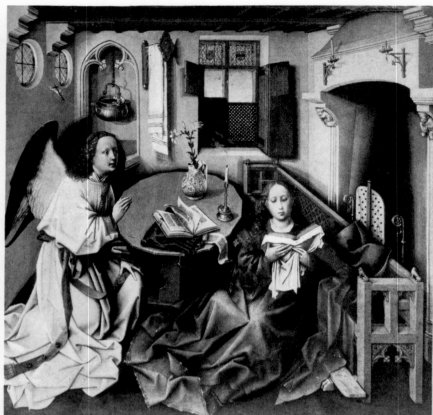

15. Robert Campin. *Mérode Altarpiece.* 25 1/4 × 46 1/2″ (64.1 × 118 cm.). The Metropolitan Museum of Art, New York. The Cloisters Collection

Jan van Eyck

Hubert and Jan van Eyck are designated as coauthors of the *Ghent Altarpiece* (figs. 17, 18; colorplate 9)³ in the famous quatrain inscribed on the outer frame of that work: "The painter Hubert van Eyck, greater than whom no one was found, began the task, which Jan, the second in art, completed at the request of Jodocus Vydt on May 6, 1432." Whether the inscription is authentic or not even Paul Coremans was unable to decide.

All we know about Hubert is that the Ghent magistrates paid him for two designs for a painting and that, according to a copy of his epitaph, he died on May 6, 1426. Opinions on his manner of painting and his part in the *Ghent Altarpiece* differ so widely that more detailed research will be necessary before a definitive statement about him can be made—if, indeed, that will ever be possible. As for Jan, we know that from October 24, 1422, he spent some time in the service of John of Bavaria, count of Holland, who died in 1425. On May 18, 1425, he was appointed *varlet de chambre* by Duke Philip the Good of Burgundy, for whom he made several secret journeys in southern Europe. In 1427 he went to Spain. He took advantage of a diplomatic mission to the court of John I of Portugal (from October 19, 1428, to Christmas, 1429) to paint a portrait of the king's daughter Isabella, which is no longer extant. This is a significant departure from the custom of Robert Campin, who dealt exclusively with

burghers and clerics. On returning from Portugal he undertook, at the request of Jodocus Vydt of Ghent, to complete the altarpiece which his brother had begun and which was set up in a chapel in the ambulatory of St. Bavo. A little later Jan went to live at Bruges. In 1435 the Duke, who had visited the artist in his workshop two years before, said he had never found a painter who equaled him in taste or was so distinguished in his art. (This contradicts the words *arte secundus* in the famous quatrain, but we must not forget that contemporary opinions of this sort are subject to caution.) In that same year Jan was paid in cash for painting and gilding six statues and their tabernacle. In 1436 he undertook other secret missions for the Duke. He died on July 9, 1441.

We have a sure date, 1432, for the completion of the *Ghent Altarpiece*, and a number of works executed in the thirties are dated. In spite of this, it has proved extremely difficult to interpolate undated works. Stylistic criteria do not provide an adequate basis and for the time being one must rely on mere probabilities. It remains to be hoped that for *The Madonna of Chancellor Rolin* (fig. 20; colorplate 11) and the *Triptych of the Virgin (Dresden Triptych)* in Staatliche Kunstsammlungen, Dresden, new facts will emerge enabling them to be placed in the proper chronological order.

There are few if any differences of opinion as to *The Madonna in a Church* in Berlin (State Museums) being Jan van Eyck's earliest known panel painting. It is the left side of a diptych known from free copies in Antwerp and

16

Rome. In contrast to Campin's early productions, it is an extremely painterly work with a Gothic architectural setting. It is not easy to say how far back it should be dated: seemingly, if appearances are not deceptive, to the early twenties. The lighting is quite extraordinary: the sun shines through the windows of the clerestory, making patterns on the floor of the church. Falling, as it does, from high up in the north—contrary to all the laws of nature—this light must be interpreted symbolically. It is the light of divine wisdom embodied in the Virgin Mary, the light of eternity. That is why a later work like *The Crucifixion* with the Virgin and Saint John could be placed

on a par with this Madonna and Child who hover so weightlessly in the church. The Virgin stands for the Church and the light is "more beautiful than the sun and above the whole order of the stars." Here, however, as in Van Eyck's entire oeuvre, all symbols are treated as potential natural phenomena; consequently, one is not obliged to consider any detail as symbolical unless one is willing to do so.

Portrait of Baudouin de Lannoy in Berlin (State Museums) is the most painterly of all Jan's portraits. The colors are warmly embedded in the ground into which the image sinks, and the wonderfully rendered brocade closely re-

16. Robert Campin. *Werl Altarpiece*. Left: *John the Baptist and Heinrich von Werl*; right: *Saint Barbara*. 1438. 39 3/4 × 18 1/2″ (101 × 47 cm.) each. The Prado, Madrid

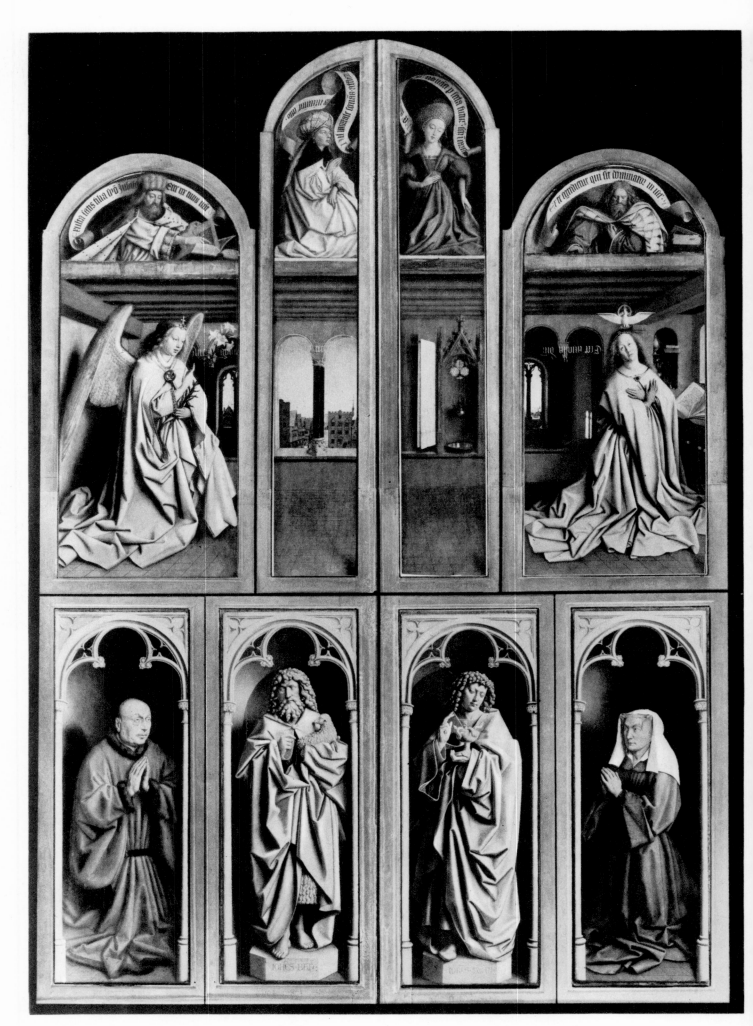

17. Hubert and Jan van Eyck. *Ghent Altarpiece* (closed). 1432. 11′3″ × 7′2″ (342.9 × 218.4 cm.). St. Bavo, Ghent

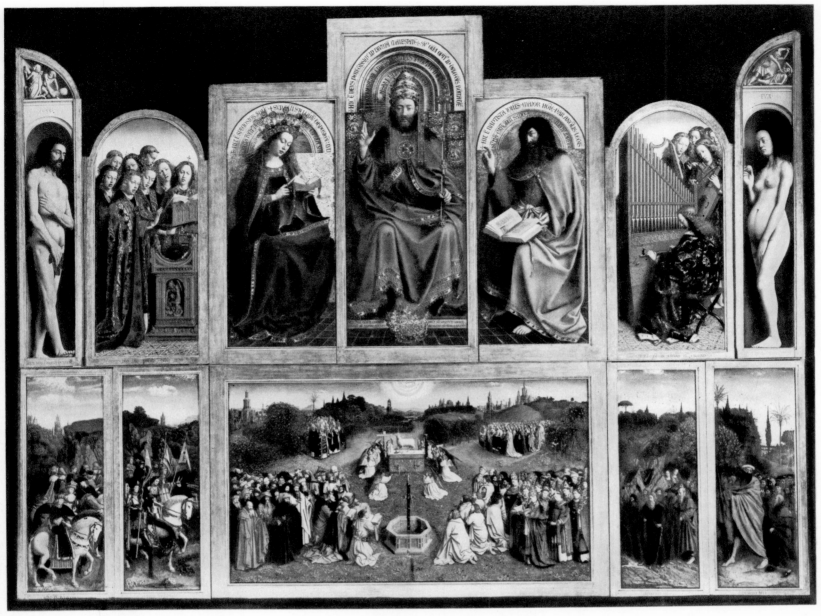

18. Hubert and Jan van Eyck. *Ghent Altarpiece* (open). 1432. 11′3″ × 14′5″ (342.9 × 437 cm.). St. Bavo, Ghent

sembles that of the musical angels on the *Ghent Altarpiece* (colorplate 9). The sitter, whose lined face denotes a man who wore himself out in service, was governor of Lille and chamberlain of Duke Philip the Good. He wears the Golden Fleece, which was only instituted in January, 1430, and cannot have been conferred on him before November of the following year. It does not seem far-fetched to assume that the portrait was painted shortly after. The broad-brimmed hat resembles that in *The Marriage of Giovanni Arnolfini and Giovanna Cenami* of 1434 (colorplate 10).

Cardinal Niccolò Albergati, who was known to be at Ghent and Bruges in 1431 and later—though he only remained for a few days—was papal legate to the court of Burgundy and may well have taken advantage of that opportunity to have his picture painted. It seems unwarranted to suppose, as has in fact been done, that several years elapsed between the incomparable preliminary drawing preserved in Dresden and the execution of the portrait now in Vienna. The latter could, however, have been painted after the cardinal's departure.

The London National Gallery's *Portrait of a Young Man* (a musician), known as *Timotheos* on account of the inscription, is dated 1432. The affinity between this cubistic portrait, in which the figure is cut off by a horizontal parapet inscribed *"leal souvenir"* (loyal remembrance), and those painted by Antonello da Messina (who was, of course, later) is clear to see. It confirms that Jan was already a painter of international importance during his lifetime. Conversely, even he could not help but assimilate some not very obvious Italian achievements (e.g., as in the figures of Adam and Eve on the arms of the throne in *The Madonna of Canon van der Paele,* fig. 19). Perhaps it was from the Italians that he learned to illumi-

nate the side of the sitter's face that is turned away from the spectator; Italian influences are also visible in some of his original frames that have been preserved. In those days there was a two-way traffic between Flanders and Italy.

The delightful *Ince Hall Madonna*—so called because it was formerly in a collection in Ince Hall, near Liverpool—in Melbourne (lapis-lazuli blue robe, barely glimpsed, and spreading, vermilion mantle before a piece of pale-green, asymmetrically patterned velvet brocade) and *A Man in a Turban* in the National Gallery, London, are both dated 1433. The latter bears the motto *"als ich can"* (as best I can) in semi-Greek characters, and, when in the Arundel Collection, was catalogued as *"ritratto di Gio. van Eyck de mano sua"* (portrait of Jan van Eyck by his own hand), so it might well be a self-portrait. Whether the likeness of Giovanni Arnolfini in Berlin was executed before or after the wedding picture of 1434 (colorplate 10) is a moot question. Factors in favor of its being earlier are the close study of Arnolfini's face; the leading role of the triangle as a compositional element (as in the London *Man in a Turban*); and the complicated headdress.

The Madonna of Chancellor Rolin (fig. 20; colorplate 11) in the Louvre must be ascribed to the period immediately after the Peace of Arras (September 21, 1435), although the ill-defined posture of the seated Virgin and the contradictory folds of her draped mantle would seem to make it an earlier work. The later date was suggested by Millard Meiss and confirmed by Emil Kieser, and the execution of the picture may well have continued through part of the following year. (The grounds for this hypothesis will be discussed in the commentary on the colorplate.) For the origin of the composition and some details of the picture, attention has been drawn to a dedication miniature from the circle of the Boucicaut Master (Paris, Bib. Nat., mss. lat. 1161) which obviously influenced Campin as well, unless it too derived from a more important work that has been lost.

In *The Madonna of Canon van der Paele* (fig. 19; colorplate 12) in Bruges, painted in 1436—of all Van Eyck's works it is the one in which he achieved the most intense plastic effect—one is tempted to see a certain affinity with the *Portrait of Jan de Leeuw* in Vienna, which

19. Jan van Eyck. *The Madonna of Canon van der Paele.* 1436. 48 × 62 3/4″ (122 × 157 cm.). Groeningemuseum, Bruges

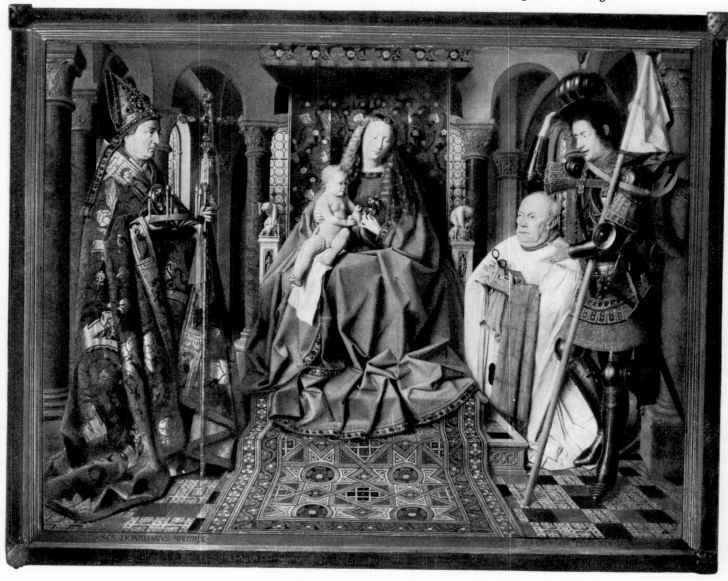

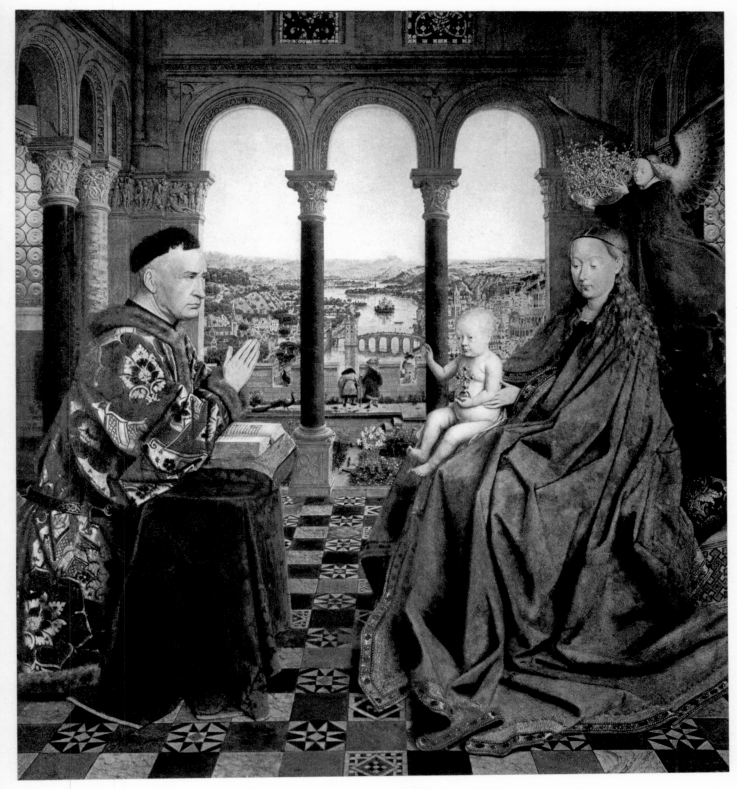

20. Jan van Eyck. *The Madonna of Chancellor Rolin.* 26 × 24 3/8″ (66 × 62 cm.). The Louvre, Paris

dates from the same year. It has the clear depth of *The Lucca Madonna* (colorplate 13) in Frankfurt, which got its name from the duke of Lucca to whom it once belonged. The date 1437 discovered in 1959 on the Dresden *Triptych of the Virgin* came as a surprise because *The Annunciation* on the outside of the wings seems considerably more Gothic than the later and more developed, little panels of the same subject in Castagnola, which accounts for its previous attribution to an earlier period. Is it too risky to

assume that the wings were painted some years before they were used for the triptych? The same date is inscribed on the fascinating *Saint Barbara* in Antwerp; the fact that it is only partly colored does not necessarily mean that it was left unfinished.

Lady at Her Toilet, no longer extant, is known through a copy by Van der Haecht. Another is mentioned by the Italian author Bartolommeo Fazio.

Both the diminutive *The Madonna at the Fountain* in

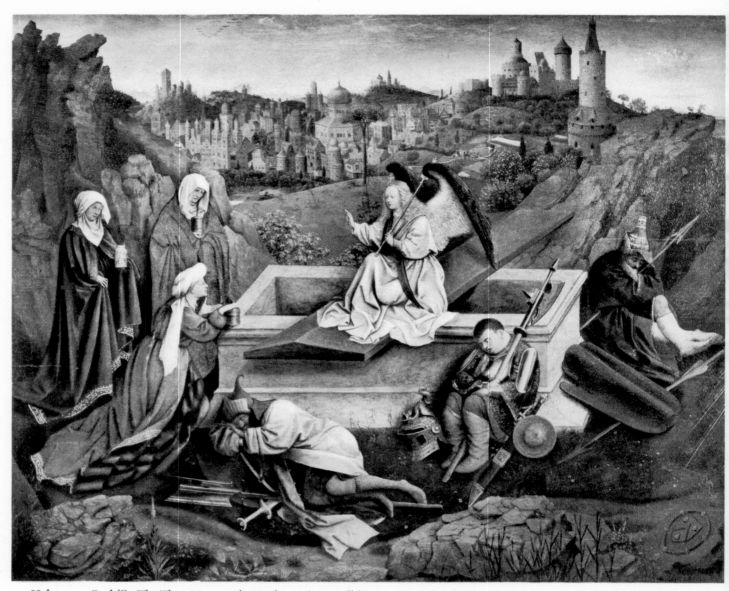

21. Hubert van Eyck(?). *The Three Marys at the Tomb*. 28 1/4 × 35″ (71.5 × 89 cm.). Museum Boymans–van Beuningen, Rotterdam

Antwerp and *The Artist's Wife* in Bruges, which display the same pronouncedly planar conception, date from 1439.

Opinions differ as to the place in the chronological order of *The Annunciation* (National Gallery of Art, Washington, D.C.), one of Van Eyck's most significant religious works (the Virgin in a mantle of an extremely refined deep blue, the angel in red-fringed gold brocade). That the Virgin's gesture occurs in a miniature by the Boucicaut Master in Paris should not lead us to assign too early a date. The magnificent painting, which may have been the wing of an altarpiece, must have been executed in the mid-thirties. Arguments in favor of that dating are the clear contrast between the frontally placed Virgin and the angel in side view (which matches the no less clear structure of the multi-story chancel); the clever use of the brocade-cushioned stool as a repoussoir; the considerable

difference between this picture and The Annunciation on the outside of the *Ghent Altarpiece*; and the combination of stained-glass windows above with bull's-eye panes below, as in *The Madonna of Chancellor Rolin* in Paris (fig. 20; colorplate 11) and the Dresden *Triptych of the Virgin*.

The *Van Maelbeke Altarpiece* (named after the donor Nicholaes van Maelbeke, Provost of St. Martin at Ypres) or the *Ypres Altarpiece* was left unfinished at the painter's death. The center panel, *The Virgin and Child with Nicholaes van Maelbeke*, resumes once again the idea of *The Madonna of Chancellor Rolin*, but the cleric in the brocade mantle kneels directly in front of the standing Virgin and the architecture—Gothic in this case—is tall and narrow to match the vertical rectangle of the panel. This work, as Panofsky says, is "a glorious finale" to Van Eyck's career. *The Madonna with Saint Barbara and Saint Elizabeth of Hungary* in the Frick Collection, New York,

was begun by Jan but finished by Petrus Christus, who is also believed to be the author of *Saint Jerome in His Study* in the Detroit Institute of Arts, another picture linked with Van Eyck.

To revert to Hubert: if, as we read in the famous quatrain, it was he who began the *Ghent Altarpiece*, it is hard to decide what that beginning looked like. It may have been a design or sketch for *The Adoration of the Lamb* (fig. 18). Many attempts have been made to discover a line of demarcation in the painting of the inner part of the work, but without success. Some scholars have attributed to Hubert a group of miniatures *(The Turin Hours)* but others have said that they correspond closely to our idea of Jan's style. Nor should we forget that, in a letter written in 1524, the Italian Pietro Summonte calls Jan the "gran maestro Johannes che prima fe' l'arte di illuminar libri sive ut hodie loquimur miniare" (the great master Jan, who started with the art of illuminating books or, as we call it today, doing miniatures).

There are works unmistakably Eyckian in character that do not readily find a place in Jan's oeuvre as, for instance, *The Three Marys at the Tomb* in Rotterdam (fig. 21) and the outstandingly sculptural *Crucifixion* in Berlin. They have in common the odd, clumsy buildings in the background which, instead of being perfectly vertical, lean slightly forward. In addition, their integration in the spatial-scenic context is not as complete as that which one finds in works that are undoubtedly by Jan. Both may possibly have been painted by Hubert. The Rotterdam picture, which is arbitrary in both composition and handling, is distinguished by its amazingly strong colors— the dark bottle green of the mantle worn by the Mary on the far left; the bright lapis-lazuli blue of the one on the right; the intense reddish brown of the prostrate one in front. The rock formation in the upper left is of the "Phrygian cap" type, which is an argument in favor of a relatively early dating. A certain similarity of the angel on the tomb to those painted by Jan does not necessarily denote a connection with that artist and consequently a rather later execution.

It is no easy matter to form an opinion concerning the two narrow little panels in the Metropolitan Museum of Art, New York, (a *Calvary* and a *Last Judgment*). The second postulates a knowledge of a miniature by Paul of Limbourg, now at Chantilly. The figure of Christ in the first so closely resembles that in the Berlin *Crucifixion* that they cannot possibly be separated. On the other hand, it is worth noting—and Émile Renders was the first to do so— that the Erythraean Sibyl standing beside Mary Magdalene, who kneels wringing her hands in anguish, is dressed exactly like the Erythraean Sibyl in one of the spandrels on the outside of the *Ghent Altarpiece;* this would be difficult to explain if they were by different painters.

Astonishing, too, is the resemblance of the highly diversified townscape in the background of the New York *Calvary* to that in Jan van Eyck's *Stigmatization of Saint Francis,* of which two versions that differ in size are preserved in Philadelphia and Turin. One would tend to prefer the smaller Philadelphia version, were they not both to be considered authentic on the basis of a contemporary will.

Petrus Christus

Petrus Christus was born at Baerle (Brabant) on the frontier between Belgium and Holland. He was a pupil of Jan van Eyck and completed *The Madonna with Saint Barbara and Saint Elizabeth of Hungary* (now in the Frick Collection, New York), which was unfinished at the latter's death. Jan de Vos, prior of the Genadedal Charterhouse, had commissioned the painting for that monastery but took it with him when he moved to Utrecht in 1450. In its place he left a modified partial copy, the so-called *Exeter Madonna* now in Berlin. Two years later, in 1452, Petrus Christus had another encounter with Van Eyck's work. Disdaining to borrow details only, as was the usual practice, he did not shrink from testing his new conception of clarified space and physical volumes by inviting a direct comparison with his master. The result is a picture now in Berlin, in which the New York *Last Judgment* is reduced to a mere formula. His own hand is more obvious in the other two leaves of the triptych, *The Annunciation* and *The Nativity* (with Zelomi), though he took his cue from Robert Campin. *The Nativity* is known in two other versions. One, which is probably the earliest, includes a midwife (Collection Wildenstein & Co., New York) and is interesting for its colors; the other, in addition to the adoring Joseph, has two kneeling figures that may be the donor and his wife (National Gallery of Art, Washington, D.C.). There are, or were, other mature paintings by Petrus Christus in Frankfurt (1457), Dessau (until World War II), and the Louvre in Paris.

His most ambitious work is *The Lamentation* in Brussels (fig. 22), a large picture of incomparably higher quality than a small version of the same subject in New York. It is a new departure in that the body of Christ does not, as in Rogier van der Weyden's treatment of the same subject, lie on the Virgin's lap but has been lowered to the ground on a shroud by two pious men, while those who are ministering to Mary form a separate group. The isolated figure of Mary Magdalene, crouching at the lower left and clasping her hands in a gesture of agony,

turns away from the painful scene. Thus she draws our gaze into the picture space, which is deepened on the opposite side by the bareheaded man and the woman in the round Burgundian headdress, who wipes her nose with her back turned to the spectator. The broad landscape with high horizon in which the scene is set was something entirely new. It is bathed in the light of evening.

About the middle of the century Petrus Christus painted some portraits of a very high order (colorplate 14).

Rogier van der Weyden

Not a single dated work by Rogier van der Weyden has come down to us, so research has to be based almost entirely on stylistic considerations. The following important works have contributed most to his fame, besides giving a clear idea of his art:

The Deposition in the Prado, Madrid (fig. 23; colorplate 15),

Mary Altarpiece (Capilla Real, Granada, and The Metropolitan Museum of Art, New York) and its excellent workshop copy known as the *Miraflores Altarpiece* in State Museums, Berlin-Dahlem, *Saint John Altarpiece* in State Museums, Berlin-Dahlem,

The Last Judgment in Beaune (fig. 27),

Columba Altarpiece in Munich (fig. 29; colorplate 19).

Rogier van der Weyden is believed to have been born in Tournai and to have entered Campin's workshop in 1427. Though far from lacking a feeling for plasticity, he tended more than his predecessors toward a sensitive, spiritual, abstract line and consequently to the plane. The problem of spatial illusion preoccupied him for many years. In contrast to Jan van Eyck, whose colors shine from the depths, Van der Weyden gave his paintings—so it has been said—an opaque surface.

The Deposition in the Prado, which very likely once had wings, has often been viewed as a sort of imitation of a framed Late Gothic carved altar. The artist's contemporaries may well have admired him even more for that reason because comparison offers a layman a handle he can grasp. As a matter of fact, points of contact between him and the Tournai school of sculpture may be presumed, and indeed established. The composition of the

22. Petrus Christus. *The Lamentation.* 39 3/4 × 75 5/8″ (101 × 192 cm.). Musées Royaux des Beaux-Arts, Brussels

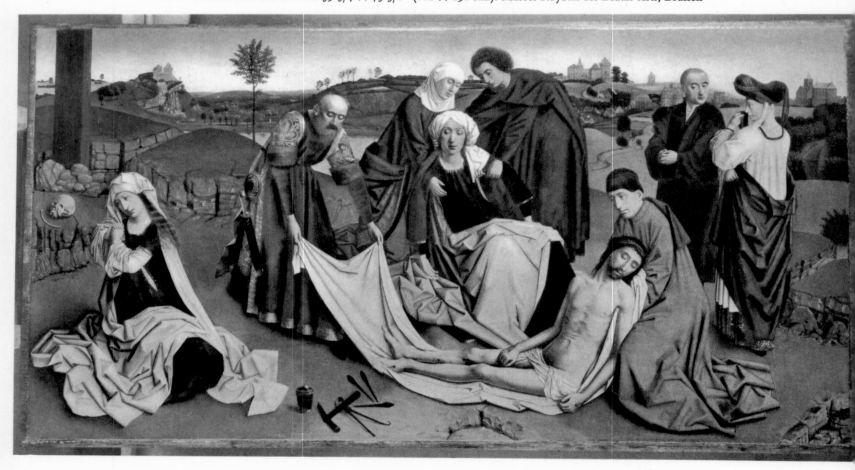

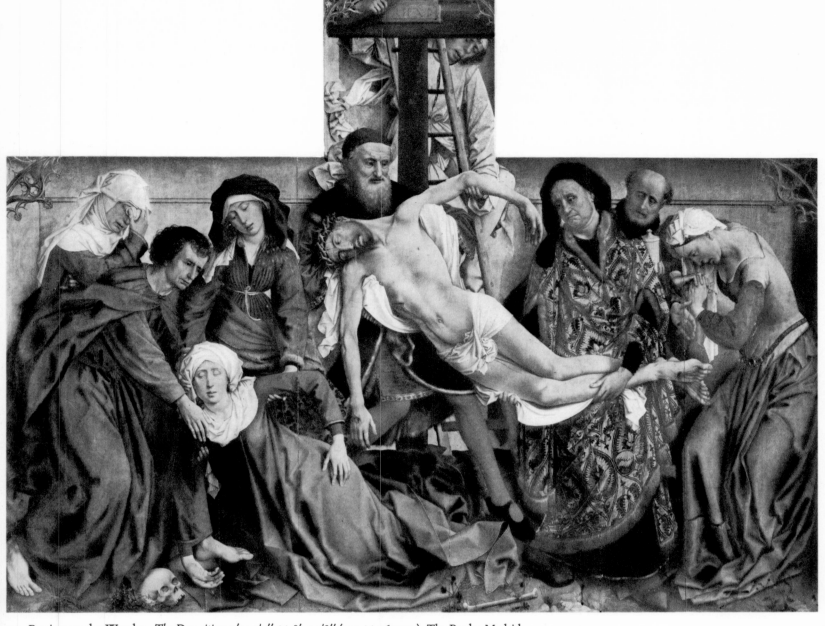

23. Rogier van der Weyden. *The Deposition.* 7′ 2 1/2″ × 8′ 7 1/8″ (220 × 262 cm.). The Prado, Madrid

Beaune picture may also have been influenced by impressions of Romanesque and Gothic tympana. But in reality Rogier was far more than a mere imitator of the wood-carver's art. He saw space as stratified, so the plane was an element of primary importance for him. In this he was in direct opposition to Campin, who penetrated through the plane, and in partial agreement with Jan van Eyck, whose *Annunciation* in the *Ghent Altarpiece* is a grandiose example of stratified planes. This is also true, despite certain apparent contradictions, of the *Mary* and *Saint John* altarpieces, the Beaune *Last Judgment,* and the late *Columba Altarpiece.*

The manner in which the Virgin's blue mantle is spread out on the ground in the Prado picture reveals an obvious derivation from Campin's exaggerated perspective. And this had other consequences. The cross is far too small and seems to slant toward the front. The Magdalene's position in space is ill defined: it is impossible to

hold one's arms as she does. From the artistic viewpoint, far from being a fault this is a positive quality.

At the same time as *The Deposition,* Van der Weyden painted an *Entombment* which we know only from a copy. His *Saint Luke Painting the Virgin* must have been executed a few years later; the original has disappeared but there are four excellent copies in Boston, Leningrad, Munich, and Vaduz. Like that of his master, Campin, the influence of Van Eyck, though less extensive, is evident (see fig. 20). Borrowings from both are almost more than was admissible even in an age when the term plagiarism had not yet been coined. In Campin's condensed treatment of the theme, which is superior to Rogier's, the Virgin is seated out of the painter's sight. We know the picture only through a copy by Colyn de Coter.

In 1435 Rogier was in Brussels, his wife's home town, where he was appointed "city painter." He remained there until his death in 1464. In 1436 he painted for the

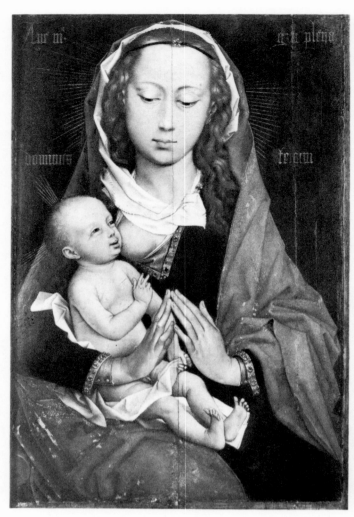

24. Rogier van der Weyden. *Madonna.* 19 1/4 × 12 1/4" (49 × 31 cm.). Musée des Beaux-Arts, Caen

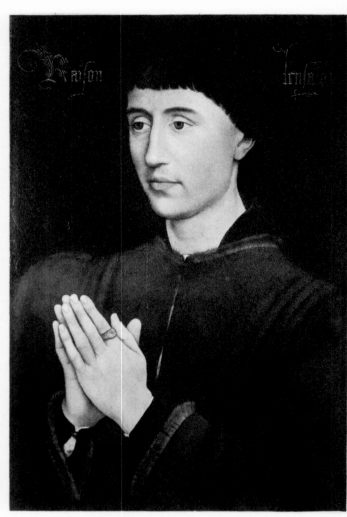

25. Rogier van der Weyden. *Laurent Froimont.* 15 3/8 × 13 5/8" (39 × 34.5 cm.). Musées Royaux des Beaux-Arts, Brussels

town hall four panels showing examples of justice (*The Justice of Trajan and Herkinbald*) mentioned by Albrecht Dürer in the diary of his journey to The Netherlands. They contained a self-portrait of the artist but were destroyed by fire in 1695 and are now attested to only by a huge tapestry in the Bern Historisches Museum. In this work, though stratification has been preserved, the artist's interest in foreshortening and perspective stressed by the pillars in the foreground (see Hans Multscher's *Wurzach Altarpiece* of 1437 in State Museums, Berlin-Dahlem) is clear to see; it led him to set the scenes within sharply delimited architectural frames. What more forceful means could he have found to achieve the illusion of three-dimensional space that was his major preoccupation then without infringing upon the law of planar representation?

The same purpose is served by the stone frames in the *Mary Altarpiece* and by the vaulted ceilings supported on columns behind them (in the *Holy Family* and *Lamentation* sections); in the scene of *Christ Appearing to His Mother* there is also a portico that leads out into the open air. These details may have been suggested by the *pleur-*

ants carved on the sarcophagi of the dukes of Burgundy now in Dijon. But the triptych with *The Crucifixion* in Vienna, which was painted about the same time, proves that Rogier had no need of any such crutch. It is assumed that *The Holy Family* and *The Lamentation* (mutilated and with the Virgin's blue mantle darkened almost to black) in Granada and *Christ Appearing to His Mother* in New York are the originals, whereas the *Miraflores Altarpiece* (Berlin) has been recognized as a copy. Don Antonio Ponz, in his *Viaje de España* (1783), says that King Juan II presented the triptych to the Convent of Miraflores, near Burgos, in 1445. So the original must have been painted slightly earlier. What is certain is that the similar *Saint John Altarpiece* in Berlin, also a triptych, in which symmetry within each single panel is sacrificed to the mutually symmetrical perspectives of the wings, must be assigned a later date. This is confirmed by the dress styles. In this work the motif of the *trompe l'oeil* carved-stone frames is expanded in that, for the sake of corporeal illusion and liveliness, the figures are placed not behind but in front of them, whereas in the *Mary Altarpiece* the

frames still serve the purpose of creating a stage for the action. The *Saint John Altarpiece* and the *Miraflores Altarpiece* give the impression of being by the same hand, thus raising doubts over the attribution of the former work to Rogier himself. Another copy of this painting, of excellent quality but obviously executed somewhat later, is preserved in the Städelsches Kunstinstitut in Frankfurt am Main.

The Last Judgment in Beaune (fig. 27) is also a very important work, though, as old photographs show, it is much restored and badly preserved in part. It was obviously executed immediately after Rogier returned from his journey to Italy in the Holy Year 1450. Some compositional traits, such as the second layer of figures, could hardly be imagined without reference to Masaccio's *Payment of the Tribute Money*. And there is no denying the kinship between the fleeing couple on the first fixed wing to the right and the great Florentine's *Adam and Eve Expelled from Paradise*. Bartolommeo Fazio, who was Genoese envoy to the king of Naples in 1454–55, relates that in the Anno Santo 1450, Rogier was greatly impressed by a painting by Gentile da Fabriano which he saw in a church in Rome. But the Fleming showed his independence in that the damned (one of whom bites his hand in remorse) are represented in size and number on a far smaller scale than the saints. Yet he could never have conceived the huge work had the Van Eyck brothers' *Ghent Altarpiece* not provided the inspiration for the triad of Christ, Mary, and John. By raising the center panel and the side pieces with the instruments of the Passion displayed by angels, he made the twelve Apostles and the figures grouped behind them to the right and left of the triad appear as if in a plane in the sky, and rendered them one of the major elements of the picture. This was a historic new departure, the effects of which can be traced right down to Raphael's *Disputà* and Dürer's *All Saints*.

By this device Rogier succeeds in making us forget the Eyckian model once the altarpiece is opened. That he does so is due to the fact that he was a master of planar arrangement from the very start, as proved by *The Deposition*. When, instead, the altarpiece is closed, there is no denying its affinity with the outside of the one in Ghent. The inside was certainly executed with the help of assistants; similarly the outside, in which the composition is more condensed—matching the square format—than that of Van Eyck's masterpiece, can hardly be exclusively by the master's own hand. The portraits of the donors, Chancellor Rolin and his wife, Guigonne de Salins, are rather stilted.

One cannot be very wide of the mark in assuming that *The Entombment* still preserved in the Uffizi (painted in a tonality that recalls Bouts) was executed during Rogier's journey to Italy. Cyriacus of Ancona mentions an *Entombment* by Rogier in 1440; but even if there was no external evidence that he went to Italy, the borrowings from important Italians displayed in his works would be proof enough.

However much he admired Italian achievements, Rogier van der Weyden was by no means ready to abandon his own manner and imitate or copy them directly. This is evident from a comparison between the Florence *Entombment* and the little pictures on the Fra Angelico predella in Munich. Not satisfied with three figures, Rogier has four tending Christ's dead body. He felt that it was not quite right for the body to be supported by a single person, particularly as there was also the question of the hands being kissed. It was better for two men, Joseph of Arimathea (in velvet) and Nicodemus (in brocade) to hold it up. A long strip of linen is carefully used to avoid direct contact with the body, while at the same time it forms harmonious folds on the ground, folds that constitute an important element of the composition. The

26. Rogier van der Weyden. *Braque Altarpiece*. 13 3/8 × 45 5/8" (34 × 116 cm.). The Louvre, Paris

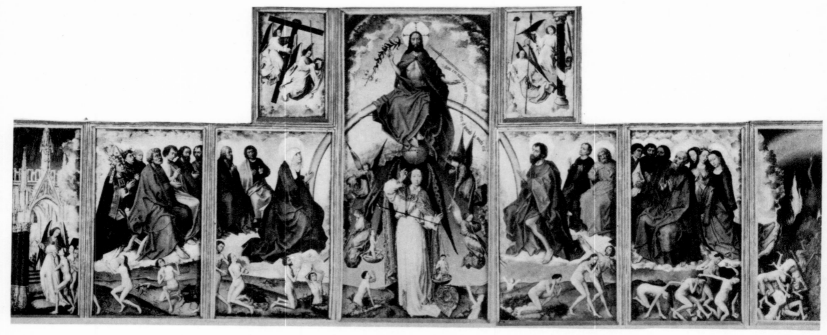

27. Rogier van der Weyden. *The Last Judgment*. Height: wings 53″ (135 cm.), center panels 84 1/2″ (215 cm.); length overall 18′4 1/2″ (560 cm.). Hôtel-Dieu, Beaune

body itself, far from being rigidly vertical, is slanting and slightly twisted. It is less the Lord one prays to than He who deserves compassion. On Fra Angelico's panel the Virgin Mary and Saint John stand away from Christ; they dare not approach Him. Rogier takes a more human view. Instead of holding her Son's hand to kiss it, the Virgin Mary grasps His arm and gazes ahead, preoccupied with her grief. Saint John is about to touch Christ's left hand with his lips.

As if to prove that things were done differently in Flanders, Rogier has set the tombstone at a slant, thus creating an essential formal contrast with the rectangular opening of the grotto. The kneeling Magdalene is useful as a repoussoir and a means to break the symmetry, which is restored to some extent by her discarded headdress and ointment jar.

In the technically perfect and magnificently preserved *Braque Altarpiece* in the Louvre (fig. 26; colorplate 16), the emphasis on symmetry is presumably also due to impressions received in Italy: the half-length figure of Christ is flanked not only by the Virgin Mary and Saint John the Evangelist but also by John the Baptist and Mary Magdalene (on the wings). The hand of the great artist is evident in the continuous horizontal lines of the landscape behind the figures. The taut composition of a less important work, *The Madonna and Saints* in Frankfurt, must also be ascribed to the same origin.

A certain mellowing is apparent in the center panel of the splendid *Bladelin Altarpiece* in Berlin (colorplate 17), where the distinguished donor, Peter Bladelin, treasurer of Philip the Good, is treated on a par with Our Lady and Saint Joseph. There is no connection between the land-scapes in the background of the three panels, but the painter would have felt at fault had he not reestablished the balance by positioning symmetrically the Emperor Augustus (to whom the Tiburtine Sibyl is pointing out the Virgin in the sky) and the foremost of the three kings, who imagine rather than see the Infant Christ enthroned in the star.

In large panel paintings like *The Crucifixion with the Virgin Mary and Saint John* in Philadelphia (John G. Johnson Collection) and the Escorial *Crucifixion*, which was originally in Scheut Charterhouse, a certain allowance must be made for the work of assistants.

The *Columba Altarpiece* in Munich (fig. 29; colorplate 19), a masterpiece entirely by Rogier's own hand, was executed about 1460. It is an extremely important late work, which understandably lacks the vigor of the Prado *Deposition;* but this is balanced by a spirituality befitting his riper age.

Like Van Eyck, Rogier seems to have painted profane as well as sacred subjects. For instance, Fazio speaks of a picture in Genoa in which "a female sweating in the bath is watched by two hidden youths through a chink."

Rogier van der Weyden only began to paint portraits during his late period. They are all half-length figures and as a rule were combined with a Madonna in diptychs which were later divided. Like Dürer at a later date, Van der Weyden never tired of ringing the changes on the traditional theme of the Madonna. Two of these works deserve special mention: the Caen *Madonna* (fig. 24), companion piece to *Laurent Froimont* in Brussels (fig. 25), and the delicate late *Madonna and Child* in the Huntington Art Gallery at San Marino, California, whose counterpart

is the superb portrait *Philippe de Croy* (colorplate 18) in Antwerp. One of Rogier's finest independent portraits is the aristocratic head of *Pierre de Beffremont* in the Thyssen-Bornemisza Collection, Castagnola (near Lugano). Of the same excellent quality is the noble *Isabella of Portugal* in the Rockefeller Collection, New York, with the misleading inscription *"Persica Sibylla."* Less good is an earlier *Portrait of a Lady* in the National Gallery of Art, Washington, D.C., which Hermann Beenken considers greatly superior to a similar work in London. Unfortunately his portraits of Philip the Good and Charles the Bold have come down to us only as free copies.[4]

Joos van Gent

Joos van Wassenhove, known as Joos van Gent, was a singular case. He was the author—if the attribution is correct, for Georges Hulin de Loo and A. P. de Schryver ascribe it to Daniel de Rijke—of a huge triptych in St. Bavo in Ghent that differs very slightly in style from the works of his Flemish contemporaries. The *Calvary* on the center panel is flanked by Old Testament parallels to the lance thrust—*Moses Striking the Rock* (fig. 28, detail) and

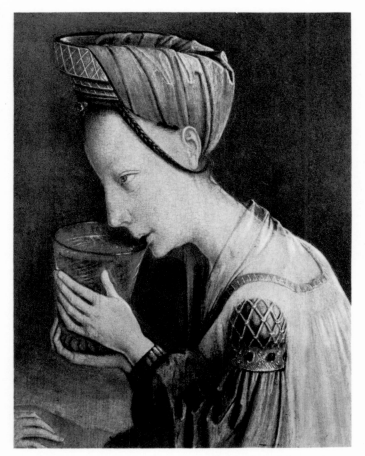

28. Joos van Gent. Triptych: *Calvary* (detail of the left wing). St. Bavo, Ghent

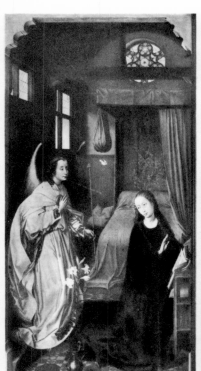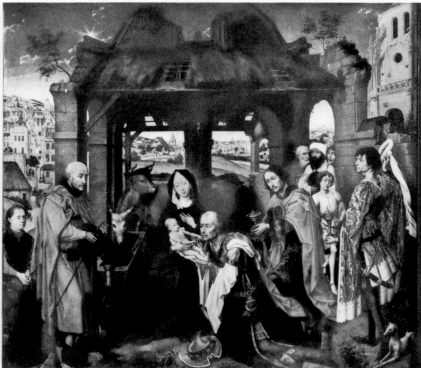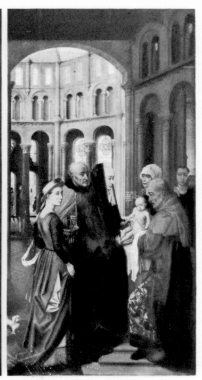

29. Rogier van der Weyden. *Columba Altarpiece.* 4′6 3/8″ × 9′7 3/4″ (138 × 294 cm.). Alte Pinakothek, Munich

The Raising of the Brazen Serpent—on the wings. In the Metropolitan Museum of Art, New York, there is a large oblong picture of *The Adoration of the Magi* in which the youthful Moorish king catches our eye with his flaming vermilion cloak.

Joos became a free master of the Ghent painters' guild in 1464 but must have been drawn to Italy a few years later. We find him at Urbino at the court of Duke Federigo da Montefeltro, who obtained for him a commission from the Confraternity of Corpus Domini to paint *The Communion of the Apostles,* which can now be seen in the Palazzo Ducale there. This large picture was started in 1472 and finished two years later. The finest and most Flemish part is the group in the background of Federigo accompanied by a bearded Venetian in a magnificent brocade robe; he is Caterino Zeno, the envoy sent by the Shah of Persia to Urbino in 1474. Still farther back the Duke's little son Guidobaldo appears in his nurse's arms.

After this a quite amazing occurrence took place. Under the southern sky Joos adopted an entirely new style very close to that of the Italian painters of his day. About 1476 the Duke ordered a series of Portraits of Famous Men for his study. Some of them are still at Urbino, others in the Louvre. There was also a series of Allegories of the Liberal Arts, two of which (*Rhetoric* [?] and *Music*) are now in the National Gallery, London,

while two others (*Dialectic* [?] and *Astronomy*) were destroyed in the Friedrichshain air-raid shelter in Berlin in 1945. According to a Spanish source, they should be attributed to Pedro Berruguete. In the Royal Collection at Windsor there is a painting showing Federigo at a lecture.

Dieric Bouts

Northern Netherlands made its entry into the history of art with an outstanding figure: Dieric Bouts. What distinguished that area from the southern provinces, besides a feeling for geometric forms, was a still more refined sense of color and a preference for tonal values. As a result, with the exception of vermilion, local colors were less frequently used than transitional colors, namely those that have the same base. This was a totally new departure and continued to be a typical feature of the painting produced in that area for centuries.

Bouts clothes his figures in silks and brocades whose colors range from an exquisite strawberry through delicate pale pink and deep cherry crimson to moss green,

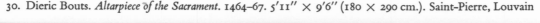

30. Dieric Bouts. *Altarpiece of the Sacrament.* 1464–67. 5′11″ × 9′6″ (180 × 290 cm.). Saint-Pierre, Louvain

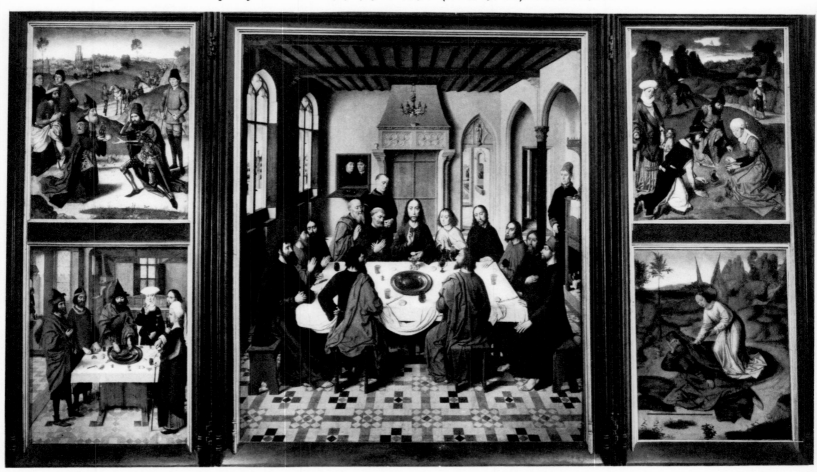

bottle green, bright vermilion, silky white, velvety blue, and warm ocher, with here and there a touch of gold and soft mink trimming. He charms the eye in a way that few of his predecessors, not even Jan van Eyck himself, have done. Needless to say, he could not have achieved this without some preliminary models to follow, but they have disappeared almost without leaving a trace. The only document that must be viewed as representing the many that are lost is the Utrecht Master's *The Crucifixion* in Antwerp (fig. 1) dated 1363 and donated by a certain Hendrik van Rijn. Though there is as yet no perspective and the figures stand out against a tooled-gold ground, like those of the first Master of Saint Clare in Cologne, one can already begin to sense the tonality referred to above and which Bouts realized about a century later. Other traits typical of Bouts are a delicate humanity, a refined sensibility, and a depth of feeling that make him a great artist who deserves to be better known than he is and to be placed side by side with Jan van Eyck.[5]

This extremely cultivated painter succeeded in creating for himself a very comfortable way of life. He was unwilling to stay in Haarlem, where not a single picture of his has been preserved, and apparently migrated to the south. He certainly saw Rogier van der Weyden's work and may have met the artist himself. About 1448 he married Catharina van der Bruggen, nicknamed "Catharina metten Gelde" (Catherine with the money). By 1457 he had settled definitively in Louvain, where he received important public commissions. He was very well off and owned so many pieces of land, vineyards, and houses that toward the end of his life he had to employ a man to manage his property.

The commissions Bouts received from the Confraternity of the Blessed Sacrament put him under the obligation to take part in the kermises (fairs) and processions they organized. On those occasions he wore a blue or black ceremonial robe for which the city gave him the cloth and ninety *"Plecken Futtergeld"*; afterward he was offered a jug of Rhine wine. In his will he left all his unfinished works to his sons Dieric and Aelbert, and those that were finished or nearly so to his second wife, Elisabeth van Voshem.

The Louvain historian Johannes Molanus mentions four of Bouts's most important pictures, all but one of which are still extant and in good condition. They are:

> *The Martyrdom of Saint Erasmus* in Saint-Pierre, Louvain,
> *Altarpiece of the Sacrament* in Louvain (fig. 30; colorplates 20, 21),
> *The Last Judgment,* whose wings are preserved in the Palais des Beaux-Arts, Lille,
> *The Justice of Emperor Otto III* in Brussels (fig. 32; colorplate 22).

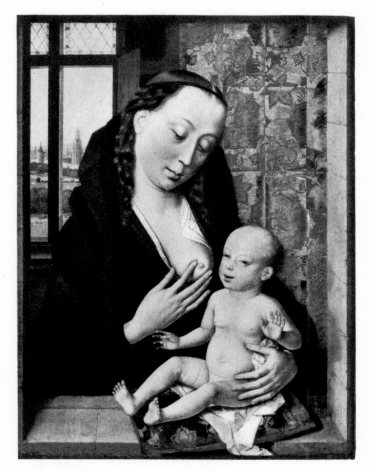

31. Dieric Bouts. *Madonna.* 14 5/8 × 10 3/4" (37 × 27.5 cm.). The National Gallery, London

The *Altarpiece of the Sacrament,* perhaps his finest work, was painted on commission from the above-mentioned Confraternity in 1464–67 for Saint-Pierre at Louvain, where it can still be seen in the central chancel chapel.

Of *The Last Judgment,* which was painted for the city of Louvain during the following years, only the wings are still extant (the center panel is known from copies). They represent *The Path to Paradise* and *The Fall of the Damned* and are preserved in Lille (the second on loan from Paris). Four panels depicting examples of justice were also commissioned by the city of Louvain, but at the time of his death in 1475 Bouts had worked on only two of them, *The Justice of Emperor Otto III: Execution of the Count* and *Ordeal of the Countess.* They are now in Brussels. Whereas Bouts's few Old Testament subjects were dictated by precedent, in *The Justice of Emperor Otto III* he gave free rein to his imagination.

Bouts was by nature an epic painter. It would be easy to call him "phlegmatic" but a more discerning critic has credited him with "an almost diffident purity of soul." Perhaps it is to a profound awareness of the irrevocability of fate that his works owe their significance and value. Rogier van der Weyden had many great qualities, and so of course had Jan van Eyck and Robert Campin, but they

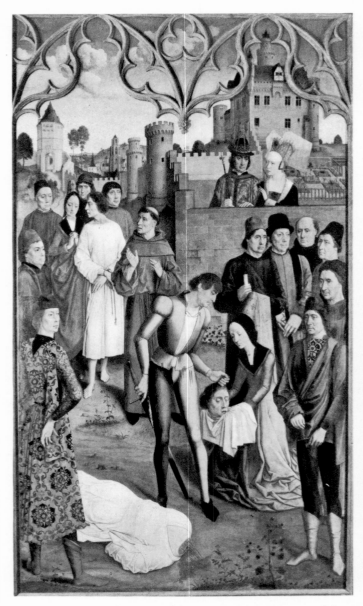 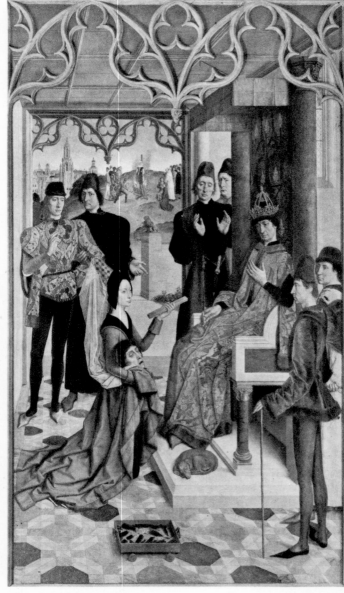

32. Dieric Bouts. *The Justice of Emperor Otto III: Execution of the Count* and *Ordeal of the Countess.* 10′7 1/2″ × 6′ (324 × 183 cm.) each. Musées Royaux des Beaux-Arts, Brussels

could not compare with Dieric Bouts in rendering ineffable spiritual happenings. To lay undue stress on the landscape element in his work, as Molanus did in the sixteenth century and Carel van Mander in the early seventeenth, is to misunderstand his genius. It must be admitted, however, that though he was neither the first artist to take an interest in landscape—Campin and Van Eyck preceded him—nor the only one, in that respect too he was a precursor: in his feeling for scenery, his pictorial refinement, his way of embedding the figures in the landscape (see *Elijah in the Desert* from the *Altarpiece of the Sacrament*), and the atmosphere with which he imbued it. A particularly fine and highly developed example of this is the *Ecce Agnus Dei* in Prince Albrecht of Bavaria's collection—the differentiated rock formations are noteworthy—which is generally viewed as a work by the artist's own hand.

The first stage of this development can be seen in an early work, the large altarpiece in the Capilla Real,

Granada (center panel, *The Deposition;* left wing, *The Crucifixion;* right wing, *The Resurrection*). But there it is less a question of the treatment of a theme and the rendering of an event as of a spiritual atmosphere, which is echoed by the refined lighting and the muffled tones of the softly luminous, yet striking, colors. It is regrettable that in 1523 the panels were put into grandiose, but overdecorated, plateresque frames. That a prop here and there was borrowed from Van der Weyden's store is of no consequence. Rogier's *The Deposition* was originally set up in the Church of Our Lady Outside the Walls at Louvain, so that Bouts could see it every day. But from the very start there was a great difference between the Dutchman and the native of the southern Netherlands who had grown up in a French enclave.

The Martyrdom of Saint Erasmus in Saint-Pierre at Louvain is a stratified work like the *Altarpiece of the Sacrament*. The revolting procedure is depicted with the utmost equanimity in a symmetrical arrangement in the

32

front plane. The rulers form a group in the middle distance linked compositionally with the two saints on the wings. The landscape with its rather high horizon sets off the executioners who are winding out the martyr's entrails at both sides. Similar principles govern the composition of the charming triptych of *The Martyrdom of Saint Hippolytus* in Bruges (Musée de la Cathédrale Saint-Sauveur).

The finest of Bouts's half-length Madonnas is perhaps the one in London (fig. 31) with the view of a distant townscape (Max J. Friedländer ascribes three other versions to the painter's own hand). The geometric scheme based on planes intersecting at right angles—the window and side pieces in the background, the brocade cloth of honor in the middle distance, the parapet in the foreground—involves even the posture of the Infant Jesus (seated on a silken cushion). The London *Portrait of a Man* of 1462 similarly shows a view through a window. The New York *Portrait of a Man,* tersely outlined and stylized in its vertical arrangement, is an example of the artist's late period.

The Entombment in the National Gallery, London, is exceptionally well preserved for a picture executed in tempera on linen. Though the Evangelists all speak of a tomb, painters have chosen to represent the scene in different ways. In Rogier van der Weyden's rendering, the cave in which the body is to be laid is clear to see, while Simone Martini, Jean Pucelle, and Robert Campin had already used a sarcophagus set parallel to the picture plane. For centuries the custom had been to place the weepers and mourners behind it. Thus Bouts, though not quite able to do without a figure as a repoussoir, shows almost the entire front of the sarcophagus. In this he differs, for example, from Martin Schongauer, who was insensible to the beauty of a plain flat surface and in his engraving placed two figures before the sarcophagus in the middle of the picture.

Campin was unable to give a convincing representation of the body, which he twisted like a jointed doll figure. Bouts's composition only a few decades later therefore constituted an amazing advance; he had the coolness needed to master the scene. Joseph of Arimathea holds the body through a shroud under the right armpit to keep the head from falling back. The balding Nicodemus, depicted in profile by way of contrast, stands at the other end of the sarcophagus with the Magdalene. In between there is room enough for the Virgin Mary, who is supported by Saint John and clasps her Son's left forearm with both her hands. One of the weeping Marys presses the corner of her kerchief to her cheek. Another, set full face in the middle of the picture plane, pressing her veil to her lips, echoes the frontality of the sarcophagus. The almost rectangular rocky spur on the left and the

vertical line of the slender tree on the right serve to stabilize the picture; behind them looms the horizontal profile of a vast, partly wooded landscape.

The colors are toned down to match the handling. The panel was probably the right wing of an altarpiece; the concentration of the figures toward the left leads one to imagine an adjacent center panel on that side.

Aelbert van Ouwater

Aelbert van Ouwater is one of the most enigmatic figures in the history of early Dutch painting. We know little more about him than that he was born in Haarlem. Though extraordinarily similar to Dieric Bouts, he differs from him in his thickset, stumpy figures; he also lacks Bouts's spaciousness and glowing colors. Compared with Bouts's dazzling vermilion, Ouwater's red is watery; his blue and green are softer too. Panofsky says that Ouwater "changed [Bouts's] colorism in the direction of tonality." That is true enough, but only up to a point: it would be more correct to say 'watery tonality.' And it should be pointed out that Bouts's handling is far more refined and the quality of his work one degree higher.

Except for a small fragment, *Head of a Donor,* in New York, the only painting by Ouwater still extant is *The Raising of Lazarus* in Berlin (fig. 33). The picture has so many focal points that one does not realize at first glance that the main incident is the act, performed by Christ with a simple gesture of His hand, of bringing the dead man back to life. In the center, Peter points to the resurrected Lazarus, obviously enjoining the group of handsomely dressed, and therefore eminent Jews not to make gestures of disgust, and if possible to cease wrinkling or indeed holding their noses. It is on these figures that the painter has lavished all his love. He paid particular attention to the one in the foreground with his back turned to the spectator, whom he has decked out in a wonderful long, mink-trimmed brocade robe and a red hood, topped by a big round cap of the same color. Another figure, also in very fine attire—he might be a Pharisee—seeks to extricate his followers from what in his eyes is a disagreeable scene and push them out of the building. Nor is Lazarus himself to be disregarded: he sits on the lid of his coffin and holds up his hands in amazement, facing the spectator instead of his savior, Jesus Christ, whose simple gesture had so magical an effect. Nearby are Martha and Mary. The latter, dressed in pale vermilion, has fallen to her knees with folded hands; the former stands with a few other people behind Our Lord. She is dressed fairly simply but

lifts her gown to show her red-flowered brocade petti-coat.

An original detail, and at the same time a clever device for producing an effect of depth, consists in herding the crowd of onlookers in the distance, where they can satisfy their curiosity only by peering through a grille in the high wall of the ambulatory. This detail recalls *The Exhumation of Saint Hubert* in the London National Gallery, which derives from Rogier van der Weyden, but the pillared ambulatory puts one in mind of Jan van Eyck, whose *The Madonna of Canon van der Paele* (fig. 19) stood godfather to this work.

It is worth noting that Carel van Mander gave a detailed description of this painting in *Het Schilder-Boeck* (1604)—quite a rare occurrence for him. This is what he says:

> After the siege and surrender of Haarlem the original was carried off unpaid for by the Spaniards under false pretences and taken to Spain together with other fine works of art. The figure of Lazarus was, according to the standards of the period, a very

33. Aelbert van Ouwater. *The Raising of Lazarus.* 48 × 36 1/4″ (122 × 92 cm.). State Museums, Berlin-Dahlem

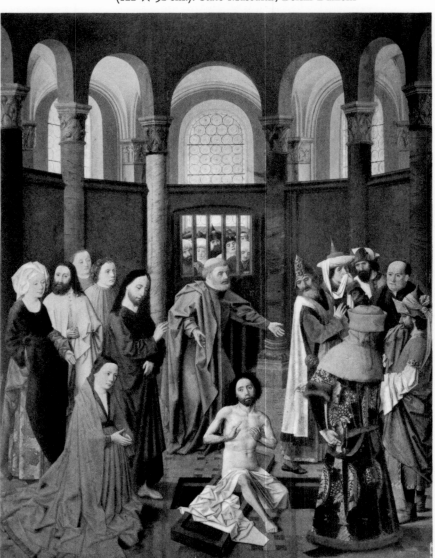

beautiful and remarkable nude and very effective. There was a handsome architectural setting—a temple—though the columns and other structural elements were rather small. On one side there were apostles, on the other Jews. There were also some pretty women, and in the background a crowd of people looking on through the slender pillars of the choir.

Van Mander knew the picture only from a copy. The original had been part of General Spinola's booty when Haarlem was sacked in 1575. It reached the Balbi family in Genoa apparently as a present from Philip II of Spain. From them it passed by inheritance to the Marchese Mameli, who sold it to the Berlin Museum in 1889.

Ouwater's portrait of Laurens Janszoon Coster, another native of Haarlem, who played an important part in the development of book printing and wood engraving, is known only through a print. The work, in which Coster points to the letter A—an argument that has been used to credit him with the invention of printing—puts one in mind of Dieric Bouts, as do the others attributed to Ouwater. The relationship between Ouwater and the greatest Haarlem painter of his day cannot be exactly defined. Rather than the interdependence of pupil and master, it seems to have been a question of their possessing a common artistic heritage. Although we have only the vaguest idea of what that heritage was, it must have comprised the block books of the *Apocalypse* and the *Biblia Pauperum*.

Hugo van der Goes

Hugo van der Goes is believed to have been born in Ghent, but his name might indicate that he came from Goes in Zeeland. However that may be, it was in Ghent that he made his reputation. On several occasions he was entrusted with the decorations for official ceremonies, and it was there that he became master, and later dean, of the painters' guild.

Van der Goes has been rightly termed an innovator. On the one hand, he introduced a new self-assurance and an awareness of man's fine physical force; on the other, a realistic view of the pitiful state of the common people, though they are capable of a touching childish wonderment and therefore of bettering their condition. His life, as we shall see, ran a tragic course. Such essential creative works as *The Nativity* and *The Betrothal of Saint Catherine* are known to us only through copies or derivatives.

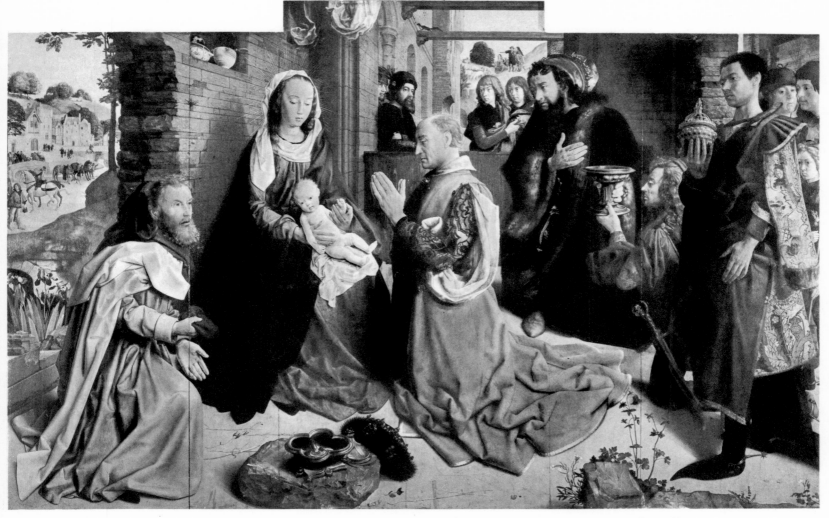

34. Hugo van der Goes. *The Adoration of the Magi (Monforte Altarpiece)*. 57 7/8 × 95 1/4″ (147 × 242 cm.). State Museums, Berlin-Dahlem

The Adoration of the Magi (Monforte Altarpiece; fig. 34; colorplate 23), executed in the early seventies, is a masterpiece not inferior to the very important *The Adoration of the Shepherds (Portinari Altarpiece)* in Florence (fig. 35; colorplates 24, 25). It reached Berlin from the monastery of Monforte de Lemos in Spain still in its original frame. The clear rendering of perspective, the vigorous modeling and monumental arrangement of the figures, the close approach to unitary space—all announce the proximity of the Renaissance and lead one to look for impressions gained in Italy. Though there is no documentary evidence of Van der Goes ever having stayed in that country, there is every reason to believe that he did so. A knowledge of Italian art, which could at a pinch have been acquired at Ghent or Bruges, would not really explain the many Italianisms that strike one in this picture.

The amazing vitality of the early period disappeared quite soon, and the course of his career, like that of Rogier van der Weyden among others, was marked by the resurgence of a medieval-spiritualistic tendency and a reversion to a planar conception. This can already be seen in his second masterwork, the *Portinari Altarpiece*. Early Netherlandish painting could not be better represented in the Uffizi than by this work, which was originally donated to the Ospedale Santa Maria Nuova in Florence and is known to have influenced local painters such as Ghirlandaio. It was executed about 1475. The only basis for its dating is the apparent age of the three children of the donors, Tommaso Portinari, the Medici's agent at Bruges, and his wife Maria Baroncelli, a lady of gentle birth worn out by childbearing, who looks older than she really was at the time.

It is the largest of all Netherlandish painted altarpieces and fortunately the wings, which are always so important for the composition, have been preserved. Faced with a task that demanded every ounce of strength he could muster—the slightest details of the huge work have been handled with amazing care—the artist must have been overwhelmed by a sense of the inadequacy of his powers. Perhaps he was obsessed by the Van Eycks' great altarpiece at Ghent. Be that as it may, he decided to renounce the world and at the end of 1478 gave up his material possessions and entered the Roode Kloster near Brussels as a *donatus* (privileged lay brother). There he enjoyed unusual liberties: he could travel, receive visitors (among them the future Emperor Maximilian), and continue his artistic activity. During the years he spent in the monastery his style underwent a complete change, not to say a

break. Toward the end of his life his melancholic disposition seems to have given way to actual mental derangement. He died in 1482.

Seven years earlier Dieric Bouts had died at Louvain. Hugo was asked to give an opinion on *The Justice of Emperor Otto III,* which Bouts had left unfinished. Not content with that, he stated his willingness to execute the missing donor's wing of *The Martyrdom of Saint Hippolytus.* These tasks were nobly performed.

The predella-like, oblong *Nativity* in Berlin (State Museums), in which he solved the problem of giving the scene depth by placing at each side a prophet who draws back a curtain, displays many features of his early period, despite its subdued colors.

The Vienna diptych *The Lamentation* (colorplate 26) and *The Death of the Virgin* in Bruges are both late works. In the latter Our Lord appears to His dying mother flanked by two angels in a glory, reversed like a mirror image so that she cannot see Him: this is an extraordinarily clever device. Also exemplary are the various modulations of a remarkable pale blue, interrupted only by a few touches of rose, vermilion, and mauve, and, on the chalky-white faces of the disciples, the expressions of grief ranging from gentle melancholy to utter despair. To view the allegedly incorrect perspective and the cool modeling as symptoms of the painter's growing mental decay is an unforgivable lapse on the part of contemporary critics. How right Max J. Friedländer was to say: "His power to objectify these experiences would have been expunged, had he passed these dark gates—indeed, perhaps it was extinguished when he entered. One who is himself obsessed cannot portray obsession."

Of all the pictures executed in water paint or tempera on canvas—Hugo van der Goes was one of the first to employ that technique frequently—I would mention *The Virgin and Child with Angels Bearing the Instruments of the Passion* before an irregular glory, on loan from Nuremberg in the Alte Pinakothek, Munich. There the delicate medium is combined with tender feeling, and the delicate treatment of the surface with a subdued range of the artist's once vivid colors (sand, pale coffee brown, dull steel blue). Another work executed in the same medium is the small *Deposition* in New York (fig. 36), which was originally the right wing of a diptych that included *The Holy Women* now in Berlin (fig. 37). Karl Arndt has pointed out that there may have been other works of the same type. In their sorrowful gravity, the encounter of Mother and Son and the juxtaposition of the Virgin's head to that of Saint John or of Christ attain a depth of emotion which can bear comparison with that of Giotto's *Crucifix* in Santa Maria Novella in the city of Florence.

Hugo seems to have been the first artist to attempt to render the birth of Christ realistically as a nocturnal scene, and he did so at a relatively early date. The work is known only through copies. This is also true of another rendering of the Nativity, where the light that bathes the Virgin Mary has its source in the Infant Christ. There was more than one version of this, and according to Friedrich Winkler it was the first night picture in early Netherlandish painting. Frequently repeated, imitated, and transformed, it has come down to us in a relatively independent work by Geertgen tot Sint Jans preserved in London.

35. Hugo van der Goes. *The Adoration of the Shepherds (Portinari Altarpiece).* 8′ × 19′ (245 × 580 cm.). Uffizi Gallery, Florence

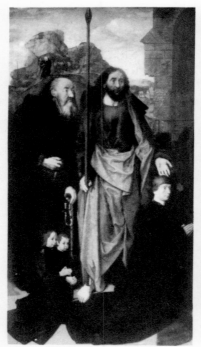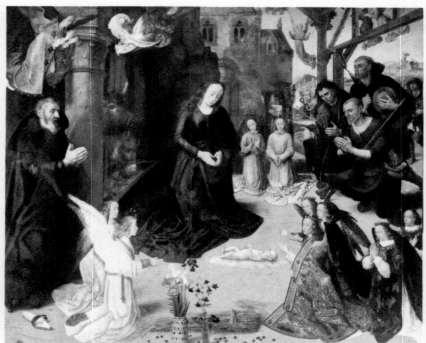

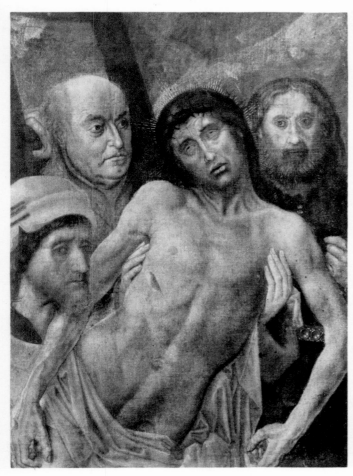

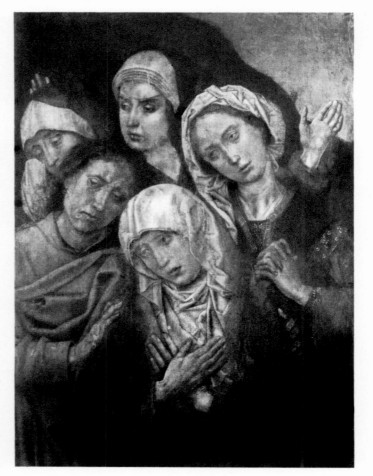

36. Hugo van der Goes. *The Deposition.* 20 7/8 × 14 1/8″ (53 × 36 cm.). Collection Wildenstein & Co., New York

37. Hugo van der Goes. *The Holy Women.* 21 × 15 1/4″ (53.5 × 38.5 cm.). State Museums, Berlin-Dahlem

Hans Memling

Memling, whom Panofsky wittily called "the very model of a major minor master," is a special case in that he was a German who emigrated to the Low Countries. Today we know for certain that he was born at Seligenstadt, near which lies the village of Memlingen. That he was not a Fleming by birth seems to have some bearing on the fact that at the beginning of his career he felt a more urgent need than other young painters to follow a greater artist—in this case Rogier van der Weyden—quite apart from whether or not he was his pupil in the narrow sense of the term. Memling—"*le doux Memling,*" as Leo van Puyvelde calls him—had a placid, sensitive nature. Visitors to Bruges are still shown the simple house where he is known to have lived as the city's leading painter from 1466 until his death in 1494. A considerable portion of his oeuvre has been preserved for centuries, not in a museum, but in the Hôpital Saint-Jean in Bruges, which seems to suit his art very well indeed.

In the Prado and at Bruges there are two very similar versions of *The Adoration of the Magi* in which the influence of Rogier, of his *Columba Altarpiece* in Munich in

particular, is clear to see. But in some of Memling's early works that influence has left hardly a trace, and their indescribable painterly charm puts the question of their historical order in the shade, so direct, timeless, and enchanting is their impact on a responsive beholder. Such are *The Madonna Enthroned* at Granada and the half-length *Madonna* attributed to him in Brussels.

Perfectly in keeping with his talent was a commission he presumably received in 1468 for a small triptych, the *Donne of Kidwelly Altarpiece*, formerly at Chatsworth, which can now be admired in the National Gallery, London. Like Van Eyck, Memling has placed the girlish madonna under a canopy before a brocade cloth of honor, with her feet on an oriental rug. The donors are presented by two female saints; the wings with the two male saints continue the porphyry-pillared hall of the center panel. The wealthy and distinguished donor, Sir John Donne, who was killed at the Battle of Edgecote in 1469, kneels on the left wearing the collar of the Rose and Sun; his wife and their small daughter face him on the right.

The same plan is expanded in the grand *Saint John Altarpiece* in the Hôpital Saint-Jean at Bruges (color-plate 27). The same female saints clad in the same beautiful fashion of that day (Catherine in a precious brocade)

37

sit at each side; the male saints, instead, have been shifted to the center panel, leaving the wings free for scenes from their lives.

The panel with *The Passion of Christ* in Turin (Galleria Sabauda), commissioned by Tommaso and Maria Portinari and executed in 1470, may be compared with *The Seven Joys of the Virgin* in Munich (fig. 38; colorplate 28), which was donated in 1480. Both were probably inspired by the mystery plays that were frequently performed in those times. The entire city of Jerusalem is depicted in the Turin picture with buildings crowded together like boxes, some of them opened to show what is going on inside. Feeling for landscape is much more in evidence in the Munich panel, which is also a work of great pictorial quality.

Memling's largest altarpiece, *The Last Judgment Altarpiece,* should have reached Italy by ship in 1473, but because of the war between the Hanseatic League and England it was captured by the Danzig privateer Benecke, and donated by the shipowners who sponsored him to the chapel of the Confraternity of Saint George in the Church of Our Lady in Danzig (it is now in that city's Museum Pomorskie). This work is considerably more important than the smaller *Lübeck Altarpiece,* which was regularly commissioned and paid for by Heinrich Greverade in 1491.

On the closed wings of *The Last Judgment Altarpiece* we see the donors, Jacopo Tani, the Medici's agent at Bruges, and his wife, kneeling in prayer before the stone-colored figures of the Virgin Mary and Saint Michael. Opened, they reveal a center panel based on Rogier van der Weyden's *The Last Judgment* at Beaune. But Memling made his picture more tall than broad with the result that he was able to deploy far more imagination in the descrip-

tion of hell on the right wing than his teacher had done; more even than shown by Bouts (in Paris and Lille), or than is evident in the small panels in New York ascribed to Van Eyck. The cascades of naked bodies condemned to eternal fire made their influence felt for generations, perhaps even on Rubens's *Fall of the Damned.* The individualization of the faces distorted by fear, horror, and pain is no less astonishing than the craftsmanship displayed in the rendering of the mass of lean, slender nudes. The blessed on the left wing betake themselves to the gate of paradise, where they are welcomed by Saint Peter and given new garments. On the center panel Saint Michael divides the just from the unjust, while in the background an angel and a devil fight over a soul. The composition recalls Stefan Lochner's in Cologne, but both pictures may well derive from a lost Flemish model (see the panel from Diest now in Musées Royaux des Beaux-Arts, Brussels).

When considering Memling as a portraitist we must distinguish between his independent portraits and the no less excellent likenesses of donors found in large numbers on his altarpieces. On the outside of the *Saint John Altarpiece* in Bruges the donors, accompanied by their patron saints, kneel in Gothic niches. On the wings of the *Moreel Altarpiece* of 1484, also at Bruges (Groeningemuseum), in which the landscape-dominated center panel marks the limits attained in the representation of saints at the dawn of naturalism, the parents with their numerous kneeling progeny seem more important than the saints who protect them. In the panel picture of the Virgin in the Louvre that belonged to the wealthy hospitaler Jacob Floreins, the Mother of God together with the saints and the whole family is posed not very happily before the church in the background.

38. Hans Memling. *The Seven Joys of the Virgin.* 1480. 31 7/8 × 74 3/8″ (81 × 189 cm.). Alte Pinakothek, Munich

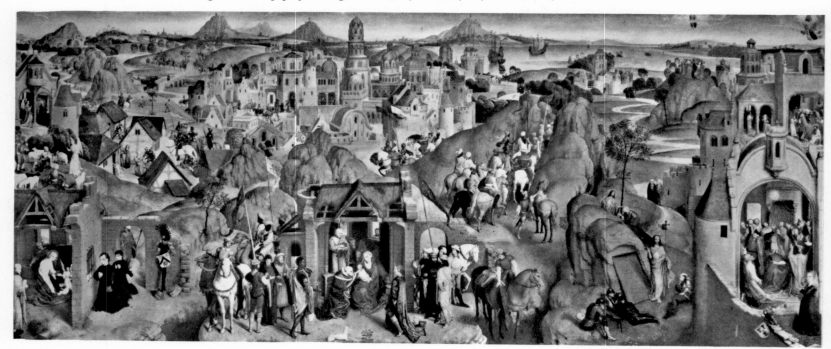

Most of Memling's independent portraits of men—very few of his sitters were women—have a landscape background. An early one in Frankfurt recalls Bouts. A diptych in Florence with Benedetto Portinari venerating his patron saint is dated 1487. In the Hôpital Saint-Jean, Bruges, is another diptych dated 1487, whose details point all the way back to Campin. It has a very different sitter from the noble youth in London (colorplate 29): the florid, worldly Martin van Nieuwenhove, then twenty-three years old, who was soon to become burgomaster of Bruges. The Madonna he worships is one of those maidenly figures that inspired Memling with such enthusiasm. A number of self-assured male portraits, undated but probably from the artist's middle period, have in common a symmetry, a ripeness of form, and attitudes that are almost Renaissance. A few small late panels with madonnas in full length worshiped by angels and donors are embellished with garlands and other decorative elements obviously borrowed from Italy. Compared with earlier works on similar themes, they display a certain deviation from Memling's typical traits.

An example of his last period is the large organ parapet with Christ surrounded by angels, from Nájera (Castile), now in Antwerp. It gave Memling an opportunity to demonstrate his ability to tackle a large area. But he did so only at the price of losing the fineness and intimacy that were his best qualities. It is gratifying to know that about the same time he received a commission that could not have been more different: to adorn a gilded reliquary with minutely painted little pictures. Executed in 1489, the *Saint Ursula Shrine* is preserved in the Hôpital Saint-Jean at Bruges. One of the characteristics of Late Gothic painting is that the same care and precision are lavished on the profane accessories as on the main story; indeed, artlovers of the present day are attracted by details that are not necessarily connected with the narrow circle of the sacred central happening.

When Memling had to adorn his *Saint Ursula Shrine* with six little scenes from the saint's life, he found no more difficulty in becoming a sort of miniaturist than he had in becoming a realist. It must have been amusing for him to observe the sites of the events on the very spot where they occurred, so far as that was possible, and, in the manner of his time, to clothe his dramatis personae in contemporary dress without a thought to the fact that what he had to describe and depict had taken place in the distant past. As a result, we are indebted to his realistic attitude for panoramas of Cologne with part of the ramparts, Romanesque churches, and the unfinished choir and steeple of the cathedral (probably based on studies from nature). The view of Basel may have been the fruit of imagination—it resembles rather Brussels or Antwerp—but he had very likely seen similar walls, gates,

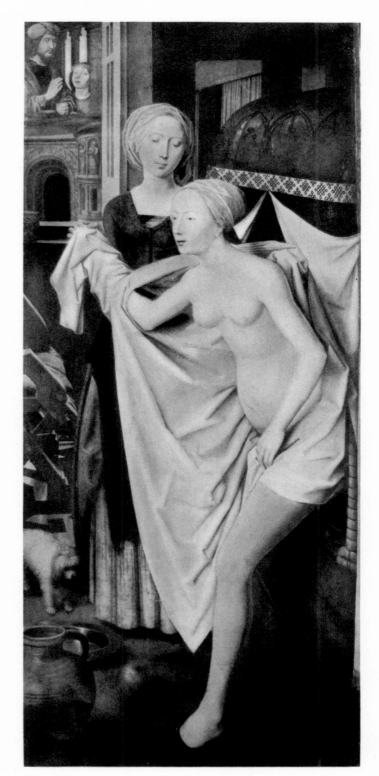

39. Hans Memling. *Bathsheba.* 75 3/8 × 33 1/4″ (191.5 × 84.6 cm.). Staatsgalerie, Stuttgart

and other details in one of the towns of his native land. He was less successful with his Roman architecture. Nonetheless, it offered him a chance to show how sails are set and furled and how porters haul bales and baggage. The crossing of the Alps cannot fail to provoke a smile in a modern observer. The virgins, dressed as impractically as possible for so strenuous an expedition, hitch up their skirts so that we can see their red or blue petticoats. Since the painter, while gradually diminishing the size of

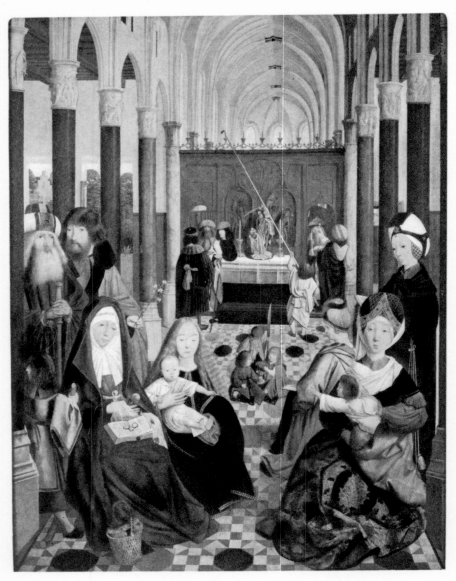

40. Geertgen tot Sint Jans. *The Holy Kinship.* 54 × 41 3/8″(137.5 × 105 cm.). Rijksmuseum, Amsterdam

are portrayed on one of its ends worshiping the madonna on their knees. On the opposite end Saint Ursula is depicted as the patron of her virgins. At the time no one was troubled by the fact that her patronage had proved so utterly inefficient. Painted medallions showing the Coronation of the Virgin, Saint Ursula with her companions, and musical angels are arranged on the lid of the reliquary.

The female nude treated with such modesty in the Stuttgart *Bathsheba* (fig. 39), whose maidservant helps her into her robe as she steps out of the bath, is poles apart from the penetrating naturalism of Jan van Eyck's Eve in the *Ghent Altarpiece* (fig. 18). The panel, which was very likely the right wing of a triptych with examples of justice in a town hall or courthouse, has been assigned to Memling's late period, but is not easy to date with certainty. The upper left-hand corner with David spying on the naked beauty from a balcony in the company of a boy was sawn off in the seventeenth century and is now preserved in Chicago.

Geertgen tot Sint Jans

Geertgen tot Sint Jans, evidently a native of Haarlem, was a lay brother in the Order of Saint John of Jerusalem: hence his name. He appears to have died about 1490 when only some thirty years old. None of his pictures is either signed or dated. To trace back all the influences that were important for him would become much too involved. Suffice it to say that as an artist of many facets (both formal and psychological) his connection with the Haarlem tradition—on closer study if not at first sight—cannot be denied. According to Van Mander, he studied there under Aelbert van Ouwater. A link with that town can be seen in his sense of what is tonal and painterly, though he is far less restricted than, for instance, Dieric Bouts in his treatment of planes. On the contrary, typical of Geertgen and the progressive, forward-looking factors in his makeup are an extraordinary opening up of the picture space and a striking lack of convention.

For these reasons it is almost impossible to form a clear idea of the chronological order of his works: the sequence set forth here is purely tentative.

The Raising of Lazarus in the Louvre apparently owes much to Ouwater. Clear signs of this are the kneeling woman and the man behind her with his hand on his purse, who turns his back to the spectator. As in Ouwater's picture of the same subject, the mass of figures

his little figures as their distance increased, arranged them one above, rather than behind, the other, he was in a position to isolate some and reduce others to amusing specks of color.

The eleven thousand virgins had to travel their dangerous route in order to receive the pope's blessing in Rome. Perhaps they told the Holy Father of the risks they had run, for he decided to escort them on the return journey as far as Basel but not, unfortunately, all the way to Cologne. Who knows? He might have prevented the virgins with the Saint at their head from being slaughtered by the heathen potentate whom Ursula had instinctively refused to marry after an angel had appeared to her in Cologne and encouraged her to go to Rome.

The shrine, in which the relics of the saint were solemnly placed in 1489, was donated by two nuns, Jodoca van Dudzeele and Anna van den Moortele. They

thrust back into the middle distance can be disposed under a horizontal line, which is actually provided by the wall in the background and is also visible in the structure of tower and landscape.

In Vienna (Kunsthistorisches Museum) there are two pictures, *The Lamentation over Christ* and *The Story of Saint John the Baptist's Remains,* obtained by splitting a panel which was probably the right wing of a triptych that had a Crucifixion in the center. They constitute a considerable advance over Bouts's *The Justice of Emperor Otto III* in Brussels. The picture is no longer dominated by a single figure; rather, the figures are arranged in groups in which none loses its individuality, but neither can any one be separated from the rest. In *The Story of Saint John the Baptist's Remains,* for instance, there are various groups, starting with the Emperor Julian the Apostate (who ordered the Baptist's bones to be burned) and his associates. Then come three groups of monks doing their best to save some of the martyr's bones; they are deployed in a hilly landscape and diminish in size as their distance from the spectator increases. This means that by breaking up the picture plane, Geertgen, whose historical importance is here clear to see, prepared the way for the open landscape of the future. The most striking illustration of this is his *Saint John the Baptist in the Wilderness* (colorplate 31). Of course, in *The Lamentation over Christ,* which is on a far larger scale and has more activity to show, the composition could only approximate a layout of this type. In effect, it still shows the impact of the covert model, namely Bouts's triangular composition in *The Gathering of the Manna* from the *Altarpiece of the Sacrament.* The kneeling bearded figure may have been inspired by Hugo van der Goes.

Though Geertgen lived for only such a short time, another series of pictures shows him from a different angle; we may presume that it belongs to his later phase. The characteristic trait of these paintings is a taste for rounded forms, ovoid or spherical, that suggest lathe-turned wooden dolls. The rather complicated *The Holy Kinship* (fig. 40; colorplate 30) in Amsterdam (where there is also an *Adoration of the Magi* by Geertgen similar to those in Winterthur and Prague), which Geertgen set in a Gothic church, should be mentioned in this context. It was perhaps influenced more by Van der Weyden than by Ouwater. The tendency to cubist forms is evident in the rather large *Virgin and Child* (State Museums, Berlin-Dahlem), with the Infant Jesus holding a columbine in His little hand, and in the London *Nativity* (National Gallery). This latter certainly derives largely from a lost work by Hugo van der Goes which was the first step in a development that continued through the Tenebrists to Rembrandt and Georges de la Tour.

The Master of the Virgo inter Virgines

This painter, like Bosch a Dutchman and with the same eccentric and unusual outlook, was given his name from a panel in the Rijksmuseum in Amsterdam. It is an early work, as is the big *Nativity Altarpiece* in the Salzburg Museum Carolino Augusteum in which the shepherds enter the stable through a stone gateway. He was the first Mannerist in the sense that, in his works, the formal outweighs the natural aspect of things. For the traditional canon of the human form in general, and for Biblical characters in particular, he substituted his own opinionated caprice. And he was the first painter bold enough to depict female saints and even the Virgin Mary with modishly shaven forehead. His ethereal figures move in snaky curves like ladies of high society; even the men perform unnatural contortions. One wonders how such odd creatures managed to pass the censor.

Not only is the Master's name unknown; so are the place and date of his birth. But singular woodcuts that appeared in Delft between 1480 and 1490, the preliminary drawings for which may very well have been executed by the same hand, permit us to situate him in that town or its environs. Ties with Gouda can also be observed. *The Crucifixion* in the Uffizi is a work of the first importance; in Berlin there is an *Adoration of the Magi* that seems to have been painted half seriously and half in jest.

Parallels to the violence of the Franconian Late Gothic might be seen in the two scenes from the Passion in the Bowes Museum, Barnard Castle, England. His finest work, aside from the one in New York, is the *Lamentation* in Liverpool (colorplate 32).

Gerard David

Gerard David was born in Oudewater (between Gouda and Utrecht) but settled in Bruges in 1484, succeeding Hans Memling, who had occupied a leading position in that town for many years. His lifespan coincided with a general revival of interest in the past, creating a demand for copies of, and variations on, earlier paintings of which David did a great number. He died in Bruges in 1523. Like Memling, David was a man of delicate sensibility and his minutely painted little folding altarpieces express the joy and sorrow that characterized Christ's relationship with His mother. His way of thinking was gentle, even

in the London *Deposition*. *Christ Nailed to the Cross* (also in London) is interesting as a study of perspective; *The Baptism of Christ* at Bruges and *The Virgin and Child with Saints and Donor* in London are both rather academic. *The Adoration of the Magi* in Munich, unlike the one in the National Gallery, London, should be viewed as a copy after Van der Goes and therefore as unworthy of exhibition in that museum.

His most important work is perhaps the big New York *Annunciation* (The Metropolitan Museum of Art) formerly at Sigmaringen—there is a derivative in Frankfurt—in which the Virgin's gestures are convincing, the angel's ample. The refined, cool, subtly graded blue and steel gray may have been inspired by the pale blue of the angel kneeling behind the Virgin in dark blue in Hugo van der Goes's *Portinari Altarpiece*.

David was probably not very happy about the important commission for justice pictures for the courtroom in Bruges Town Hall (*The Legend of Cambyses and Sisamnes*, 1498, now in the Groeningemuseum in Bruges). They are a horrifying demonstration of what corruption may lead to. The accused judge, Sisamnes, is found guilty and his flayed skin is used to cover the chair on which his son will later have to sit in order to give judgment.

The Marriage at Cana in the Louvre made its influence felt as far away as in Rembrandt's *Marriage of Samson* (Dresden). The care lavished on the wedding roast and its dissection proves that David was a true Dutchman. If his religious pictures reveal a certain decline in his creative powers, here we see what may be termed the first germ of the innumerable still lifes and genre pictures produced in the course of the following centuries.

The Virgin and Child ("*Virgin with a Milkbowl*"; colorplate 33) was already a great favorite when new, as proved by the fact that no fewer than five versions are listed by Friedländer. The original is preserved in Brussels.

Hieronymus Bosch

Hieronymus Bosch marks the appearance of something entirely new and diametrically opposed to the compact world of medieval, scholastic themes. He did not rest content with setting before our eyes holy persons or stories from Bible history clothed in gorgeous apparel as objects worthy of devotion. He dug deeper and discovered the submerged strata of the human soul: in his eyes evil was the soil from which good can occasionally grow. For him piety was something entirely different from what it had meant to his predecessors. Bosch's oeuvre, as Weigert says, is a mirror of the disruption that characterized the age in which he lived and worked. Before Sebastian Brant, Erasmus, or Thomas More, and more intensely than they, he felt the folly of the world. Demons sit on men's necks; all around us swarm uncanny creatures—devils, birds, fish, batlike forms, rats, rays, pigs, frogs, toads, and crosses between all the weird beings that people the earth. His irrational surrealism anticipates modern psychoanalysis and was never paralleled before our own times. Yet man himself stands there like a child, naked as God made him but no less a slave to his depraved senses: a sinner, a sadist, a criminal, he raves at himself and at others. And the painter's abominable visions would have devoured his very vitals had he not been able to spew them out in concrete form.

But however important and progressive an artist Bosch may have been, his most personal works, the triptychs, could never have been produced by painterly intuition alone. They spring from a way of thinking whose exponents seem to have belonged to a secret sect. If today we can get a clearer view than was formerly possible, we owe it to Wilhelm Fraenger, a scholar who was naturally in sympathy with Bosch's mentality. He took the trouble to trace back the central themes of Bosch's oeuvre to a specific person—the converted Jew, Jakob van Almangien, grand master of the Adamite sect of the free or high spirit. Hans Rothe has derived plausible explanations from a more poetical standpoint. Dirk Bax has dotted Fraenger's assertions and assumptions with question marks, but has failed to shake the foundations of that author's splendid effort to achieve a complete clarification of Bosch's universe.

The Adamite sect was an association of men and women who thought they could realize a sex life without shame, like that of Adam and Eve in the Garden of Eden before the Fall, and so vanquish the Christian notion of original sin. It was those conceptions that gave rise to the big triptych in the Prado which is still erroneously entitled *The Garden of Delights* (fig. 41; colorplates 34, 35). We may presume that the work was executed for a secret order and known only to a small group of heretical initiates. Fraenger has investigated the part played by the idolatrous or satanical cult of the androgynous frog or toad, but it may take several years to elaborate a synthesis of the divergent opinions of the various scholars who have studied the question.[6]

Bosch, who was born at 's Hertogenbosch in northern Brabant, is first mentioned in 1480. He apparently spent all his life in his native town and died there in 1516. Many of his paintings are signed but none is dated, so it seems impossible to trace his development in detail. There is

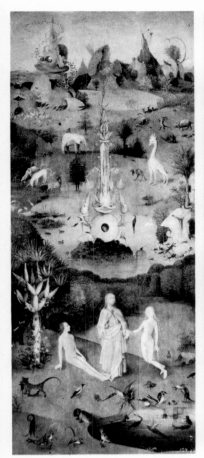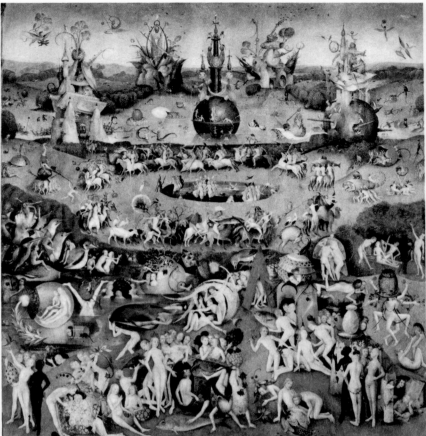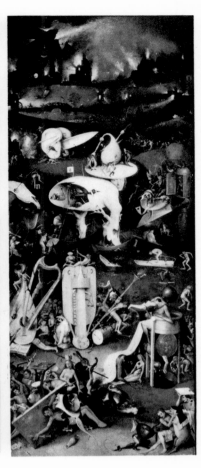

41. Hieronymus Bosch. *The Garden of Delights*. 7′2 5/8″ × 9′5 3/4″ (220 × 289 cm.). The Prado, Madrid

some degree of certainty as to how it began and ended, but opinions vary greatly when it comes to dating the works that lie in between.

The painter was already greatly appreciated during his lifetime and his works found princely purchasers. In 1504 Duke Philip the Fair commissioned "un grant tableau de paincture . . . où doit estre le Jugement de Dieu, à savoir paradis et enfer, que Monseigneur lui avait ordonné faire pour son très noble plaisir" (a large painting where there shall be the Judgment of God, namely heaven and hell, which His Grace had ordered him to do for his very noble pleasure). Shortly before Bosch died, Margaret of Austria, Regent of The Netherlands, acquired a *Temptation of Saint Anthony*. Later in the century King Philip II of Spain inherited six paintings and bought several more. Whether the members of the high aristocracy were attracted by the unique quality of his work, or whether they saw Bosch as a sort of court jester whose task was to relieve their boredom is still a moot question.

Early works like the Brussels *Crucifixion* or *The Adoration of the Magi* in the Philadelphia Museum of Art (with the Moorish king's whitish scalloped sleeves wonderfully embroidered in colors) are not basically different from others of the same period. The charm of the New York *Adoration of the Magi* (Metropolitan Museum of Art) lies in its primitive character, which contrasts with

the mature, plastic, grandiose, though not very late version in the Prado. The latter is noteworthy because it comprises a figure presumed to be "Antichrist"; this is an extremely rare occurrence. The shepherds in the Prado picture squat oddly on the roof of the stable—perhaps a reference to John X, 1–3. The panel with *The Seven Deadly Sins* in the Prado has already a rather spooky atmosphere. Some other early works seem, as Karl Arndt has pointed out, to have come down to us only in copies—though good copies at that. One is *The Wedding Feast at Cana* (in Rotterdam), in which a rod calls attention to curious objects—some of them sex symbols—displayed on a wall; the bagpipe player too has a sinister undertone. Another is *The Operation for the Stone*, which has been variously interpreted as meaning that a doctor extracts money from the pockets of his wealthy patients or that he cures them of their folly. *The Conjurer* at Saint-Germain-en-Laye, which also seems to have survived only in copies, required a commentary. Of course, one does not need any special knowledge to smile at the demonstrations of men's weaknesses—curiosity, stupidity, and credulity.

In the Frankfurt *Ecce Homo* (Städelsches Kunstinstitut), from the left-hand side of which some figures have disappeared, one is still troubled by the faulty perspective. But the symbolic frog on a shield cannot evade a closer examination. The fragment in Philadelphia—

43

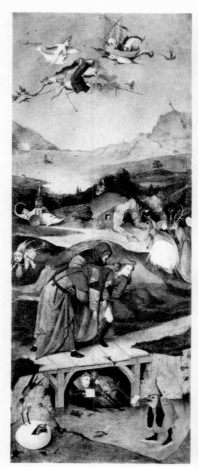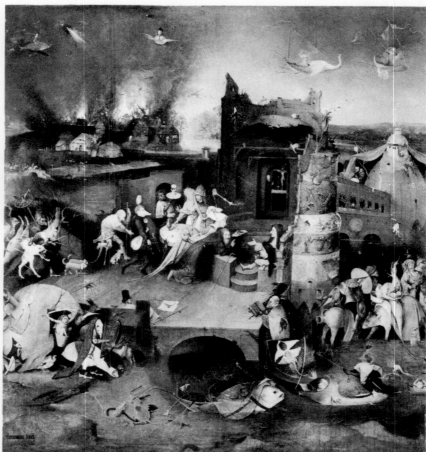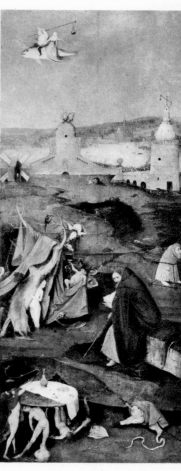

42. Hieronymus Bosch. *The Temptations of Saint Anthony*. Center panel 52 1/2 × 47″ (133.5 × 119.5 cm.); wings 51 3/4 × 20 7/8″ (131.5 × 53 cm.) each. Museu Nacional de Arte Antiga, Lisbon

another work known solely through copies—of which only one-quarter still exists, is quite differently developed on the picture plane. It is boldly articulated in curves and voids that guide the eye here to the wildly gesticulating mob, there to the poor fellow under judgment beside whom stands the effeminately dressed Pilate, with a smug expression. The roundel in the Prado was probably executed shortly after. Later the same theme underwent a significant further development in the upright picture in the National Gallery, London (*The Crowning with Thorns*), which is filled with half-length figures reduced almost entirely to heads and hands.

But some of Bosch's triptychs are really alarming. They exploit, or so it seems, the hallowed form of the tripartite altarpiece for satanic manifestations that begin in heaven and end in hell. One cannot imagine their ever having been displayed in public. They must have been kept in the precincts of the sect or the homes of wealthy, eminent artlovers who had no fear of being denounced.

One of the earliest is *The Hay Wain* in the Prado, which can be explained with the help of the Dutch proverb, "The world is a haystack from which each takes what he can snatch." The left wing shows the Garden of Eden. The center panel is dominated by a big hay wagon hauled along and accompanied by an excited crowd; on it a young couple sits engrossed in music, encouraged by a

devil; while in a bush behind, a pair of lovers are quite unaware of the menacing approach of the jealous husband. People fight, some are killed. Each wants his share of the hay; even the pope and emperor come with their retinues to get theirs. In the foreground nuns fill sacks with hay; one of them tries to entice a piper—the bagpipe is always a sex symbol—with it. In the center a quack has set up his stall and nearby a fortune-teller plies her trade. The procession advances toward hell (depicted on the right wing), where fiends are building a tower and naked sinners are handed over for punishment to devils and demons.

For the big triptych known as *The Garden of Delights*, also in the Prado (fig. 41; colorplates 34, 35), Fraenger suggested as a title "The Millennium"; it might also be styled "The Tender Eroticism of the Adamite Age and Hell."

Formerly *The Garden of Delights* was viewed as a masterpiece of Bosch's youth (c. 1485), but most recent studies assign it to his late period. The author of the present work inclines to accept the earlier opinion because the quality of the painting is not very highly developed. A second reason is that otherwise there would be no room in his oeuvre for such works as the very important mature triptych *The Last Judgment* in the Vienna Academy of Fine Arts. The authenticity of this picture was formerly put

44

in doubt, quite inexplicably, though supported not only by *pentimenti* but also by the excellent copy (in Berlin) executed by Lucas Cranach the Elder, who would hardly have taken the trouble to copy a copy. It may perhaps be a replica or variant by the artist's own hand of a larger picture which we know only through documentary records. In which case, since the date of that work is known, it must have been done after 1504. The Vienna triptych displays the most gruesome happenings in the whole history of art.

In *The Garden of Delights* the part most easily understood is the left wing with the representation of the Garden of Eden (fig. 41). We see the Creator presenting Eve to Adam. The latter lies on the greensward and gazes at his mate with a mixture of interest and astonishment. The foreground is enlivened with all sorts of animals gathered round a water hole. Among the birds, all of which have an esoteric significance, we can recognize the hooded crow and the three-headed ibis—a bird of dual role acting as both midwife and strangler. The turgid tree rather like a euphorbia—the tree of life, or dragon tree—was borrowed from Martin Schongauer's engraving of the Flight into Egypt. In the middle distance the fountain of life, colored pink like the shell of a prawn, rises in the axis of the picture. The vertical structure built up of phallic forms rests on a hollow disk in whose center—which is also the center of the picture—is a hole that reveals an owl. This bird, which occurs frequently in Bosch, is very important as a symbol of introspection and self-knowledge. The disk rests on a heap of material dotted with glass tubes, pearls, and glittering stones. The beasts of paradise disport themselves a little farther back. At the top the panel is framed by oddly intricate pointed peaks, one of which is the mountain of the blessed birds.

The right wing, called Hell or, better, Retribution (see colorplate 35), is a pandemonium in which Bosch, like a second Dante, acts as guide. Here too, close investigation is needed if we are to understand at least part of what is going on. The first thing that catches the eye is also the most enigmatic—a chalky-gray anthropoid form, whose legs develop into mangled tree trunks that stand in boats and whose body is represented by an empty eggshell. The cavity is a tavern—the last stop on the road to hell. Some people are already drinking there; others are arriving by climbing up a ladder. The equally gray face that looks back over its shoulder at the spectator has been viewed—like the man resting on his elbows in the tavern—as the painter himself or as a sort of mirror image of the grand master, who knew all the infamy of Satan. The head is surmounted by a disk of the same gray, on which grotesque couples gyrate around a pink bagpipe (here too a sex symbol). Higher up on the left a huge knife

is planted between two gigantic severed ears skewered by an arrow—perhaps a reference to the Biblical text, "He who has ears, let him hear." It might also symbolize the torture of the noise that prevails in hell. Silhouetted against the flames of burning houses is an execution and a crowd of antlike figures that proceed in the dark night through gateways and over bridges, passing a mill wheel and windmills and the outlines of ruins, houses, and mountains on their way. This is the world of Mars and Vulcan, of war and technology—the world Bosch saw as diabolical.

In the lower half of the panel we are shown the "gamblers' hell" and the devil's throne; higher up, on a smaller scale, the "monks' hell" and the "knights' hell." The huge instruments of the "music hell"—a lute-harp hybrid, hurdy-gurdy, shawm, and kettledrum—occupy a large area. Their surface tension injects a measure of stability into the chaos, and they are rendered with a precision worthy of the Surrealists of our own day, which is particularly notable in view of the fact that the devout of the Middle Ages, like Plato, despised all music that was not sacred as the work of the devil. Is it despair or ecstasy that makes a naked man bitten by a snake cling to the strings of the harp which, as the symbol of masculinity, penetrates the lute, the symbol of femininity? In any case it is a devil that drags a man threatened by a two-legged reptile away from the neck of the lute. The music book underneath the instrument might be connected with the Adamite marriage ceremony, though here a demon is roasting a speckled toad on a spit. It is impossible to decipher the notes written on the buttocks of a naked man over whom a hideous choir leader raps out a two-octave descending scale. Another naked man, apparently branded as a beggar, is forced to turn the enormous hurdy-gurdy with one hand while holding a bowl in the other. Near him another attempts to make an egg drop from his back onto his bowed head. Inside the instrument a woman in a bonnet plays a cymbal. The din around the drum is so dreadful that a man is forced to stop his ears. In the main it is apparently monkish vices that are pilloried here.

Lower down, in the "gamblers' hell," despair has overturned the table—in other words, bankrupted the player, who is being speared by a demon. Another lifts the backgammon board high above his head before dashing it to pieces on the ground. A naked girl, waitress and harlot in one, with a huge die on her head holds the jug and candle that are her attributes. A buck rabbit blowing a horn attempts to carry off a woman; two hellhounds lick a corpse. In the lower right-hand corner a pig dressed as an abbess tries to persuade a rich man to sign a will. Higher up a monstrous bird sits enthroned with a caldron on its sparrow hawk's head—Satan himself,

45

seated on a commode with his feet in pitchers, swallowing humans and excreting them into a cesspool into which one man vomits while another defecates ducats. This is the counterpart of the water hole on the left wing, through which the animal kingdom came into the world. Satan has unwound a cloth under which a wench, in the same posture as Adam on the left wing but embraced by a devil and with a toad between her breasts, gazes at her ravaged face reflected in a round mirror stuck on a demon's backside. On the bed a sleeper is apparently tormented by a nightmare.

The "monks' hell" is represented on a smaller scale. The roof is a horse's skull from whose eyesocket protrudes a rod suspending a key—another sex symbol. A man swings like a clapper in a bell. A spoonbill quacks at a monk seated on a naked man. In this zone the colors are surrealistic—indigo and gray. The "knights' hell" opposite is particularly cruel. A man clad in armor lying on a pink disk above a huge knife is torn to pieces by basilisks; another is speared and hanged. Strange creatures on sleds and skates move on the ice and break through. Perhaps they are the sinners who freeze in hell. Here too there is a sexual overtone. In a hollow a woman on hands and knees is ridden by a fiend.

The center panel of *The Garden of Delights* will, like that of *The Temptations of Saint Anthony,* be described in detail in the commentaries on the colorplates (34–36).

On the left wing of *The Temptations of Saint Anthony* (fig. 42) demons carry the saint through the air—or, more exactly, he is dragged through it on a spread-eagled frog driven by a hell-bent foxlike creature armed with an ashplant. Neither the knight flying on a fish nor the flying sailboat seems to be signaling readiness to help. On the contrary, the skipper of the latter holds an obscene posture. No wonder the saint, completely shattered on his return to earth—the scale is larger here—has to be supported by two good monks of his own order and a friend, who haul him like a dead man over a bridge. Under it a goblin is making mischief with a rat-faced bird and a monkey. Nearby a birdlike creature on skates—possibly a satirical reference to the trade in indulgences—holds what looks like a letter in its beak, while a bittern standing on an egg, from which young birds are hatching, swallows a frog, or perhaps one of its own young. The creature on the left-hand edge of the panel is a heretic guilty of the *peccatum contra naturam,* intercourse with animals—hence the bovine hindquarters. The saint takes no more notice of these horrible figures than of the heretical bishop accompanied by a stag and a spoonbill in the middle distance. They advance toward a gigantic sodomite who, his head pierced by an arrow, exposes his buttocks in an attempt to squeeze through a hut—perhaps a brothel, which would explain the lance, port-

cullis, and so on. The whole scene is set against a bleak but grandiose scenery of sea and mountains.

On the right wing we see the saint in a cowl seated, nervous and distressed, by the roadside. He does not even glance at the naked young woman half hidden by the stump of a willow that designates her as a witch. An androgynous frog couched on a huge, rank flower pulls back a big wine-red cloth that is spread over the willow. A transparent scarf hangs from its sexual organ toward the young witch, who presses it to her sex. In its raised right arm the frog holds out a bowl to catch the liquid that an old witch, mock-haloed with an umbel, pours out of a bottle, while a hoopoe—the bird of stench and foulness—perched on a branch keeps them company. A few hardly recognizable figures lurk in the dark zone behind the tree.

The apparition in the sky probably represents the transport of a witch on her way to visit the saint. The latter averts his gaze from all these horrors, including the scene depicted in the lower left-hand corner: three naked men support a table set with scanty fare; a horrid form approaches with a knife stuck in its face. It is presumed to represent *Gula* (gluttony). At the top of the picture, in the distance, massed troops move on a causeway between two castle-like buildings. In his speech to the monks Saint Anthony says that devils assume strange forms, appearing as women, wild beasts, and snakes, as gigantic monsters, even as troops of armed men. But they can be annihilated by reciting the Creed or making the sign of the cross.

In the Vienna *Last Judgment,* as in *The Temptations of Saint Anthony,* architectural elements (a flat-roofed house, a stone bridge) provide clear three-dimensional accents. On the flat roof a horrible beast with a candle leads a young girl to a man who lies on a bed, while a second, no less horrible, plays a tune on its trumpet-beak. The center panel and right wing are filled with an immense chaos riddled with sex symbols like the big knife. They are peopled by naked humans given over to such deadly sins as gluttony and lust; or torturing each other in all imaginable ways—some are nailing horseshoes on naked figures before a brothel; or in turn being tormented by demons. One sinner is conveyed in a cart drawn by a ducklike creature with a huge beak over a bridge to the mills where others are broken on the wheel or subjected to still worse tortures, and where he is to suffer his punishment. In the background, as in the version in Madrid, fires rage. Above them Christ is enthroned, unconcerned, small, naive, surrounded by no less naive saints. The cruel torments continue on the right wing. There the prince of the underworld in poison green sits at the entrance to a shelter full of toads and supervises the frightful atrocities. Above him sinners are cruelly tormented by devils in a tent. The huge head belching fire on the edge

of the panel—perhaps a fallen angel—is still waiting to be explained. So are the strangely disguised figures above the tent. Scenically and spiritually the left wing is amply articulated; the fall of the angels is far more fantastic than in the Madrid picture.

However, Hieronymus Bosch's teeming brain, which may possibly have been on the very brink of paranoia, was also able to produce something totally different. He took saints as his theme in some pictures, among which may be included, because treated in the same manner, *The Itinerant Peddler* (formerly entitled *The Prodigal Son*) in Museum Boymans-van Beuningen, Rotterdam[7]—it has a precursor on the outside of *The Hay Wain*—and the *Altarpiece of the Hermits* in the Palazzo Ducale, Venice, where surrealism plays a quite secondary part. Four panels (also in Venice) that relate to the Last Judgment are pregnant with future developments. Though not entirely free from recollections of the past

(e.g., Bouts's *The Path to Paradise* at Lille), they contain a first representation of the infinitesimal: the blessed hesitantly ascending to heaven in an endlessly narrowing tunnel through which a strong light shines. The creation of a spherical universe by a God who stands at an infinite distance and the separation of light from darkness on the fourth day of the creation, on the outer wings of *The Garden of Delights,* were already amazing for their scientifically presented modernity. Here we find a presentiment, if not an anticipation, of Copernicus's concepts.

Saint Julia of Corsica on the Cross, parts of which can bear comparison with the most pictorially attractive paintings in the Palazzo Ducale, where it is preserved, displays Bosch's skill in drastically conjuring up before our eyes the results of a horrible deed. One is struck by the paradox that the criminals stretched out on the ground are clad in such charming shades of crimson and vermilion. In the Vienna *Ascent to Calvary* (Kunst-

43. Hieronymus Bosch. *Christ Carrying the Cross.* 30 × 32 7/8″ (76.5 × 83.5 cm.). Museum voor Schone Kunsten, Ghent

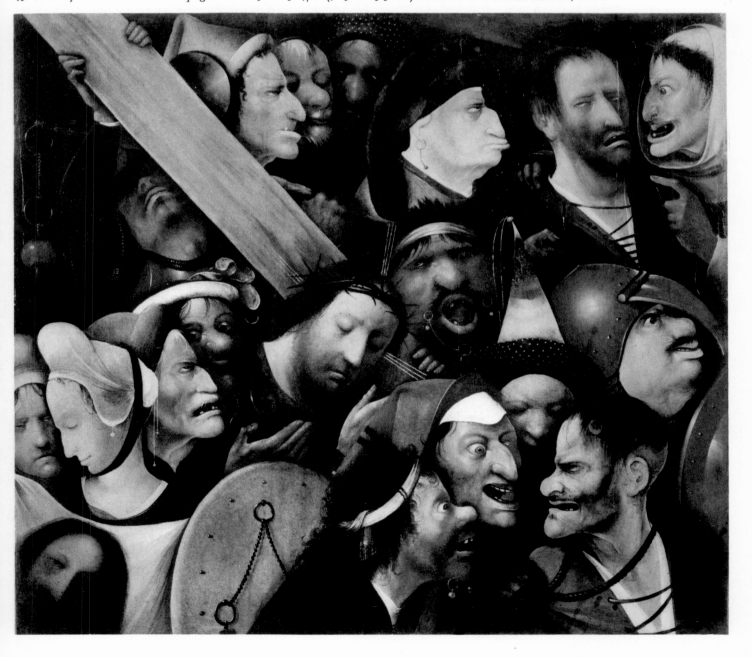

historisches Museum) the possibility of arranging the figures in various vertical layers to show them one behind the other is exploited in a masterly fashion. Below, the Bad Thief is bound with rope while the Good Thief confesses his sins; above, the main scene shows the brutality of the executioners. *The Ship of Fools* in the Louvre, with a tree for mast and a negligent helmsman who feasts with monks and nuns and would like to get a bite of the cake that dangles before his eyes, belongs to the same category. *The Ascent to Calvary* in the Palacio Real, Madrid, is of a quality that recalls Titian and other Italian painters of the first rank. The whiplash motif is more mature and the composition in general is richer than in the Vienna picture; the slanting cross is foreshortened, the crowd is represented by a few sparse figures.

Bosch's last works formed a totally new departure. They consist of figures in half-length or more precisely of a mass of revoltingly ugly heads that fill the picture plane in a true *horror vacui*. They will be discussed in detail in the commentary on the colorplate of *Christ Carrying the Cross* in Ghent (fig. 43; colorplate 37).

Quentin Matsys

Quentin Matsys, the son of a cutler, was born at Louvain about 1466 but moved to Antwerp when he was some twenty-six years of age, thinking, quite rightly, that prospects there were better than in Ghent or even Bruges. In 1491 he became a free master of the Antwerp painters' guild. His art made an essential contribution to the city's cultural prestige and influence. He died in 1530. Dürer tells us that he visited the house where Matsys lived but does not make it clear whether he saw the master or not.

In keeping with his country's general development and on a par with its prominent citizens, Matsys's characteristic traits were self-confidence, a certain brilliance, and more than a little pathos. Instead of ascetic figures marked only by their religious vocation, he took as models for his madonnas lovely examples of ripe womanhood. His art is not epic but dramatic. Unlike Dürer, for whom Italy was an almost fatal invasion of his medieval world, Matsys grew steadily and imperceptibly into the new age that came to be called the "Renaissance" and may be counted as one of its greatest men and artists. No one seems to have formulated the hypothesis—though it looks more than probable—that he went to Italy, where it was Leonardo da Vinci who made the

deepest impression upon him. The Poznan *Madonna,* in which the Infant Jesus plays with a lamb, quite obviously derives from Leonardo's *Virgin and Child with Saint Anne* in the Louvre.

The two big altarpieces Matsys executed in his late forties stand alone, for though they gave him an opportunity to display his skill, he never again received a commission of that sort. Is one justified in believing that Matsys's true importance was not fully understood during his lifetime? Or had the trends that led to the Reformation and, later, to the Iconoclastic movement already set in?

The dates of these two great triptychs are known. One, the *Altarpiece of the Holy Kinship,* originally intended for Saint-Pierre in Louvain and now in Brussels (Musées Royaux des Beaux-Arts), was executed between 1507 and 1509. Unlike Geertgen tot Sint Jans, who still thought in Gothic terms, Matsys attached importance to a three-dimensional architectural setting divided by sturdy pillars into three compartments framed by round arches. The Virgin with the Infant Jesus and Saint Anne are depicted in the forefront of the domed center field. They are flanked to right and left by the seated women of the family and their children, whereas the menfolk are shown in half-length (this is an important point) cut off by a low wall that rises behind the women. On the inside of the wings we can see *The Annunciation to Joachim* and *The Death of Saint Anne.* The quality of the outer wings deserves special mention. The submissive kneeling figure of Saint Anne presenting a casket to the high priest—the cathedral in the background to the left is reminiscent of Antwerp—and more especially the repulsed Joachim, who turns away in distress, are profound psychological studies that one can never forget.

The *Saint John Altarpiece* (fig. 44; colorplates 38, 39) commissioned by the joiners' guild for Antwerp Cathedral took three years to paint and was finished in 1511. It shows Matsys at the peak of his powers, and *The Lamentation* on the center panel is almost on a par with Rogier van der Weyden's *The Deposition* in the Prado (fig. 23). No less important are the wings: on the left, Salome before Herod with the head of John the Baptist (colorplate 39); on the right, the martyrdom of the Evangelist in the caldron of boiling oil. The outer sides of the wings are known only from copies by the Master of Frankfurt.

What was apparently Matsys's last work of this type seems to have been a large altarpiece whose presumed left wing ended up in the Prado. It is an *Ecce Homo,* dated c. 1515 by Friedländer, which may have been inspired by Dürer's woodcut of the Great Passion and more clearly displays the artist's talent for caricature. The same may be said of *The Carrying of the Cross* in the Mauritshuis, The

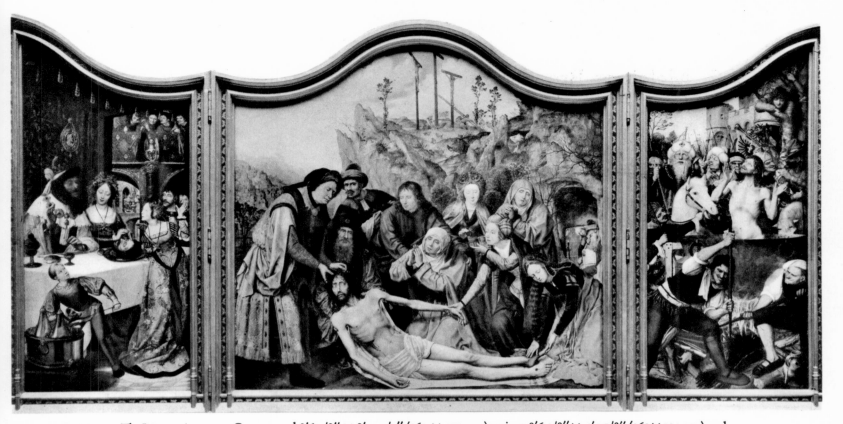

44. Quentin Matsys. *The Lamentation.* 1511. Center panel 8'6 3/8" × 8'11 1/2" (260 × 273 cm.); wings 8'6 3/8" × 4'5 1/8" (260 × 135 cm.) each. Koninklijk Museum voor Schone Kunsten, Antwerp

Hague (on loan from the Rijksmuseum, Amsterdam).

The remainder of Matsys's oeuvre comprises Madonnas and portraits. The *Rattier Madonna* in the Louvre, painted in 1529, a year before his death, is the only one which can be dated with certainty. But that date helps to place others in his early period. For instance, in both the *Madonna* in Brussels and *The Virgin and Child Enthroned, with Four Angels* in the London National Gallery there is a Gothic throne. *Saint Christopher* in Antwerp belongs to the same period; though derived from Bouts it is already much tauter. *Madonna Enthroned ("The Kissing Madonna")* in Berlin seems to have been painted in an erotic mood: the very motif would have been unthinkable before Matsys's day. *The Virgin and Child with Saints* in London and the Madonna in the Von Pannwitz Collection have formal architectural settings that do not yet show Italian influence. For Matsys a woman had to be attractive even in the throes of deepest grief (see *Mary Magdalene Grieving,* fragment of a *Lamentation,* in State Museums, Berlin-Dahlem).

Portrait of a Man dated 1509 in the Oskar Reinhart Collection in Winterthur, Switzerland, prefigures Matsys's future development. Like all his portraits it is in half-length and catches the sitter's diffident, questioning expression; in his hand a piece of paper with the Cross of Saint John of Jerusalem gives his age and the date. Here remarkable local shadows combine with those cast by the head to stretch realism to the point of verism. This is the first of a series of portraits of scholars, each treated individually and differently from the others, which show

us in what circles the painter moved. They incorporate Italian innovations without infringing upon his own idiom in the slightest. Matsys was on friendly terms with Desiderius Erasmus, which explains the double portrait with Petrus Aegidius (colorplate 40). This work marks the transition to the full maturity of probably later portraits like that of the man with a bottle nose before a river landscape in the Städelsches Kunstinstitut, Frankfurt, and the striking likeness of a cleric in Vaduz, in striped rochet with a pair of spectacles in his hand and a prayerbook on the parapet, who stands looking straight at the beholder between two trees before a broad landscape.

A humorous genre picture like *The Old Man and the Courtesan* (Collection Comte de Pourtalès, Paris) was imitated by Marinus van Roymerswaele and others. The rather disgusting *Ugly Duchess* in a two-horned headdress (National Gallery, London) bows to the contemporary trend toward abstruseness. It is demonstrably related to a study in physiognomy by Leonardo da Vinci, as is the unforgettable *Portrait of an Old Man* dated 1513 in the Musée Jacquemart-André, Paris, which may have found its inspiration in Florence. This is the first time in Netherlandish painting that a man is depicted in full profile with brutal frankness, with no attempt to attenuate ugly traits. The fifteenth century had preferred the three-quarter view.

The Money Changer and His Wife in the Louvre, dated 1514, is an example of imitative reversion to the past. Whether it owes more to Jan van Eyck or to Petrus Christus, it is not a spontaneous work.

49

2 Melchior Broederlam

(active 1381–1409)

Altarpiece of the Crucifixion

Detail of the right wing: The Flight into Egypt
Musée des Beaux-Arts, Dijon
See also figure 4

Early Netherlandish painting, so far as we know it from what little has come down to us, begins with one of the most extraordinary phenomena in the whole history of art: Melchior Broederlam's wings for an altarpiece, now preserved in the Dijon museum.

These precious documents of the dawn of realism deserve to be examined in detail.

Each wing holds two scenes: on the left, *The Annunciation* and *The Visitation* (fig. 4). God the Father, surrounded by red and blue cherubim, sends forth the Word—it issues literally from His mouth—from heaven to earth. It enters the building in the shape of rays and strikes the forehead of the Virgin, who sits clad in a dark cornflower-blue mantle on a gold-brocade seat before a lectern on which is a prayerbook; in her hand she holds a skein of purple wool. The building in which she sits is a very flimsy structure. The slender pillars that support the roof are adorned with the statues of two prophets who serve as witnesses. The little room seems to function as the vestibule of a domed, temple-like edifice.

The reddish structure that joins the domed edifice with the two-storied building on the edge of the panel is paved with a swastika design and topped by three Gothic windows that symbolize the Trinity. The Archangel Gabriel has golden wings and wears a lilac robe and red mantle; he kneels by a tall lily—the symbol of chastity—on the stone step that leads to the Virgin, and waves a scroll with the words he addressed to her. Behind him a low wall that even he dare not pass protects the rose hedge. The barren, beetling crag on the right is crowned by a castle. At its foot flows a brook on whose bank stand the two women: Elizabeth in bright red with a green mantle that shows a glimpse of the gold-brocade lining, her head covered with a white kerchief as befits a middle-aged woman; Mary wears the same cornflower-blue mantle as in the Annunciation.

Whereas the building on the left wing is set cornerwise, the left-hand side of the right wing is occupied by a whitish, choirlike central structure with blue-and-gold dome set square to the picture plane (fig. 4). It cannot be denied that the slender pillars in front—their projection was a great novelty at the time compared with the two-dimensional flatness of the High Gothic style—derived from the Sienese. They create depth, so that there is room enough for the ceremony performed by the high priest in lilac chasuble over red-and-gold brocade. Behind Mary stand Simeon in a green cap and an attendant carrying a candle and a pair of turtledoves in a little basket. To the right stretches a landscape—here green and scattered with diminutive trees. In the foreground the brook is collected in a square basin with an overflow outlet. Mary, clad once again in cornflower blue, rides a donkey that seems to be emerging from a narrow gorge; Joseph, in soft, yellow boots and red tunic with a green-and-yellow cap on his head, is drinking from a small canteen. He carries a cloak and a cooking pot slung over his shoulder. Higher up the mountain an idol is falling off its pedestal. Here too the mountain is topped by a castle that fits into the acute angle of the wing.

Melchior Broederlam was born at Ypres and started his career as court painter to the counts of Flanders. On his accession to the county of Flanders in 1384, Philip the Bold of Burgundy confirmed his position as *"peintre de monseigneur et varlet de chambre."* He was paid on a princely scale but, as was expected of the duke's painter, he continued to paint banners and other accessories for festivities, as well as to carry on the more important work of decorating the Château de Hesdin. We know that he stayed twice in Paris. The large altarpiece commissioned by the duke was executed at Ypres between 1394 and 1399. Jacques de Baerze did the sculptures, which were gilded by Broederlam, who also painted the wings. This important work was set up in Champmol Charterhouse, which the duke had founded and whose stone sculptures by Claus Sluter had been finished not long before.

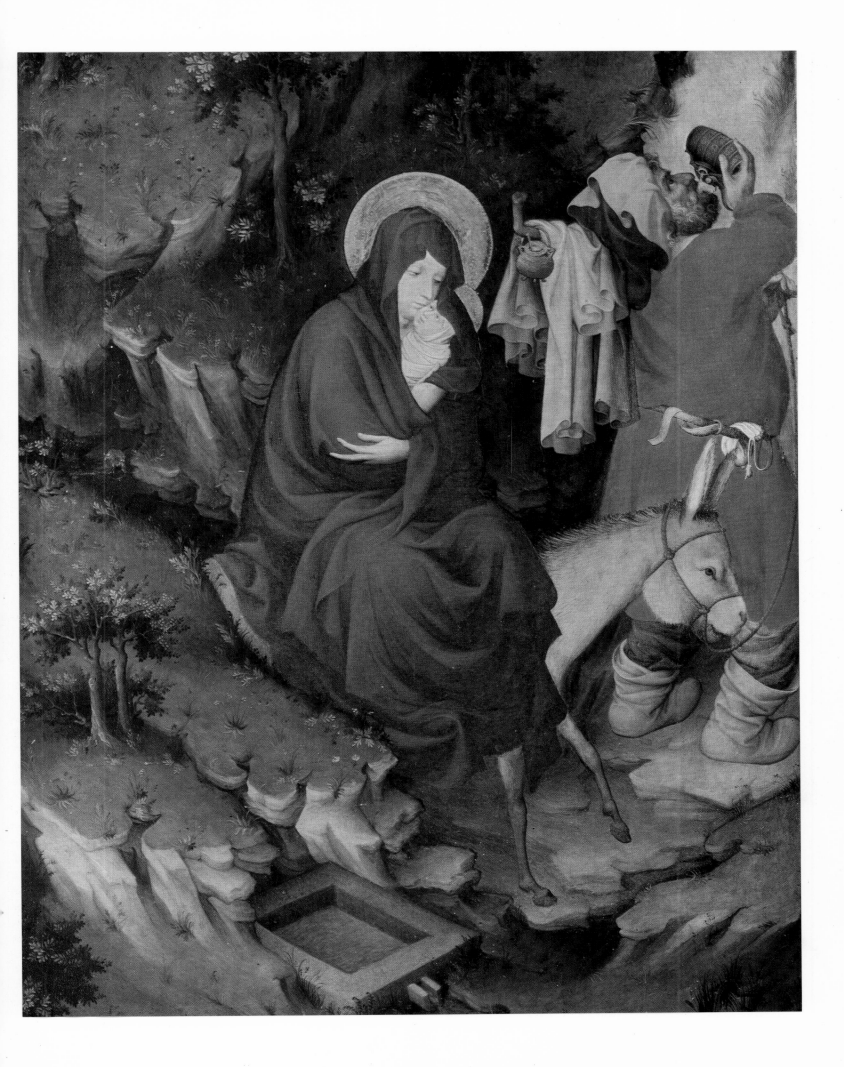

3 South Netherlandish Master

(c. 1400)

Saint Christopher

13 × 8 3/8" (33 × 21.4 cm.)
Museum Mayer van den Bergh, Antwerp
See also figure 6

Very few of the works produced within the broad circle of Melchior Broederlam have come down to us. One that deserves special mention is a charming little altarpiece, parts of which are preserved in the Museum Mayer van den Bergh, Antwerp, and the Walters Art Gallery, Baltimore.

Apparently it was a quadriptych that had a *Baptism of Christ* (Baltimore) and a *Saint Christopher* (Antwerp) on the outside of the wings. When the wings were opened they displayed, from right to left, *The Annunciation* (Baltimore), *The Nativity* (Antwerp, fig. 6), and *The Resurrection* (Antwerp).

The work reveals influences from far and near. The Virgin's folded hands in *The Annunciation* also occur in Giotto's Arena Chapel (Padua). Details of her throne recall the left wing of Broederlam's altarpiece in Dijon; the hermit drinking outside his cabin on the river-bank reminds one of the Joseph on the right wing of Broederlam's work (colorplate 2); while the bearded Joseph resembles the Simeon of *The Presentation in the Temple* (fig. 4). A unique feature is the representation of Saint Christopher beckoning to the Infant Jesus across the river: he is usually depicted in the act of wading through the water with the Child on his shoulders. Another extremely rare feature is that in *The Nativity* Joseph is busy cutting out a hose or stocking, evidently with the intention of using it to cover the still naked Infant (fig. 6).

By and large the little panels are even more indebted to the Italian trecento than were Broederlam's wings. The river teeming with fish, through which Saint Christopher is wading, stretches almost to the top of the picture, as does the Jordan in *The Baptism of Christ*. This means that on the whole the composition is planar, which is what gives the little panels, particularly the outer faces of the wings and *The Nativity*, their peculiar charm. True, the figure of Saint Joseph and the "breakfast tray" are, so to speak, incunabula of the repoussoir; the manger and the midwife who holds the Infant Jesus are placed behind Our Lady's couch, and the ox and ass crane their necks from beyond the valley that separates the flat-topped mountains. In spite of this, the plane is still the major element in combination with the gold ground, which explains why the red of Joseph's gown, the cornflower blue of the Virgin's mantle, and the orange-and-gold brocade of the midwife's gown are so luminous and how the mattress on which the Virgin lies could be given so decorative a treatment.

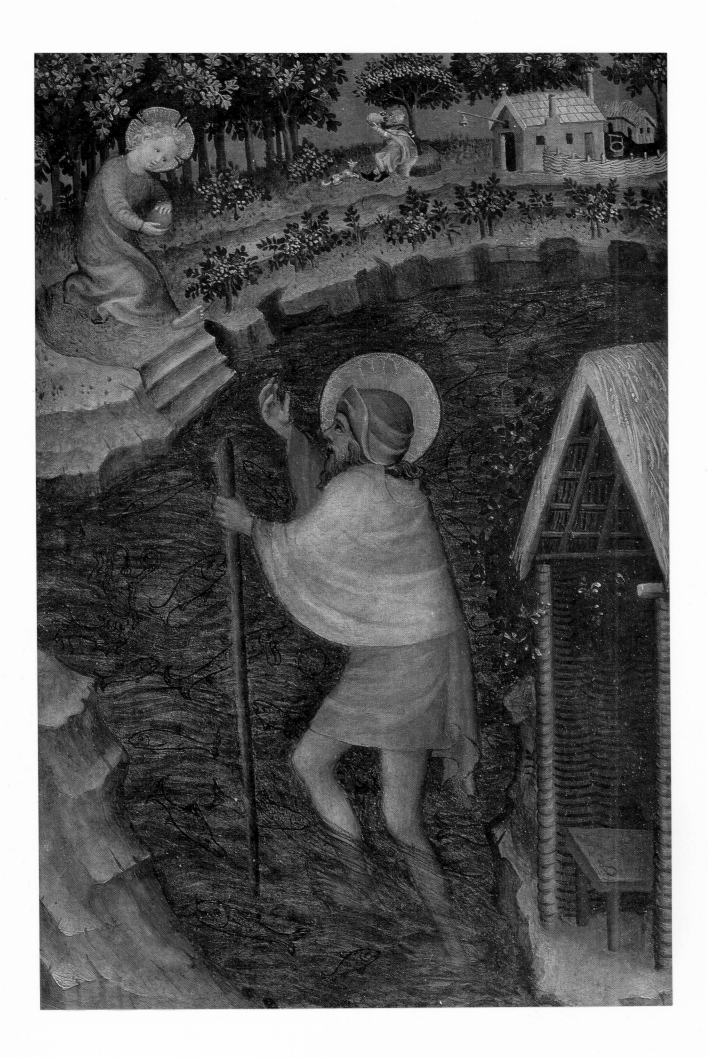

4 Robert Campin

(before 1380–1444)

The Nativity

34 1/4 × 27 5/8" (87 × 70 cm.)
Musée des Beaux-Arts, Dijon

If *The Entombment* in London (Collection Count Seilern, fig. 8) and *The Betrothal of the Virgin* in the Prado (fig. 11) still show signs of belonging to an early phase of Campin's art, *The Nativity* in Dijon displays a fully developed mastery. Our Lady, in a gold-embroidered white gown and mantle—a rare occurrence—that become bluish only in the shadows, kneels with her hands raised in a gesture of prayer before the Infant Jesus, who lies naked framed by an aureole on the bare ground. Behind or rather above Him, Joseph kneels on one knee; he wears a red cloak (whitish where the light strikes it) lined with grayish brown and a dark blue cowl, and with one hand shields a lighted candle, indicating that it is actually nighttime. His bearded countenance has a parallel in *The Entombment*. The door of the stable is open to admit three shepherds. They have come to see and worship the divine Child. One, dressed in tobacco-brown cowl, has brought his bagpipe; another, in a bright-red cowl, wears thick gloves and holds a hat shaped like a pot or helmet; between the two, the third wears a dark-blue bonnet. The group was inspired by one in Paul of Limbourg's *Très Riches Heures* at Chantilly. The wall of the stable, which is in a state of utter decay, reveals the wooden laths from which the plaster has fallen and lets us see the ox and part of the ass within. Atop the roof, to the left, hover three little angels bearing a scroll; the one in front is dressed in cornflower blue, the one in the middle in bright red, the third in yellow-green.

An unusual, if not unique, feature is the presence of the two midwives (at the right-hand edge of the panel). Zelomi—in a gray skirt that spreads out toward the right, revealing the sole of her red right shoe, and falls open to show the striped pattern of the lining—turns her back to the spectator. She wears a headdress ranging from whitish to whitish blue and a tucker to match in such a way that her long pigtail appears in two places (see the female figure in the foreground of the Prado *Betrothal*, fig. 11). The second, Salome, in a still more ample headdress and a gown with jeweled border, is placed behind—or, more precisely, above—the first. The foot glimpsed under the hem of her gown indicates haste. She is apparently calling attention to her right hand, which withered because she refused to believe in Mary's chastity and insisted on putting it to the test. But the little angel that hovers near her head, dressed in white with lilac shadows, bears a scroll that says: "Touch the Boy and thou shalt be healed." And so it came about.

Equally typical in this picture are the naturalness of the gestures and facial expressions and the cheerful brilliance of the splendid colors. No less important is the spreading landscape in the distance. It is a typical late winter landscape with a tree-lined, winding road that leads our eye past willows and fields and a few scattered houses to a town with a majestic castle and turreted walls, which is framed on one side by a lake and on the other by rocky peaks behind which the sun is rising. One of the peaks is of the "Phrygian cap" type that we have already seen in the delightfully composed landscape of Campin's small *Saint George* (fig. 10) and Jacquemart de Hesdin's *Flight into Egypt* in Brussels (fig. 7). Incidentally, in Campin's work nature is observed in far more detail and with greater precision.

5 Robert Campin

Portrait of a Man

16 × 11" (40.7 × 27.9 cm.)
The National Gallery, London

The deep vermilion of the turban blazing in a diagonal line contrasts boldly with the leathery yellowish skin, the dark greenish eyes, the eloquent, energetic mouth, and the somber blue-green coat. No less bold is the dark violet gown of his wife (fig. 12), whose head is swathed in a bulky veil with white folds in double and quadruple thickness held together by pins. Her eyes too are greenish, her complexion is clear, her cheeks are a healthy pink. We can glimpse one of her hands thrust into the fur-lined sleeve. This double portrait is a magnificent early example of an art that was practiced for centuries. The impression of reliability and efficiency in the man and of discretion and solicitude in the woman seems typical of the moral attitude of the people of that whole period.

A great many portraits of men and women by Campin have come down to us. The best of them—*Robert de Masmines* (in two versions; fig. 13) and the pair of portraits in London—are undoubtedly early works, as are the portraits of Barthélemy Alatruye and his wife

known only through a copy in Brussels (on loan to the Musée des Beaux-Arts, Tournai). The portrait *Woman with a Kerchief* in Berlin is a slightly later work that was formerly attributed almost unanimously to Rogier van der Weyden. It has all Campin's rugged plastic force and dates from before Rogier's earliest known works. *Portrait of a Man in Prayer* in New York (The Metropolitan Museum of Art) already calls to mind the donor of the *Mérode Altarpiece,* as does *Portrait of a Man with a Pointed Nose* in the Philadelphia Museum of Art, John G. Johnson Collection. The portrait of a man thought to be Guillaume Fillastre in the National Gallery, London (on loan from Lady Merton), was probably executed after these two. The *Portrait of a Princess*—which is obviously not a sibyl—in Washington, D.C. (Dumbarton Oaks Collection), *Portrait of a Man* (a musician?) in New York (Collection Mrs. John E. Magnin), and the *Head of a Man* in Berlin (State Museums) are not generally accepted as originals but nonetheless bear witness to Campin's extraordinary ability.

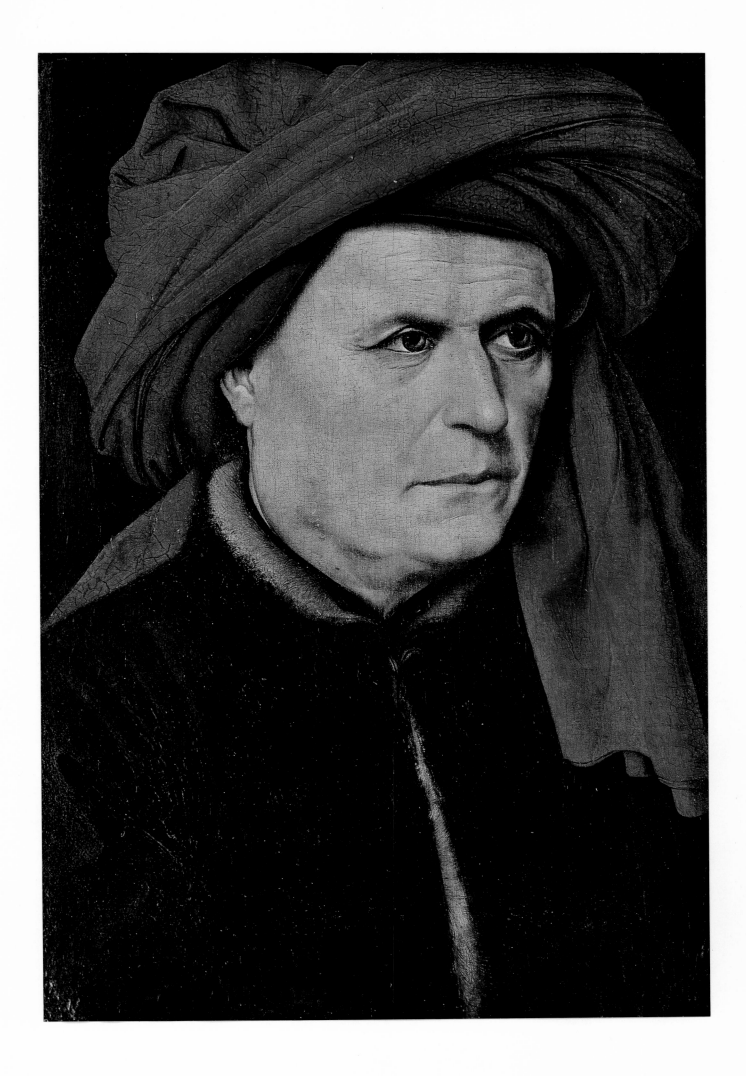

6 Robert Campin

The Virgin and Child Before a Fire Screen

25 × 19 1/4" (63.5 × 49 cm.)
The National Gallery, London

Robert Campin was a rebel and if for one reason or another he kept to traditional themes, which he treated in a grand manner, some things were in direct opposition to his new views and discoveries. It is only in the works of his early period that we find a gold ground, and the last time he employed a halo was evidently in the Frankfurt *Madonna*. He was well aware, however, of its decorative function, and therefore seized the opportunity to utilize a plaited fire screen in its place, very likely with the idea that by so doing, he could give the head of his madonna the same relief. This may well be the reason why, in the London panel, she is backed not simply by an open fire but by a screen as well (see the picture of January in Paul of Limbourg's *Très Riches Heures* at Chantilly).

The head of the madonna on which the accent is thus placed, though quite unconventional, is truly magnificent with its long nose, close-set eyes, and masses of wavy hair. This latter is a novel feature, for the Virgin's hair had previously always been swathed in an ample headdress.

Wearing a flowing, draped robe with jeweled border, she is seated on—or rather, typically, before—a bench (one of Campin's favorite pieces of furniture, which he used repeatedly) and offers her breast to the naked Infant, who is already well grown and vigorous. On a cushion by her side lies a handsome prayerbook resting on its crumpled white pouch. The tiled floor develops its perspective toward the wooden stool beneath the shuttered window, through which we can see a marketplace with houses and streets and a Gothic church in the distance. Motifs of this kind occur repeatedly in Campin's works, but whether or not he borrowed them from Jan van Eyck is a moot question. Be that as it may, the discovery of landscape was complemented by the discovery of the pictorial value of the townscape in the middle distance, which, from then on, became an integral part of European painting in general and of Netherlandish painting in particular.

It should be noted that to the right of the Infant's elbow an entire vertical strip or board of the picture has been restored.

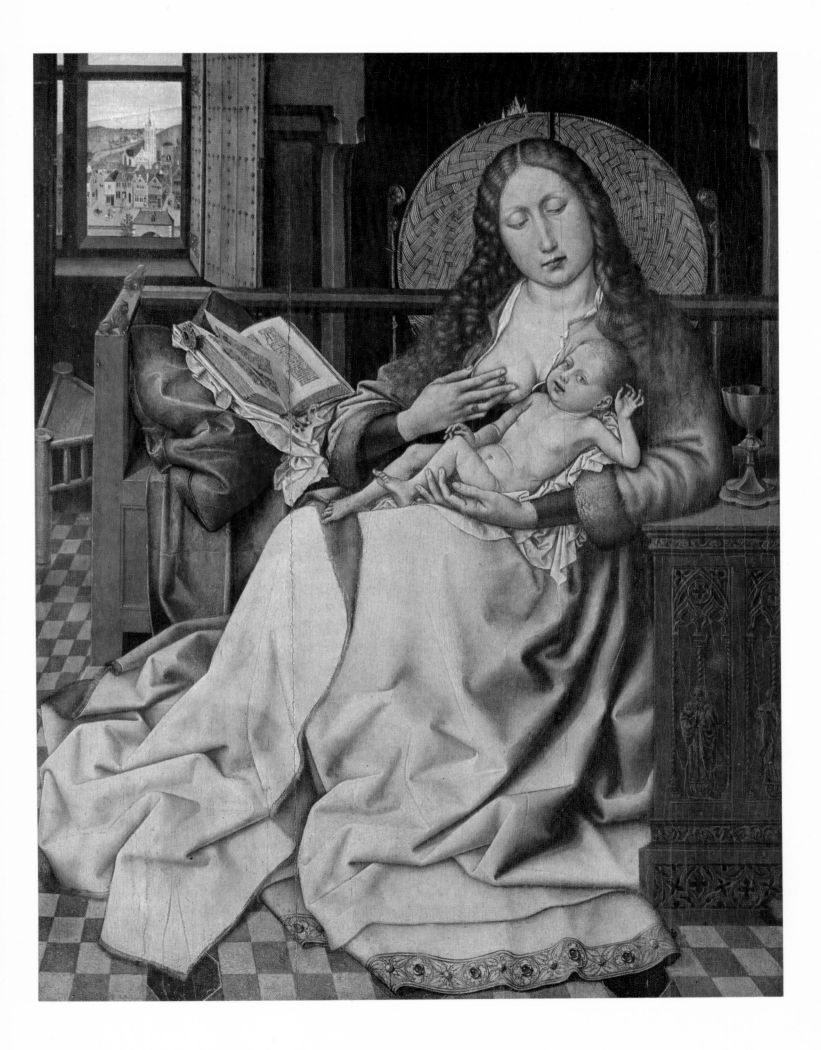

7 Robert Campin

The Bad Thief Gesinas

52 3/8 × 36 1/2" (133 × 92.5 cm.)
Städelsches Kunstinstitut, Frankfurt am Main

In Frankfurt Robert Campin is splendidly represented by the surviving panels of an altarpiece that is believed to have belonged to Flémalle Abbey, near Liège, which led to the coining of the name "Master of Flémalle," a makeshift that no longer serves a useful purpose. The panels are three narrow upright rectangles with *The Virgin and Child, Saint Veronica,* and (in grisaille) *The Holy Trinity.* But equally if not more important is the fragment of another huge altarpiece on which is depicted *The Bad Thief Gesinas.*

We can form a very precise idea of what this second altarpiece looked like from a small-scale, but apparently quite exact, copy in the Walker Art Gallery, Liverpool (fig. 9). It displays a *Deposition* framed by two wings. The ladder cuts across the picture at an angle and at the top of it, the pious men's assistant balances with his right foot on a rung in an awkward, even risky, position. His left foot rests on the next rung higher up and only his left arm is free to hold the body. In this he is hampered by his fur-lined cloak, which also serves to support the body. No wonder he grips the ladder with his right hand, ready to intervene if necessary at the last moment or, in the event of a fall, to prevent the worst from happening. Joseph of Arimathea stands on the ground, his outstretched arms covered with a sheet to support Christ's thighs. Nicodemus, dressed like a pasha, has discarded his pattens in order to get a sure purchase on the rung and makes a rather poor attempt to help the others. Mary Magdalene, with her back to the spectator and with her mantle tied round her hips in an old-fashioned manner, is also anxious to lend a hand. She has set one foot on the ladder and stretches out her arms.

This part of the picture gives the impression of an immature and provisional, though on its own terms highly significant, solution of the problems involved in representing the scene. That the Virgin Mary is no longer engaged personally in removing her Son's body from the cross is a great improvement on Simone Martini. One gets the same impression from the left-hand side of the panel, where the Virgin sinks to the ground, still gesticulating but stiff as a board. She is overcome with grief and is about to swoon, but Saint John just manages to catch her as she falls. Two other women standing by merely make plaintive gestures.

The mount of Calvary itself is represented as the cap of a sphere. It extends from one wing of the altarpiece to the other, but leaves room for views of a barren landscape at either side. The thieves, whose arms are bound over the crossbeam in an unusual manner, are depicted on the wings completely isolated from the main event. On the left, another mourner is shown in almost total rear view, as is the Good Thief, while the kneeling donor is shown in full profile. On the right, at the lower edge, is a blank tablet which in the original very probably contained all the information we would like to have: the painter's name and the date when the work was executed.

We are lucky that the copy in Liverpool gives us some idea of the huge gold-ground altarpiece, but it is only when one stands before the fragment of the original in Frankfurt that one realizes the importance of what has been lost. Even if Masaccio built something greater still on the foundations already laid in Italy, it does not seem unwarranted, when faced with Campin's plastic force, to recall that Florentine painter, who was the standard-bearer of the proto-Renaissance. The brilliant colors and precise, sure characterization were entirely new. The captain in full armor, with his hand on his heart (not pointing but affirming), wears a jeweled surcoat over his coat of mail; his companion is dressed in vivid vermilion with a brown-and-gold patterned silk turban on his head. Their grave mien commands respect. So does that of the thief, who is painted a cadaverous gray. The nude figure is so excellently modeled that it must have been based on a study from life. The inclusion of two more soldiers on the center panel is a rather rare occurrence.

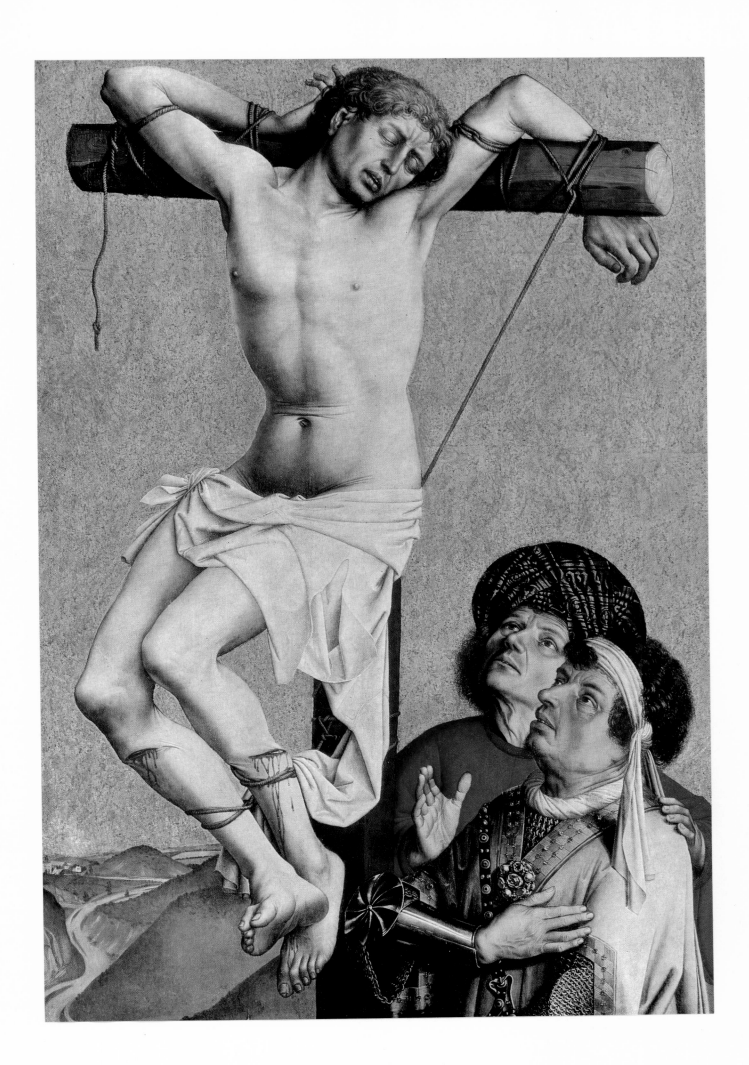

8 Robert Campin

The Annunciation

22 7/8 × 25 1/4" (61 × 63 cm.)
Musées Royaux des Beaux-Arts, Brussels

Perhaps none of Campin's works has been puzzled over as much as the *Mérode Altarpiece* (fig. 15). It owes its name to the fact that, until some fifteen years ago, it belonged to a Princess de Mérode, who allowed hardly anyone to get a glimpse of the original. Thus, very few people had seen it before it reached the Cloisters, in New York City. The work should perhaps be better named after the donors, a couple called Ingelbrechts from Malines.

The altarpiece is a triptych. On the left wing the donors kneel in a garden before a timber door through which the announcing angel may have passed. On the right wing Joseph is busy making a mouse-trap. The open windows behind him afford a view of a marketplace like that in *The Virgin and Child Before a Fire Screen* (colorplate 6).

The Brussels museum has a similar *Annunciation* which, until about ten years ago, was thought to be a copy. In actual fact, however, it is older than the center panel of the *Mérode Altarpiece* and therefore the true original of the panel in the Cloisters. It must be borne in mind that what we now term "autograph derivative" did not necessarily

have any overtone of disparagement in those days.

Campin included a long bench—his favorite piece of furniture—in both works, and in both it is exaggeratedly elongated. He also used the same polygonal table, which is viewed from a very slightly higher angle in the Brussels version. In the Brussels work, both the Virgin and the angel display modest Gothic attitudes. In the Cloisters version, the Virgin faces the spectator squarely with a self-assurance that anticipates the Renaissance; she no longer rests her hand meekly on her breast but is still immersed in her prayerbook. A second prayerbook lies on a velvet pouch on the polygonal table, whereas in the earlier work a striped wrapper is used and the pouch is placed on the floor.

It is high time that the Brussels panel, which is painted in beautiful tones, be recognized for what it is—namely, a masterpiece of the first rank, superior to the *Mérode Altarpiece* and one of the finest paintings on view in one of the major European art galleries.

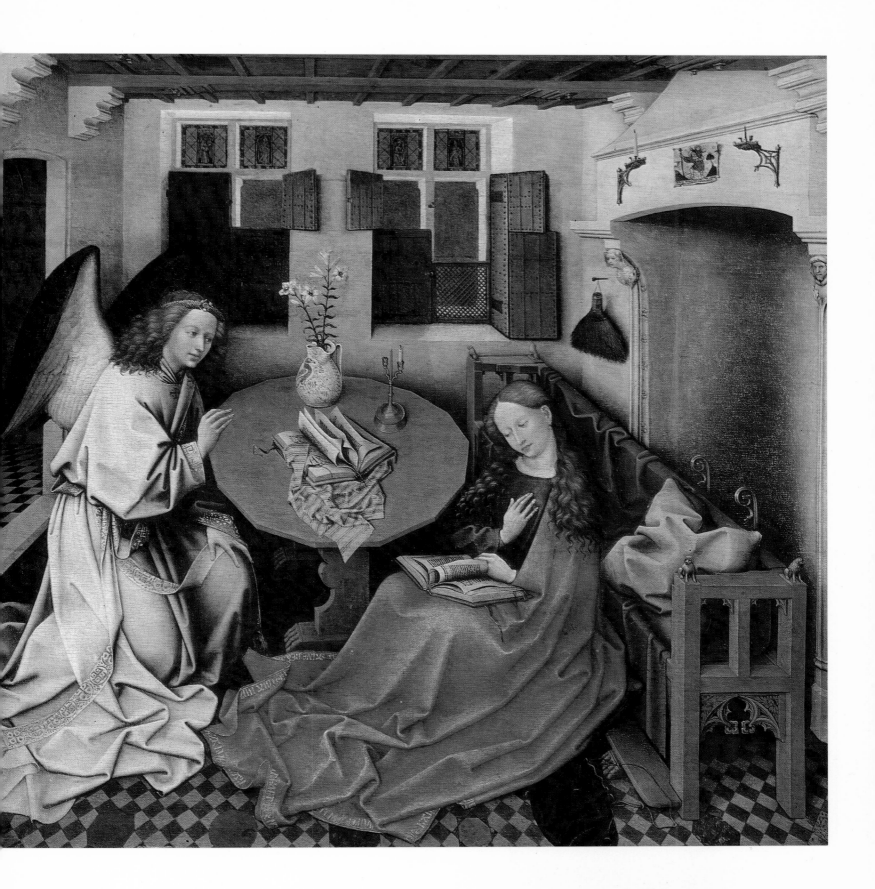

9 Hubert and Jan van Eyck

(c. 1370–1426; c. 1390–1441)

Ghent Altarpiece

Detail: Singing Angels
Completed 1432
St. Bavo, Ghent
Reproduced in full in figures 17 and 18

The germ of the *Ghent Altarpiece* was *The Adoration of the Lamb* (fig. 18) commissioned by the Ghent Court of Justice in 1425 for the town hall. It was based on a passage from the Apocalypse. The kneeling figures at each side of the *fons vitae* are generally held to be apostles (on the right) and prophets (on the left). The Lamb stands on an altar, its blood flowing into a chalice. It was a charming idea to surround it with young angels who adore it on their knees or bear the instruments of Christ's Passion or swing thuribles. The altar, adorned in front with purplish-red velvet brocade cloth, stands on a knoll in the center of a sloping meadow, shutting off the middle distance. The upper end of the meadow is bounded by trees and shrubs, while a row of cathedrals and urban buildings closes the far horizon. The dove of the Holy Ghost hovers above the Lamb. The groves at the sides leave room enough for the group of holy bishops, popes, and confessors on the left (most of them dressed in blue) and the virgin saints dedicated to the love of Christ on the right.

The themes treated on the two wings (fig. 18) were happily inspired. On the left, Christ's Champions and the Just Judges on horseback (a copy—the original was stolen in 1938); on the right, the Holy Hermits (behind whom we can glimpse two female saints) and Pilgrims with the giant Christopher in the lead.

The true crowning feature of the work was the addition of the triad above *The Adoration of the Lamb*: in the center, God Almighty stiffly symmetrical in purple; on the left, the Virgin Mary in blue, leafing through a prayerbook; on the right, John the Baptist in grass green, apparently chanting from a book that rests on his knee.

Instead of designing the upper wings to match the lower ones, the artist inserted two narrow panels—naturally respecting the articulation of the outside—with Adam and Eve. The naked figures are treated as individual examples of sensuality with a realism that is truly amazing: Adam seems almost about to step out of the frame. Above their heads are Cain and Abel in prayer and Cain slaying Abel, both painted in grisaille to imitate stone reliefs. This arrangement was a brilliant idea because it left room for the two wider panels where the adoration theme is resumed once more in the singing and musical angels.

Perhaps these two panels are those that have been imprinted most deeply on our consciousness through the centuries. Never was so lofty a mood suggested with such keen realism. The angels' faces are not beautiful but full of character and therefore true to life (insofar as life offers us angels in female guise). The flowery velvet brocade of their robes is magnificent: red, green, and gold on the left; yellowish and black on the right. Jan van Eyck seems to have been the first painter to succeed in the feat of rendering such exquisite materials. In this not even Rogier van der Weyden, and still less Robert Campin, could hold a candle to him. As Tolnay says, "Paradise is fetched down to earth, else how could one understand the unique splendor of the Eyckian image world."

When the wings are closed, the lower part of the altarpiece provides four fields of equal width for the donor Jodocus Vydt (in vivid vermilion), his wife Elisabeth Borluut (in gray and reddish violet), and the two Johns; the latter are painted in trompe l'oeil as statues. But what was to be done with the two narrow fields framed by two wide ones higher up? Jan van Eyck had no objection to using them for an *Annunciation*. Boldly, making a virtue of necessity, he spread through the entire width of the middle register a room with beamed ceiling that offered space enough on the left for the announcing angel and on the right for the Virgin (whose reply is written upside down, as was customary. so that it could be read "up" in heaven). It did not worry him in the slightest that there was a lot of empty space between them. The left-hand side of that space is occupied by a Romanesque mullioned window through which we can see a street with houses; in the right-hand half there is a Gothic-framed toilet recess with brass basin and water kettle and freshly pressed towel. Two other windows to the right and left are fundamentally Gothic: a symbolic reference to the new era that the Virgin was to bring in. Through the Gothic window on the right the pale sun that illuminates the townscape shines on the wall behind the kneeling figure. A recess cut in the wall to the left of her prie-dieu holds some books, an alabaster vase, a metal pitcher, and a lamp. All these objects, like the glass vase on the windowsill, are symbols of her chastity. Panofsky quotes a poem, with which Van Eyck was familiar, that says that, despite her impregnation by the Holy Spirit: "As the sunbeam through the glass passeth but not breaketh / So the Virgin, as she was, virgin still remaineth."

The arched top pieces contain the Erythraean and Cumean Sibyls (the first in white, the second in fur-trimmed green). They are flanked by the busts of the prophets Zechariah and Micah in the two somewhat lower lunettes to the left and right.

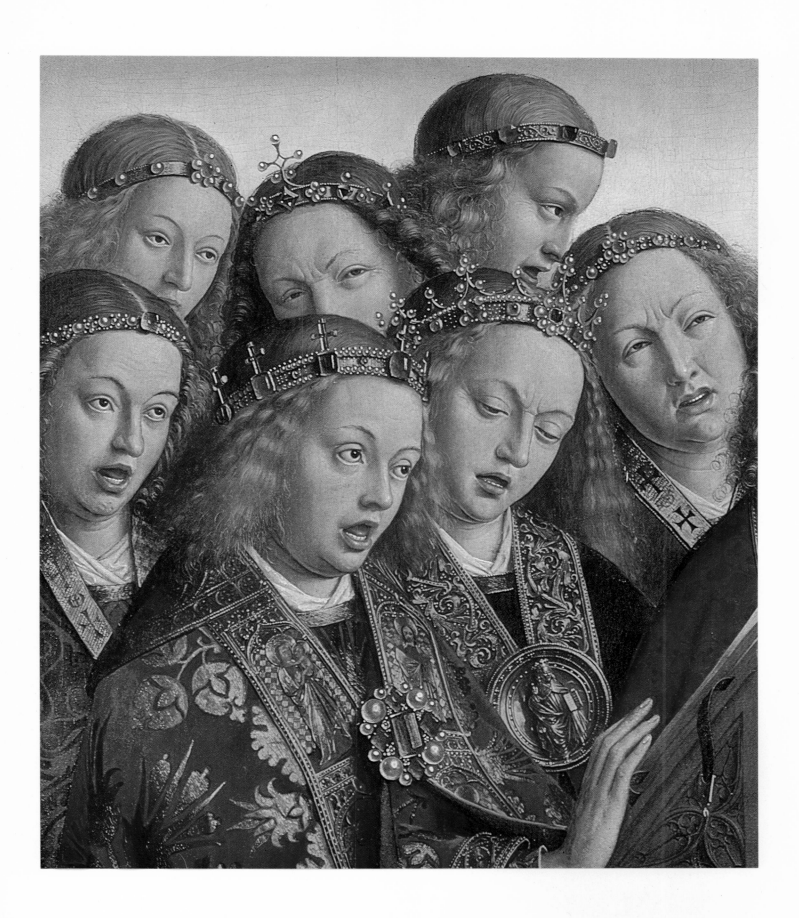

10 Jan van Eyck

The Marriage of Giovanni Arnolfini and Giovanna Cenami

1434
32 1/4 × 23 1/2" (81.8 × 59.7 cm.)
The National Gallery, London

The independent portrait made a good start with Robert Campin in the 1420s and Jan van Eyck followed up with a no less important series during the next decade. Some of these likenesses are dated: 1431, *Cardinal Albergati* in Vienna; 1432, *Portrait of a Young Man (Timotheos)* in London; 1433, *A Man in a Turban* in London; 1436, *Portrait of Jan de Leeuw* in Vienna; 1439, *The Artist's Wife* in Bruges.

In 1434 he was faced with the task of painting a full-length double portrait, namely, a married couple in their bridal chamber; in other words, a marriage picture, confirmed by the inscription *"Johannes de eyck fuit hic"* (Jan van Eyck was here). This can hardly mean anything else than that the painter acted as witness to the marriage, together with the other man whose reflection we can glimpse in the round mirror framed by ten small scenes from the Passion which, like the brass chandelier suspended from the beamed ceiling, lies in the central axis of the picture. The affluence and social standing of the couple are reflected in their bearing and modish attire. The solemn, tranquil atmosphere that reigns in the room denotes the high level of civilization enjoyed at the time.

The bridegroom, Giovanni Arnolfini, was born at Lucca and represented a firm of Lucchese merchants at Bruges. He wears a mink-trimmed surcoat whose reddish-brown tint grows paler in the bluish folds and a big, broad-brimmed fur hat which, like his robe, is almost black. He holds his right hand vertically upward in what seems like a reassuring gesture; his bride, Giovanna Cenami, has laid her slender right hand in his outstretched left.

Born in Paris of Italian parents, she has small eyes under high arched brows, a rosy complexion, pink cheeks, and red lips. Her sumptuous wedding gown is grass green and its unusual magnificence is accentuated by the little ermine collar and the long ermine-trimmed armholes that are prolonged below by a broad band of green scalloping. Her slender left hand emerges from a pale-blue velvet sleeve to hold up to her stomach the bulging front of her extraordinarily ample gown, which nonetheless spreads out on the floor in a number of angular folds. The vermilion coverlet and canopy and the slightly darker shade of the cloth and cushions on the bench beside the bed form the ideal color contrast to the striking green of the gown.

The room is obviously a bridal chamber and consequently almost every detail has a symbolic significance. For example, the fruit on the windowsill refers to the innocence of Adam and Eve before the Fall, as does the tree with green leaves and red blossoms that we can just glimpse through the narrow slit of window. The cork pattens to protect the groom's leather shoes out-of-doors should call to mind Moses on Mount Sinai, while the little dog stands for conjugal fidelity.

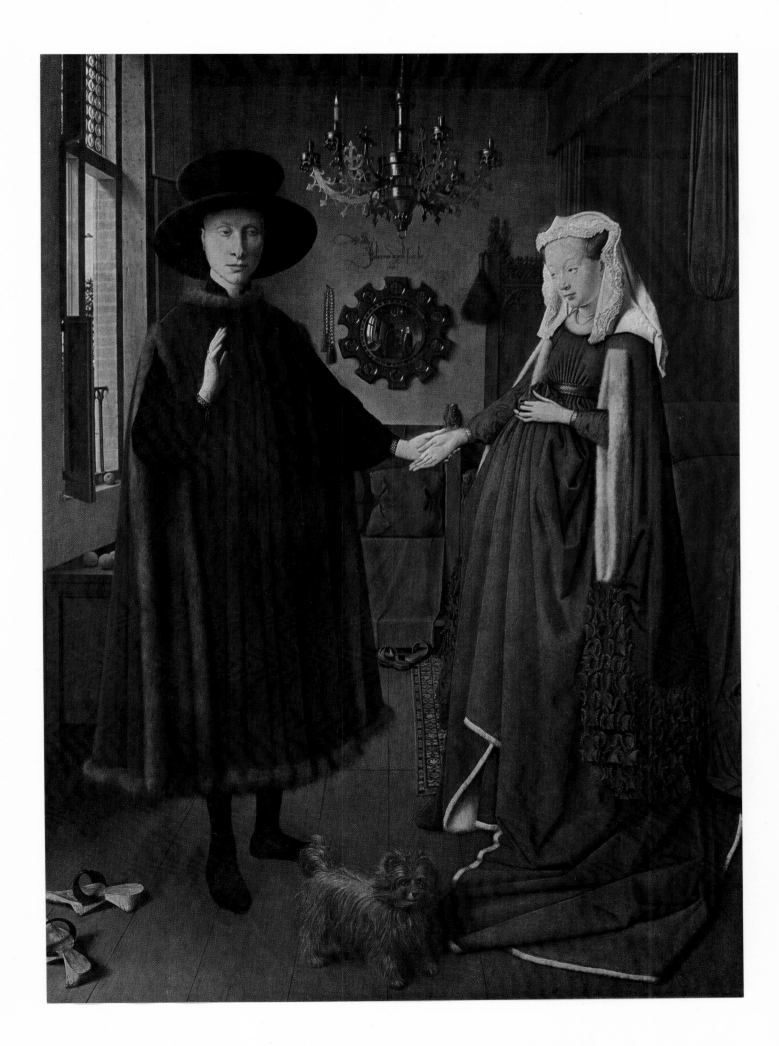

11 Jan van Eyck

The Madonna of Chancellor Rolin

Detail: The Chancellor
The Louvre, Paris
Reproduced in full in figure 20

This is not only one of the finest pictures in the Louvre but also one of the finest and most colorful that Jan van Eyck ever painted. Moreover, as Emil Kieser was the first to realize, it is a supreme example of late medieval symbolism and numerical science. Decoding the symbols is particularly important, for they provide us with a *terminus post quem* for the execution of the work.

The scene is set in the splendid pillared hall of a palace built on an eminence in the Romanesque style—the style employed to designate the past. One of the most charming landscapes in the world can be admired through its open arches. Nicolas Rolin, born in 1376 and chancellor for Duke Philip the Good from 1422, kneels before the Virgin Mary. Dressed in a robe of gleaming yellowish-brown, pomegranate-patterned velvet brocade, his arms resting on a prie-dieu covered with a dark-turquoise blue cloth, on which is a prayer-book protected by an old-rose pouch, his hands raised in prayer, he is depicted in profile gazing straight at the miraculous apparition. On the opposite side of the room the Madonna, in a spreading, dark-red mantle with *exaltata sum in libano* embroidered round the hem, poises the Infant Jesus on her knees so that both of His arms are free: one diminutive hand is raised to bless the donor while the other holds an orb. Behind her hovers an angel, in blue with rainbow-tinted wings, bearing the heavenly crown.

Nothing is spared to make the setting as magnificent as befits a mansion in paradise. The columns of the hall are made of variously colored marble; the crocket capitals are adorned with ingeniously interlaced tracery; the architrave is carved with reliefs depicting on the left, Adam and Eve expelled from the Garden of Eden (which brought death, sin, and the curse of labor into the world); Cain and Abel (above them God the Father accepts Abel's sacrifice, hence the fratricide); and Noah's drunkenness (above it Noah and the dove with the olive branch are visible), which brought scandal into the world. On the right, above the Virgin, the justice of Trajan is depicted as an example of virtue. Gothic trefoils and quatrefoils embellish the bases of the columns and the spandrels between the arches. Roses, irises, and white lilies, symbols of purity, bloom in the little garden (most likely an allusion to the *hortus conclusus*). Peacocks strut about to symbolize pride and vanity, and magpies are tokens of those who doubt salvation. In front of a low crenellated wall that is reached by a short stairway, we can see two little figures wearing the costume of the period in old-rose and blue. They stand where the diagonals of the picture plane intersect and are in this way related to the two figures in the foreground and the two windows higher up.

While the palace is the visible anticipation of a celestial abode graciously reserved for the donor, the eye is also gladdened by a splendid panorama beyond the little wall. A broad, shimmering river, whose banks are lined with vineyards, woods, and coppices, is spanned by a bridge with six arches and a drawbridge tower that links a compact Gothic town (with cathedral, towers, and houses) with a suburb in which a minster with cloisters can be clearly seen. All attempts to identify the town layout with an existing place, Liège for instance, have come to nought. On the other hand, one cannot go far wrong in presuming that the unique panorama with the glistening, snow-clad Alps in the distance was based on an experience and study of nature. The castle on the little island in the axis of the picture, toward which the center row of floor tiles leads the eye, is a charming focal point.

Chancellor Rolin, a self-made man of humble parentage, did not rise to the first place at the court of Burgundy without standing up to the great feudal lords. He was one "who always sought to reap on earth as if it would be his for ever, who was accustomed to decide everything quite alone and to manage and execute everything on his own, whether war, peace, or finance. . . . His character was such that he would not give up his office to anyone and retire in peace, but on the contrary aimed at rising higher and higher and extending his power right up to the end of his life." This is what Georges Chastellain says about Rolin in his chronicle (1454–58) without realizing that, as Van Eyck's painting proves, he also had in mind a continuation of his glory after death.

The work was obviously executed in connection with the Peace of Arras (September 21, 1435), which marked the apogee of Rolin's career. The connection lies not only in the general content and inner form of the picture but also in its smallest details. For instance, Article Seven stipulated that a cross should be erected on the bridge of Montereau in expiation of the murder of Philip's father, John the Fearless, which was perpetrated there on September 10, 1419: a tiny cross is visible on the bridge in this painting. If this might be viewed as a chance occurrence, there are other facts that quell all doubts. Consider for a moment the tiled floor of the hall. The day and month of the conclusion of the treaty are encoded in the middle tile at the lower edge of the picture—it is repeated at the foot of the Chancellor's prie-dieu—which has twenty-one tiny dark and light squares around its edge and nine black-and-white squares in the center. The number of the years elapsed since then is indicated by the sixteen tiles that run from back to front. Elsewhere too "numbers and figures as the measure of invisible time are balanced and made clear in the visible dimensions of the room."

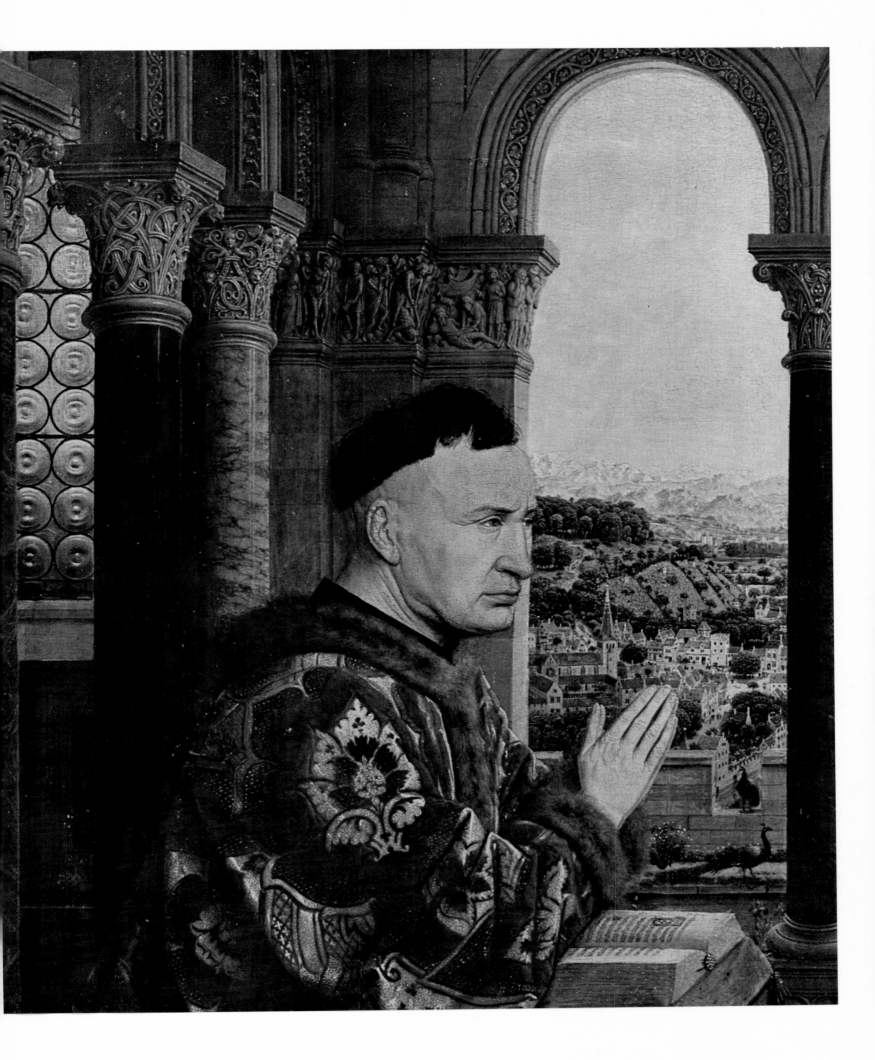

12 Jan van Eyck

The Madonna of Canon van der Paele

Detail: The Canon
1436
Groeningemuseum, Bruges
Reproduced in full in figure 19

The theme of this panel preserved in the Bruges museum—the largest single panel picture the master ever painted—is the Virgin and Child surrounded by saints. It orininated in Italy as the *sacra conversazione* and was first introduced to the Low Countries in this painting by Jan van Eyck. But here he has expanded that theme by adding the donor commended to Our Lady by Saint George, his patron saint, in the presence of Saint Donatian, to whom the church in Bruges for which the panel was originally commissioned was dedicated. Saint Donatian's attribute is explained by the legend that he was pushed into a river, but when a wheel with five candles was launched on the water it drifted to the spot above which he was lying on the riverbed. On being taken out of the river, he was restored to life. If Saint George's smile is rather forced and the commending gesture of his hand somewhat stiff, it is due to the effort required to doff his heavy helmet and to the weight of his suit of armor. He is also handicapped by having to hold the red-cross banner that is his attribute in the crook of his arm, taking care not to let it slip. There is almost certainly a symbolic significance in his treading on the hem of the Canon's surplice: it indicates that the latter is mortal and earthbound.

The Infant Jesus, who is playing with a parrot, offers His mother a little posy. Her attention has been drawn away from her Son by the saint's gesture and she nods slightly toward the donor; but it would be beneath her dignity as the mother of God to look straight at either him or his patron. That is left to the divine Child, and it seems quite natural considering the saint's gleaming armor, so brilliantly polished that the painter and his red turban are mirrored in the oval elbowpiece.

An unusually important role in the picture is allotted to Saint Donatian, "a living pillar of the Church," as August Schmarsow calls him. Besides his attribute, the wheel with the five lighted candles, he bears the crosier that denotes his rank as an archbishop. His monumental cope, of a blue-and-gold velvet brocade which contrasts with the Virgin's red mantle, is closed with a huge clasp. The donor is admitted to the community of saints, which is doubly framed by the pillared ambulatory and the semicircular apse.

When Jan van Eyck received the commission for this panel from Canon George van der Paele, his ambition was to achieve the utmost plastic relief. The scene is set in a low hall that stresses the size of the figures. Dominating the others, the Virgin Mary is enthroned in the center of a Romanesque apse framed by dark-colored marble columns, some of them half concealed, which rise to a climax at the two sides of the picture, giving the composition balance and stability. Their crocket capitals are embellished with tracery and a pilaster behind them is topped by a relief. The blocklike triangular volume of the madonna and the severe simplicity of her drapery recall the sculptural Virgin on the outside of the *Ghent Altarpiece*. They form a remarkable contrast with the flower-patterned silk brocade of the canopy and the colorful geometric design of the oriental rug, which is cut off by the frame—the picture's original frame adorned with lengthy inscriptions. The armrests of the throne are embellished with little sculptures whose themes are also symbolic (Cain and Abel, Samson and the lion); beneath them, on a diminutive scale, are Adam and Eve, no longer Gothic as in Ghent, but conceived in the spirit of the Renaissance.

The inevitable rigidity of so strict a tectonic composition is relaxed in the happiest possible way by the figure of the donor, who kneels on the quatrefoil-decorated step of the throne. Instead of folding his hands in the customary pose, the canon leafs through a prayerbook protected by a leather pouch in a characteristic gesture that is observed with a very keen eye. He holds his horn-rimmed spectacles in his right hand and his gray, squirrel-fur stole is draped over his left arm. Rather than look at the madonna, he turns his gaze toward Saint Donatian. It is the gaze of an old man still in possession of all his faculties, with short neck and double chin, clean-shaven jowls, turned-up nose, narrow but quick-witted lips, and stubborn eyes—a man who has spent a lifetime in the service of the Church. Rendered with extreme realism are the wrinkles, round the eyes and at the bridge of the nose, the protruding artery at the temple, which is prolonged by deep creases on cheek and jaw, and the sharply convoluted ear with outsize lobe. Is it going too far to say that this is the very epitome of a shrewd but pious cleric?

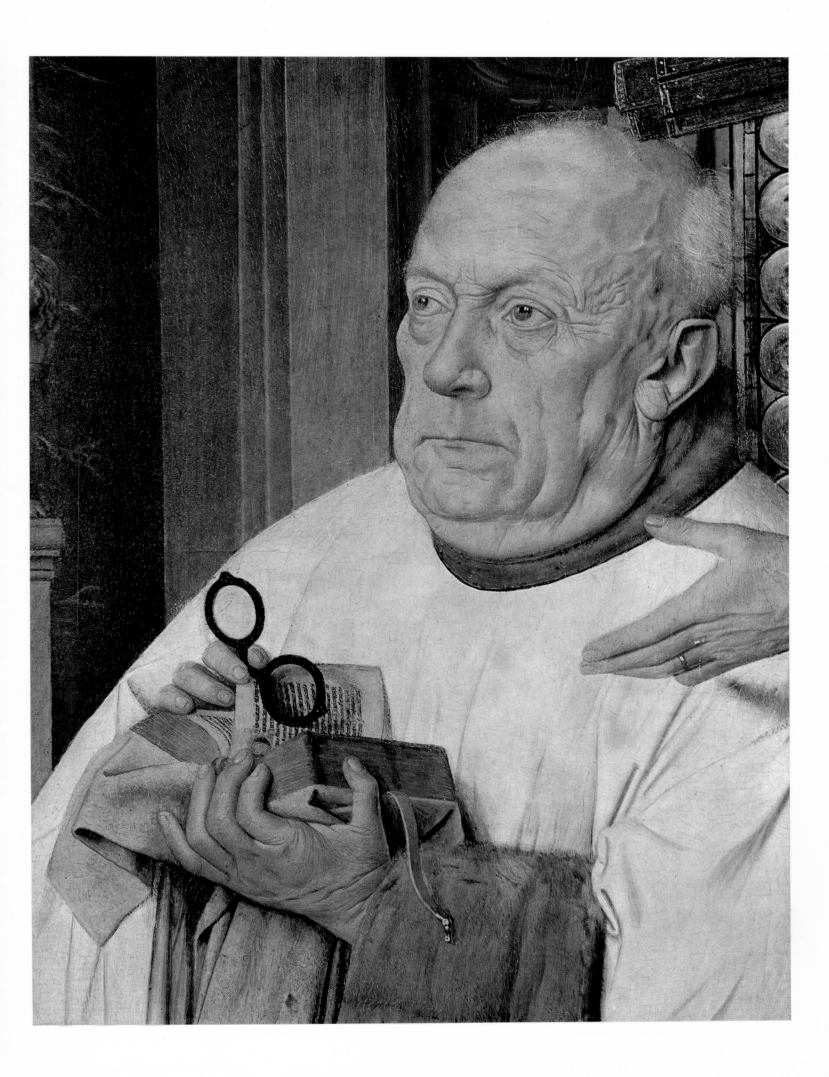

13 Jan van Eyck

The Lucca Madonna

25 3/4 × 19 1/2″ (65.5 × 49.5 cm.)
Städelsches Kunstinstitut, Frankfurt am Main

Perhaps no theme illustrates so palpably the difference in art north and south of the Alps as that of the Madonna. At Siena (with Duccio) and Florence (with Cimabue) its hieratic and elegiac aspects are closely linked: there is a premonition of grief and tragedy. In the north, one instead finds an acceptance of the world, at once optimistic and realistic, coupled with an intimate familiarity. Campin blazed the trail with his *The Virgin and Child Before a Fire Screen* (colorplate 6) and was followed with a certain caution by Jan van Eyck. Eight full-length pictures of the Virgin and Child by the latter are still extant: *The Madonna in a Church*, *The Ince Hall Madonna* (1433), *The Madonna of Canon van der Paele* (1436), *The Madonna Enthroned* in the small Dresden *Triptych of the Virgin* (1437), and *The Lucca Madonna* executed about the same time. These were followed by *The Madonna at the Fountain* (1439), *The Madonna with Saint Barbara and Saint Elizabeth of Hungary*, and *The Virgin and Child with Nicholaes van Maelbeke*; the last two were left unfinished. In each case the painter found a new way of rendering the relationship between mother and child.

The dominant feature of the Frankfurt picture is the Virgin's mantle—its ill-defined but fascinating color ranges from rust red to brandy—solidly anchored in the composition by its triangular form. The *Maria lactans* motif, rarely met with in Italy, was one of Campin's innovations. Here Van Eyck has adopted it for the first time. The contrast between the Virgin Mary set frontally with her small, maidenly head slightly bent and the Infant Jesus viewed in profile is consistent with the taut arrangement on which the composition is based.

Compared with *The Ince Hall Madonna*, whose vermilion mantle

over the lapis-lazuli robe spreads out wide before the yellowish-green velvet brocade cloth of honor with its asymmetrical pattern, here all is stabilized: the throne on which the Virgin is seated and the canopy above it adorned with stylized white, red, and yellow flowers; the narrow chamber in which the throne is placed; the oriental rug that covers the platform on which it stands (the designs of the pattern recur in *The Madonna with Saint Barbara and Saint Elizabeth*, an argument in favor of a late dating). The taut construction is further stressed by the symmetrical arched openings in the walls to right and left (one glazed with bull's-eye panes, the other a niche holding neatly arranged objects), the two round windows higher up, and the repetition of the lions on the armrests of the throne and at the level of the Virgin's head. The same tautness is shared by *The Madonna of Canon van der Paele* and the Dresden *Triptych of the Virgin*. *The Ince Hall Madonna* (1433) in Melbourne is essentially different. There symmetry has not the slightest importance, either in the figure of the Virgin herself or in the single window.

Just as in the composition of *The Lucca Madonna*, nothing is left to chance, so each apparently insignificant detail of the decoration has its own symbolic meaning. The lions refer perhaps to the Throne of Solomon. The brightly colored, spherical fruits on the windowsill are as fresh and intact as Mary herself, the Eve of the regained paradise. The candlestick, the water bottle, and the basin in the niche on the right symbolize her purity. Light passes through water without changing it, just as the Holy Spirit passed through the Virgin. All this could already be seen, no less finely limned, in *The Annunciation* in the *Ghent Altarpiece*.

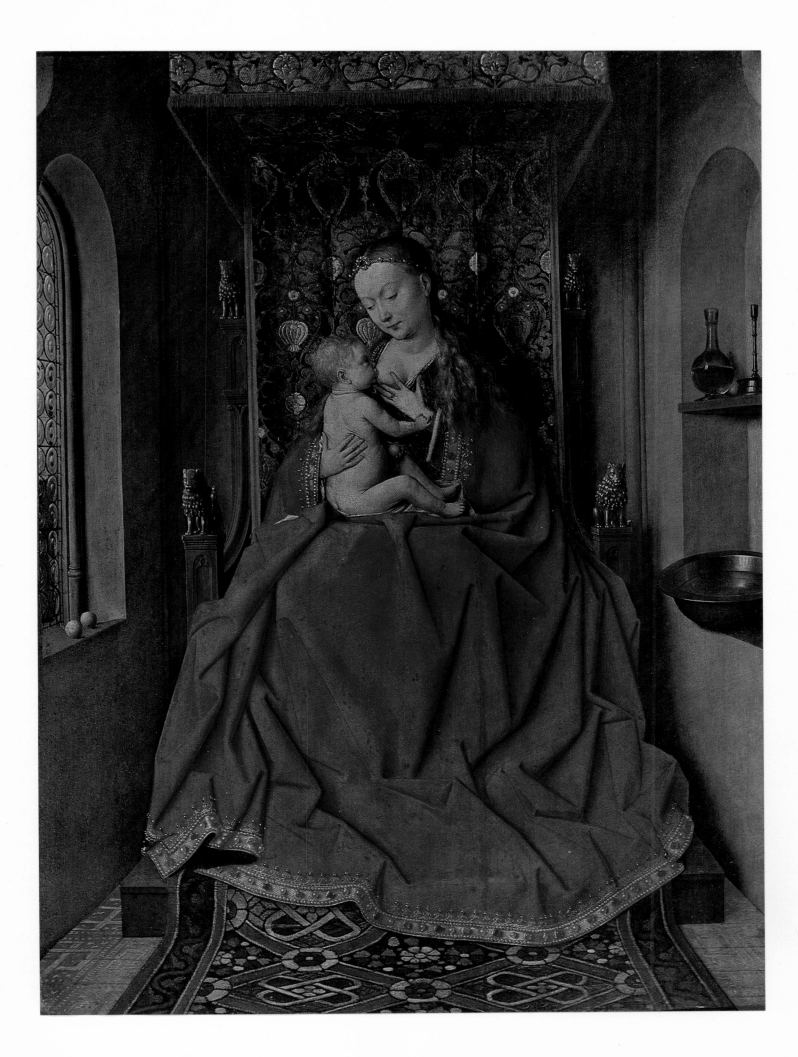

14 Petrus Christus
(c. 1410–1472/73)

Portrait of a Young Girl

11 × 8 1/4" (28 × 21 cm.)
State Museums, Berlin-Dahlem

It is quite normal for a young artist at the start of his career to follow an established master so closely that it is sometimes no easy matter to distinguish clearly between them. In the case of Petrus Christus the first phenomenon occurred but not the second. He did replicas, though in a greatly simplified form, of some of Jan van Eyck's works but there is no danger of making an erroneous attribution.

His portraits make one forget his great model, for as a portraitist Petrus had something new to say. Unlike Campin and Van Eyck, he never failed to specify the environment in which he placed his sitter and, as if aware of their importance as landmarks in his artistic development, he dated most of those works. This is true both of the *Portrait of a Carthusian* in the Metropolitan Museum of Art, New York (not quite twelve inches high), executed in 1446, and of the *Portrait of Sir Edward Grymeston* in the National Gallery, London, on loan from the Earl of Verulam, which dates from the same year. In the latter, three ceiling beams show how the room stretches back into the distance, which is further emphasized by the bull's-eye window in the side wall and the dado with the coat of arms in the background. In *Saint Eloy* of 1449 there is not only a parapet but an entire wall

display, while a glazed window marks the extension of the room in depth.

In *Portrait of a Young Girl* in Berlin, the only known female likeness by Petrus Christus, he thought he could make do simply with a dado. Whereas in the portrait of his wife in Bruges (1439) Jan van Eyck reverted to painting in the flat, Petrus spared no effort to give his female figure plastic volume. The few years that had elapsed since Van Eyck painted his wife were enough to bring about a total change in fashion. Instead of an ample pleated kerchief, the sitter wears a plain black velvet headdress edged with narrow gold braid and secured under her chin by a sort of Burgundian scarf. A small black loop protrudes over her high forehead. It is the brow of a very aristocratic young lady, whose small dark eyes gaze quizzically, even peevishly, at the beholder. Her complexion and barely hinted lips are pale. Her slender little frame is clothed in an ermine-trimmed gown, that ranges in color from light blue to steel gray over a black front, to which is pinned her gauze kerchief. No more fitting ornament could have been found for her than the finely wrought triple necklace.

74

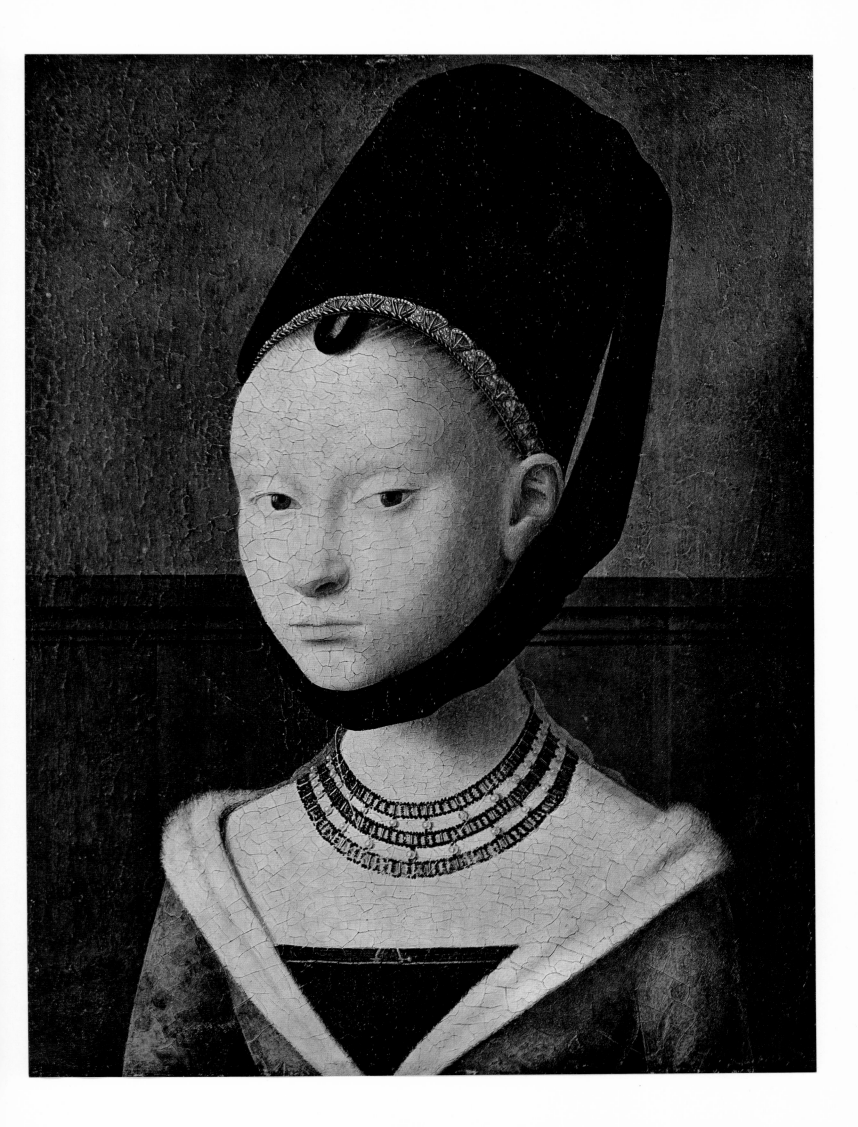

15 Rogier van der Weyden
(1399/1400–1464)

The Deposition

Detail: The Head of the Virgin Mary
The Prado, Madrid
Reproduced in full in figure 23

No attentive visitor to the Prado in Madrid can ever forget Rogier van der Weyden's *Deposition*—not simply for its large size, but for its ingenious composition and deeply moving subject. It was painted only a few years after Rogier had left Campin's workshop as a free master. One wonders whether their relationship was that of master and apprentice, or a working partnership due to peculiar circumstances. In this splendid work Rogier surpassed his senior at least where the conception of the event is concerned, as far as one can judge from the small copy of Campin's *Deposition* preserved in Liverpool (fig. 9). This opinion refers, of course, merely to the composition and not to the details, which are not only very similar but also of equal quality in both. But whereas Campin still lacked a grand, ordered vision, Rogier succeeded in achieving a convincing and—to employ the word for once—classical solution. We must not forget that the work was an altarpiece designed to display before the eyes of the faithful one of the most distressing scenes of the Passion. But an altar is also a part of the architecture, whose strict laws the painter must obey, though perhaps unconsciously, if he is not to involve himself in contradiction.

Consequently, if Rogier kept to a relief-like treatment and maintained the gold ground—here not really abstract but rather motivated—that, far from being a fault, was an instinctively clever expedient. To outclass Campin and invent something that was not only new but also more suitable required both creative power and an independent mind.

Lodging the cross in the raised portion of the panel was no less clever than was his unconcern over the fact that the beam was far too short to serve its terrible purpose. The result was to make the Madonna's mantle (a detail borrowed from Campin) spread unnaturally far toward the rear and at the same time swell as it unfolds on, or rather over, the ground. It was also clever to set up the ladder behind the cross and place the youthful assistant clad in bluish-white upon it. This made it possible to show clearly Christ's twisted body on its sheet supported under the armpits by Joseph of Arimathea (in brilliant red hose and tunic), while Nicodemus holds the legs. The right arm hangs limply vertical, the body lies in the diagonal of the picture, while the left arm (though bent) and the legs are almost horizontal.

There was plenty of room for the rhythmic grouping of the Marys and, if what one admires at first glance is the composition, it is they who appeal to our feelings and sensibilities. The Virgin, dressed in blue, has sunk to the ground in a swoon. Her countenance is one of the most sublime achievements in the whole history of art: it is impossible to look upon it without being deeply moved. Here, too, it was Rogier's instinctive observance of the laws of painting that caused him to set the deathly pale face with closed eyes full front in the picture plane while keeping the arms close to the right angle of the picture frame. The similarity of posture of John in red to the mourner behind him, on the one hand, and of Nicodemus, who faces the spectator full front in magnificent gold brocade, to the woman in green who attempts to help the Virgin, on the other, are important elements in the composition; no less important is the Magdalene at the right-hand edge of the picture, whose posture is the complement of John's and whose sleeves echo Joseph of Arimathea's brilliant red clothing. For her close-fitting gown the painter has chosen a beige tint and for her mantle, which is slipping to the ground, a pale violet. Evading the temptation of greater naturalism, Rogier has consistently conformed to the law of planar representation. The Magdalene's right arm is bent almost at right angles; her heartrending, tearful face is viewed in exact profile. The man holding a pot of ointment, visible behind Nicodemus, serves to loosen up the group and prevent it from seeming stiff or stilted.

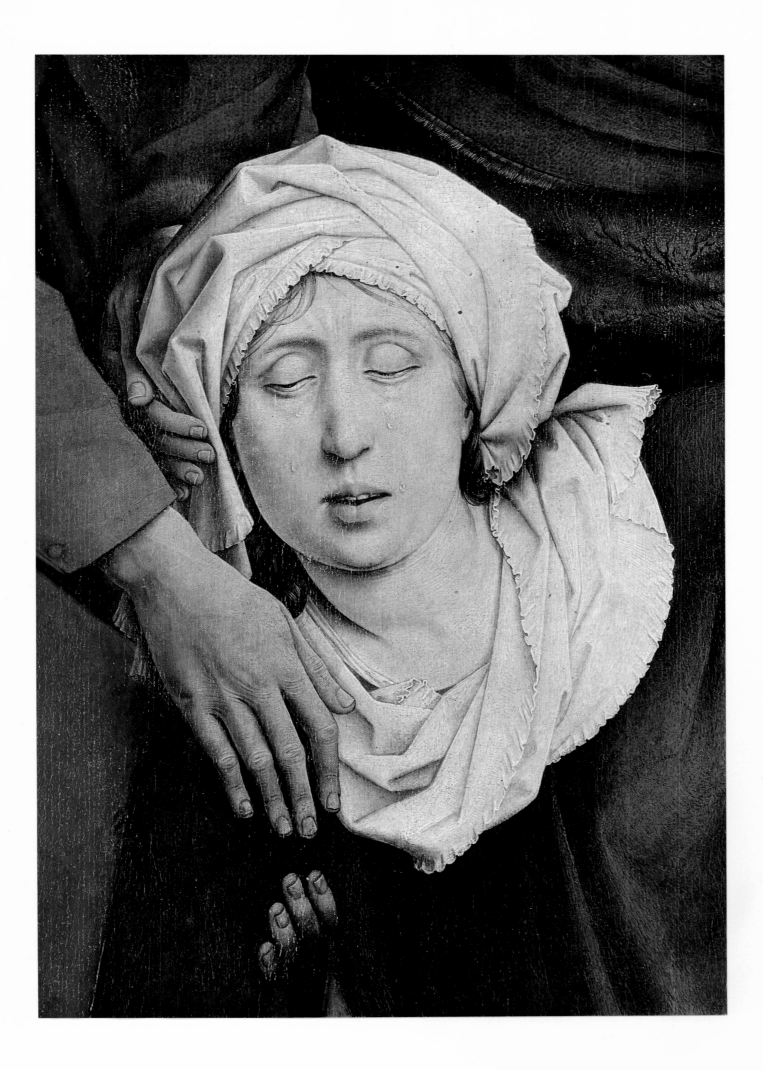

16 Rogier van der Weyden

Braque Altarpiece

Right wing: Mary Magdalene
16 1/8 × 13 1/2'' (34 × 27 cm.)
The Louvre, Paris
Reproduced in full in figure 26

The triptych in the Louvre known as the *Braque Altarpiece* can be dated with some certainty. On the back of the wings are the coats of arms of Jean Braque and his wife Catherine de Brabant. Since the donor died in 1452 when his wife was only nineteen years old, little time can have elapsed between their marriage and the year of his death. The painting must have been executed after Rogier's trip to Italy. Pictures with rows of half-length figures, mostly in the shape of polyptychs framed by arcades, had been produced there since the thirteenth century (as exemplified by Guido da Siena's five-part reredos in the Pinacoteca Nazionale, Siena), but not in the Low Countries. The combination of a triad with wings was a novelty, but where Rogier showed his independence was in the scenery. To extend a uniform but differentiated landscape, flat, grayish green, dotted with hills, through all five compartments was quite unheard-of. The master succeeded in avoiding the danger of losing credibility by heightening realism to an unusual pitch. Thus he created a unity of such extremely impressive ideality that no observer would dare to ask whether or not it was possible for five holy persons to appear in front of a typically Flemish landscape complete with streams, hills, and sea.

The types of Christ, the Virgin Mary, and John the Baptist differ little from those in the Beaune *Last Judgment* (fig. 27). But we must not overlook the fact that in those days it was quite customary for artists to execute replicas of their own works; and the Beaune altar-

piece is known to have been copied by others too. There is evidence that Schongauer and Dürer admired the figure of Christ in that picture, and they were not alone in doing so.

The figures in the middle form a triad of which Christ (in gray black) alone is depicted full front and clearly forms the center; they maintain a certain distance from John the Baptist and Mary Magdalene on the wings. Christ's gesture of benediction differs from the Evangelist's on His left, which is that of a witness taking an oath. The Virgin (in dark blue) places her hands together; the Baptist holds a book in one hand and points to Our Lord with the other; and the Magdalene, by way of contrast, holds the ointment pot. Thus all risk of monotony is avoided in "delicately felt harmony."

Though each figure forms part of the whole, each may be removed from its context and examined separately, as the Magdalene reproduced here, who wears what was then a very modern headdress—a flat drum with a veil looped under her chin. Her features are so unstereotyped that we may presume that she was painted after a portrait drawing from life; but it is hard to say whether or not it is the one preserved in the British Museum. Rogier and his contemporaries knew the secret of dressing a society lady fashionably and expensively—here, in a dove-gray laced bodice (which reveals every detail of her figure) with scarlet, gold, and green velvet sleeves and a cloak in lapis-lazuli blue—and yet make her look every inch a saint.

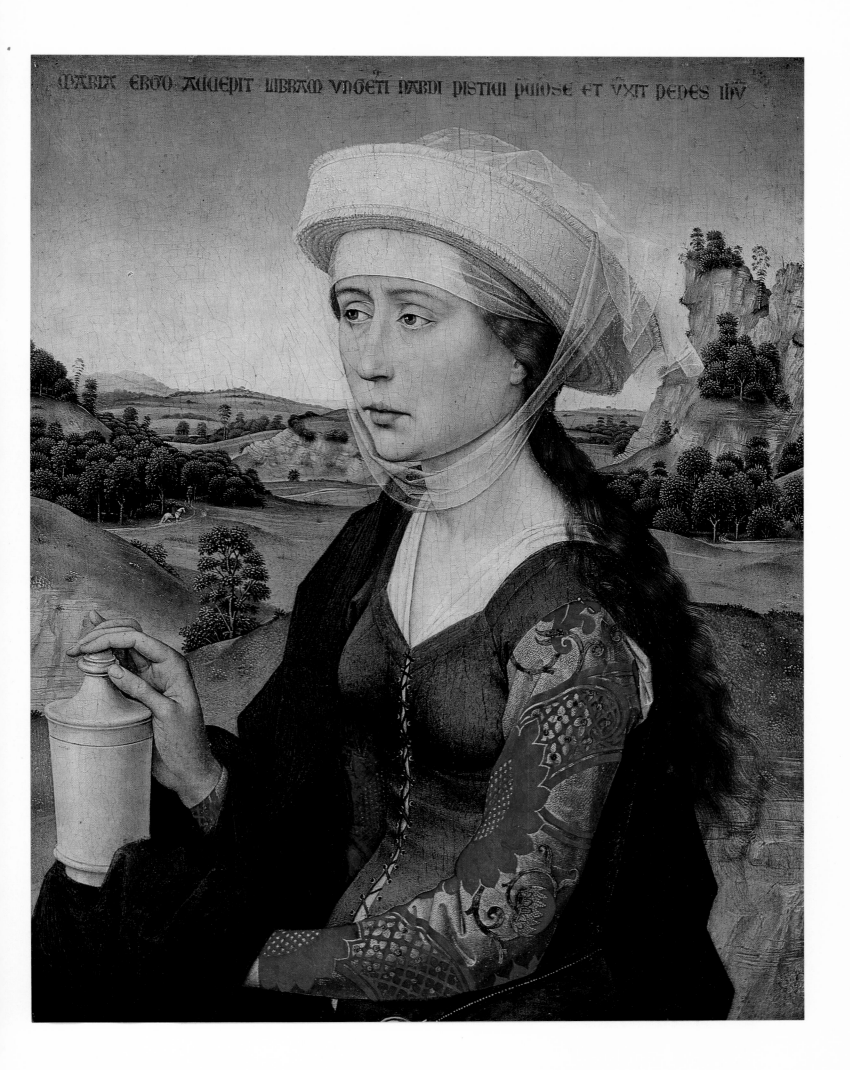

MARIA ERGO ACCEPIT LIBRAM VNGETI NARDI PISTICI PCIOSE ET VXIT PEDES IHV

17 Rogier van der Weyden

Bladelin Altarpiece

Center panel: The Nativity
35 7/8 × 35" (91 × 89 cm.)
State Museums, Berlin-Dahlem

The Berlin *Nativity* is one of Rogier van der Weyden's finest works and attains a high degree of perfection. The individual significance of the few figures in the center panel is heightened by the closely packed figures on the wings. The column that supports the stable roof—even Hugo van der Goes could not do without it in his *Portinari Altarpiece*—stabilizes the tripartite composition and creates a well-defined area that is limited at the back by a Romanesque double window. The white-robed Virgin Mary is the focal point of the picture. Attended by three little angels behind whom are the ox and the ass, she kneels in adoration before the Infant Jesus, who lies with His head framed by a radiating halo on the ground. The blue mantle she has taken off spreads in billowing folds around her. On the left Joseph, in red, holds a lighted candle, for it is of course nighttime. The donor, elegantly dressed in black, is treated as an equal of the holy persons. He wears a serious, circumspect expression as he kneels over a cellar venthole that symbolizes the spot in Bethlehem where a chapel was erected centuries after the event. Gert von der Osten sees it as one of the mouths of hell.

The noble donor, Peter Bladelin, was treasurer to Duke Philip the Good of Burgundy, and one of the richest men of his day. He and his wife, Margarete von Vagewiere, had the idea of founding a new town northeast of Bruges complete with church and castle. That initiative denotes a farsighted attitude which amounts almost to a social conscience and must have seemed incredibly modern at the time. Rogier's altarpiece was commissioned for the church of the new town—it was called Middelburg—which he depicted as a backdrop in this center panel, though (as in the later *Columba Altarpiece*, fig. 29) the painted townscape can hardly have borne more than a vague resemblance to

reality. It must have taken about ten years to build and the altarpiece was executed in the 1450s. Middelburg, which grew to be the capital of the island of Walcheren, was razed to the ground in World War II.

The scenes painted on the wings stress the universal importance of the event represented on the center panel and its acceptance by the great ones of this world in east and west alike. *The Vision of the Emperor Augustus,* on the left wing, is set in a bedroom with canopied bed. The kneeling Emperor holds his crown in one hand and swings a thurible with the other; he is attended by a trio of dignitaries who are confined to the right-hand edge of the picture. The Tiburtine Sibyl calls his attention to the Virgin Mary who, seated on an altarlike throne in the sky, offers her Infant Son for his admiration. The two double-headed eagles in the upper panes of the window evoke the association with the Holy Roman Empire of the German nation.

The right wing shows the three Magi on their knees dressed in sumptuous apparel. Their hands are raised in gestures of astonishment, reverence, or prayer. The Infant Christ appears to them framed by a glory in the star of Bethlehem—minute but sculptural, and not really far away. The three kings are not actually looking at the Child; to render that would have required a distinction between what is near and what is far off, which artists of that age (luckily) were as yet incapable of drawing. The landscape with the closeup hillock that merges charmingly with the plain offers a distant view of a town with turreted walls and a castle. Like the background on the left wing, it stands on its own and has no connection with that of the center panel.

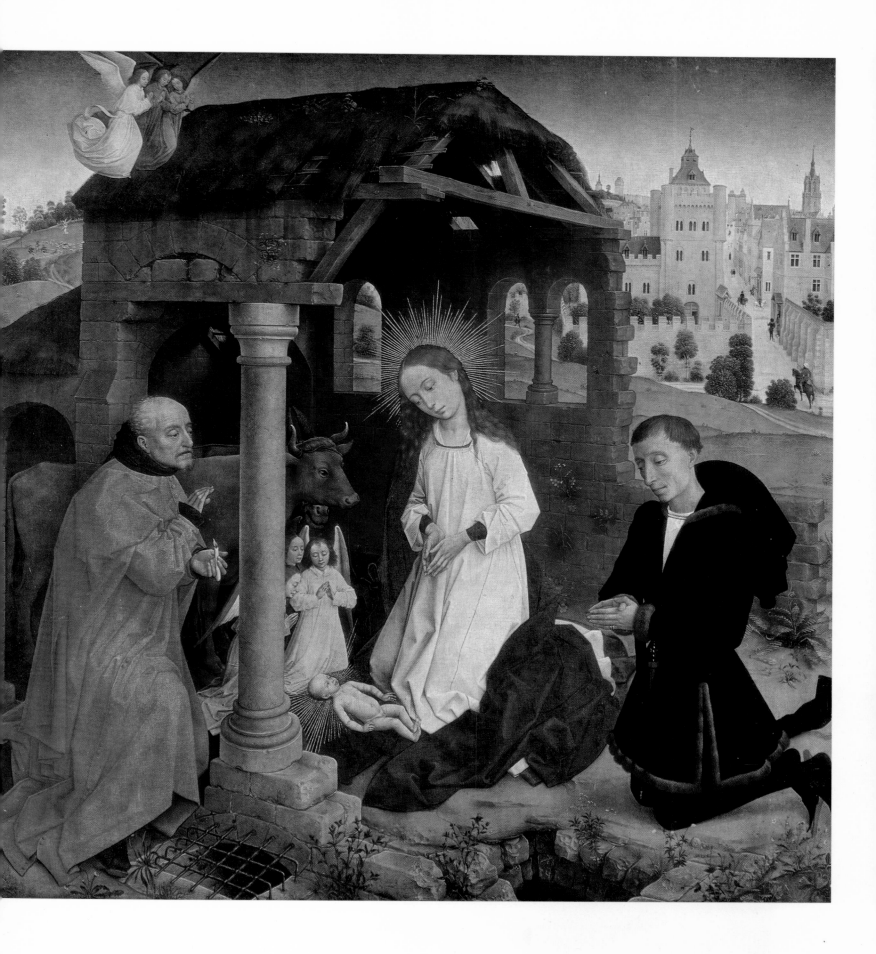

18 Rogier van der Weyden

Philippe de Croy

19 1/4 × 11 3/4" (49 × 30 cm.)
Koninklijk Museum voor Schone Kunsten, Antwerp

The half-length figure of the Madonna was a favorite theme with painters in Italy even before the dawn of the Gothic period. In the Low Countries, on the other hand, it was introduced relatively late, but became a very popular motif frequently combined with the portrait of the donor in a diptych or small folding altar. If we except Campin's little roundel, which has only come down to us in copies, Rogier van der Weyden was the first artist among whose works it is attested. In his picture of *Saint Luke Painting the Virgin*, the original of which is probably no longer extant, she was represented in full length, but the detail of the mother nursing the Child was the subject of several replicas. The later variants, too, were frequently copied or modified and it is sometimes no easy matter to recognize them for what they are and distinguish them from genuine originals. I am convinced that, though many a painter came very close to Rogier, of the numerous derivatives only two diptychs with the Madonna deserve to be considered authentic. They are:

> *Madonna* in Caen (fig. 24) and its companion piece, *Laurent Froimont,* in Brussels (fig. 25),
> *Madonna and Child* in the Henry E. Huntington Library and Art Gallery, San Marino, California, and *Philippe de Croy* in Antwerp.

Both these double portraits date from late in the artist's life, but *Laurent Froimont* seems earlier than *Philippe de Croy*. In the Caen *Madonna*, the youthful Virgin faces the spectator holding the Child (who makes a playful gesture of benediction) in the crook of her right arm and joins her hands in prayer. In the San Marino picture the Virgin's posture is more complicated. Her right hand supports the Child, who stands almost erect on a brocade-covered parapet playing with the golden clasp of the prayerbook—presumably a book of hours *(livre d'heures)*—which she holds in her refined, slender left hand. The intricate pattern of arms and hands, rather confusing at first glance, indicates an end stage of Rogier's artistic development. In spite of the gold ground, this must be a late work. It is significant that the Virgin is no longer depicted in the act of nursing her Child. Her features, more delicate and elegant than in the Caen picture, put her in the uppermost class of society. Her head is bent in a rather melancholy attitude, which is stressed by the blue mantle drawn over it. The donor, Philippe de Croy, Seigneur de Sempy (later de Quiévrain and Governor of Hainaut), was one of the most cultivated noblemen at the court of Philip the Good and Charles the Bold. His device, the monogram "lp," has not yet been explained. This portrait of him is one of the finest of all produced during that period.

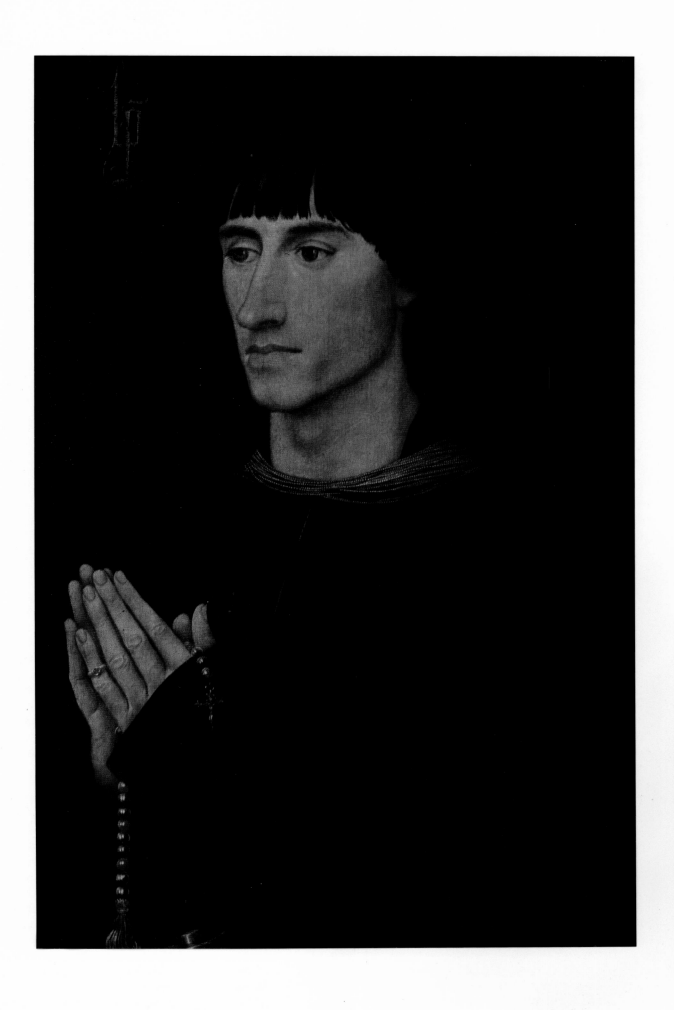

19 Rogier van der Weyden

Columba Altarpiece

Right wing: The Presentation in the Temple
54 3/8 × 27 5/8'' (138 × 70 cm.)
Alte Pinakothek, Munich
Reproduced in full in figure 29

The magnificently preserved *Columba Altarpiece* is the crowning glory of Rogier van der Weyden's career as a painter. It was acquired by King Ludwig I in Munich together with the other treasures of the Boisserée Collection. Originally it was set up in the Church of Saint Columba in Cologne: in fact, the donor, presumably Goddert von dem Wasservass the Elder, burgomaster of Cologne, is portrayed kneeling humbly behind Joseph in the center panel. Goethe once sat for hours lost in admiration before this splendid work, which he thought had been painted by Jan van Eyck. True, some details—for instance, the bed with the red canopy in the Virgin's chamber, which the angel enters so silently—remind us of Jan; but there are others, such as the domed ceiling with its bracing beams, that evoke Campin.

Though, as a young man, Rogier could well have prided himself on his success in developing the composition of the Prado *Deposition* in a shallow plane, what he aimed at now was to convey an impression of depth. In the center panel this is obtained by the perspective foreshortening of the arches that support the thatched roof of the ruined stable and offer a view of a townscape (the same Middelburg as in the *Bladelin Altarpiece*) in the distance. On the wings the same effect is produced by the vanishing lines of the inner side walls of the Romanesque hall and the Virgin's chamber.

In the center panel the vanishing point, like the Virgin herself, is shifted slightly to the left in order to make room for the three Magi. One of them is already on his knees; the second is about to kneel in homage; the third, wearing red-and-gold brocade, stands opposite Joseph—together they may be said to frame the central group—and has doffed his hat in a gesture of salutation. But all the figures are situated in the same plane, which also comprises the chief actors in *The Annunciation* and *The Presentation in the Temple* on the wings. To demonstrate how consistently the laws of planar representation are observed here, the page entering from behind with a cup for the third king is not allowed to break into that plane.

It is hard to say which part of the altarpiece deserves pride of place. The artist's contemporaries were most deeply impressed by *The Annunciation*, but the gesture of the kneeling king who presses the Child's little hand to his lips was also imitated again and again. And admirers have never ceased to wonder at the incomparable, thrice-repeated lapis-lazuli blue of the Virgin's mantle, which draws the eye like a magnet. It forms a vivid contrast with the richly orchestrated range of reds—bright vermilion and crimson juxtaposed in robes and canopy—which are put in the shade by the splash of the bright yellow, shot with red, made by the kneeling king's sleeve.

Never before had a Flemish painter produced so loftily ideal a figure as the Virgin Mary in *The Presentation in the Temple*. It must have been due to impressions received in Italy that Rogier was able to strike so high a note. Properly speaking, what we have here is a statuesque heroine, performing the ceremony of consecration of the Child. Something must have happened to her since *The Annunciation,* when she turned toward the angel with a timid, girlish gesture. Now she seems resolved to accept a sublime destiny. Goethe already felt this, for he said: "Mary appears here already almost as a matron who with lofty gravity senses in advance what fate has in store for her Child." She has drawn her mantle over her head so that it falls in long, simple folds. Even in apparent stature she dominates Simeon. As if to emphasize still further that she is a tower of strength, her attendants draw close to her—Joseph in red cloak with black hood holding the candle and the girl in light green with the doves in their little basket. The three figures form a group of almost blocklike compactness, to which the figures of Simeon (in brocade robe, bluish-gray cloak, and bright-red cowl), the prophetess Hannah, and two onlookers, seem to be joining in haste and quite by chance.

The scene is set in the front part of a dark hall that opens onto a brightly lit polygonal structure with Romanesque ambulatory and triforium. The outside of this building, already embellished with details in the Gothic style, projects onto the center panel. There is nothing to criticize in the fact that figures and architecture are not yet represented in their natural proportions. It merely proves that we are still in the Gothic period, for which a premature development would have been fatal.

20/21 Dieric Bouts
(c. 1415–1475)

Altarpiece of the Sacrament

Two wings: The Gathering of the Manna
The Passover Feast
34 5/8 × 28″ (88 × 71 cm.) each
Saint-Pierre, Louvain
Reproduced in full in figure 30. See also frontispiece

The *Altarpiece of the Sacrament* at Louvain (fig. 30) is Dieric Bouts's most important work. How carefully he prepared it is proved by the fact that, under the terms of the contract of 1464, he was in duty bound to follow the program of two professors of theology of Louvain University, Johannes Vaerenackers and Aegidius Bailluwels, when elaborating the themes of the various scenes.

Those depicted on the wings refer to Christ's feeding of the Apostles by analogy with the Old Testament parallels illustrated in the *Biblia Pauperum*. Definitive agreement on how the wings should be arranged has not yet been reached, and the order in which the scenes are placed at present at Louvain is not the same as it was after World War I. There are many arguments in favor of the former scheme, which was accepted by Schoene and Panofsky among others. One is the crowding of the figures toward the left (i.e., toward the middle picture in the old arrangement) in *Abraham and Melchizedek* (fig. 30, top left) and *The Gathering of the Manna*. Another is the

fact that in *The Passover Feast* the open door on the left draws the eye of the viewer in that direction, which would indicate that its former position at the bottom right was probably correct.

Though conceived three-dimensionally, *The Last Supper* avoids all the really effective vanishing lines of realistic perspective. Ernst Heidrich still considered the medieval displacement of the foreshortened form in the picture plane the most cogent reminder of the bounds that limited Flemish painting. There could have been no worse misunderstanding of Dieric Bouts. He thought in terms of flat planes and many of his compositions may be reduced to simple geometric figures. Maximum importance is given to the horizontal lines of the picture, a typically Dutch trait, as well as to the verticals and diagonals. The top view of the table is merely a consequence of a design intimately linked with planar thinking.

What the painter has depicted in the central scene (fig. 30) is not the moment when Christ announced His betrayal but the consecration of

the bread and wine, namely the institution of the Eucharist. So we are left in doubt as to whether He had any idea that He was going to be betrayed. Something like a quiver of astonishment passes through the twelve Apostles, Judas still among them, but it does not necessarily spring from the enormity of the betrayal. The two men visible through the hatch in the back wall are Zachaeus and Tubal—others say Urion and Piragmon—who received the Lord in their house and offered Him hospitality. They are quite unmoved, as is the man-servant in the bright-red cap who stands by the sideboard with his thumbs stuck in his belt (frontispiece). Through the Gothic windows we can see a street on the left and a well-tended garden to the right; the chink in the door affords a glimpse of a handsome red bench covered with red cushions.

Bouts's space is unreal, and thus the armor-clad Abraham does not actually kneel before Melchizedek. Similarly, the gathering of the

manna has a merely formal significance: the people who kneel in their gorgeous apparel know that a higher power has come to their as-sistance. The woman on the left does not even have to bend down; she carries a little basket in one hand and holds a child with the other. Those on their knees do not represent human beings in physical distress but the splendor and majesty of their God. "Their food and drink," one might say, "are not of this earth."

The same is true of *The Last Supper* and *The Passover Feast*. Those who are partaking of the latter eat tiny rolls and lettuce leaves. The narrow, shutterless window on the left is handled in a rather vague painterly fashion—bluish, pinkish, and diaphanous. In *Elijah in the Desert* (fig. 30, bottom right), is the angel part of the prophet's dream? Only in a dream is there such silence, such absence of space and time; and, as in a dream, Elijah sees himself in two places at once.

22 Dieric Bouts

The Justice of Emperor Otto III: Ordeal of the Countess

Detail of the Emperor's brocade robe
Musées Royaux des Beaux-Arts, Brussels
See also figure 32

It was to the praiseworthy custom of reminding rulers of their duty to be just by representing suitable historical events in the rooms of public buildings that Dieric Bouts owed the commission to paint four large panels for that Late Gothic jewel, Louvain Town Hall, which had only recently been completed. When he died in 1475, only one, *Ordeal of the Countess* (fig. 32), was quite finished. Hugo van der Goes was asked to give an opinion on the second, *Execution of the Count* (fig. 32). Legend has it that Otto III's empress fell madly in love with a certain count and denounced him when he rejected her. The count was beheaded. Too late he was vindicated by the ordeal undergone by his wife.

In one picture we see the emperor listening to his wife's false denunciation in the grounds of the castle, and the count led to the place of execution dressed in a hair shirt and accompanied by the countess. In the foreground the countess on her knees receives her husband's head from the executioner. In the other picture, which was evidently painted first, the countess kneels before the throne on which is seated the emperor, clad in red-and-gold brocade. She holds her husband's head in the crook of her right arm, while in her left hand she grasps the red-hot iron bar without batting an eyelid. In the distance (on a minute scale) we can see the false accuser being burned at the stake. In both panels there are bystanders, some of them dandies wearing the short, mink-trimmed doublet in velvet or brocade, and the tight-fitting hose that were the fashion at the time; they were very likely men well known in the town.

Owing to their large size, one could not expect to find in these panels the finish one admires in the *Altarpiece of the Sacrament* (fig. 30; colorplates 20, 21). Nonetheless, they too show us Bouts as a story-teller and master of composition who knew how to bring out the essentials of his theme. However lamentable the event may be, the behavior of all concerned is noble and controlled; even the gruesome procedures are accomplished in an atmosphere of calm and quiet that imposes dignity and discipline on all those, high and low, who take part in them. The face of the countess undergoing her ordeal has an incomparable purity.

These works are major examples of the stylizing impact of the vertical architecture that was taken for granted in the chamber of the town hall where they were hung. Vertical lines predominate decisively over horizontal, though the latter are not entirely suppressed. The gradually diminishing size of the figures in the foreground, the middle distance, and the background permits the eye to roam around in a space that is further opened up by the presence of diagonal elements. This procedure was soon after incorporated in a scientific system by the French perspectivist Jean Pélerin. Even the flamboyant Gothic frames—the upper part is repeated on a smaller scale at the far end of the throne room in *Ordeal of the Countess*—and the multicolored tiles of the floor help to give the same impression.

A few years ago the two panels were very successfully restored by Paul Philippot and today shine with all the splendor they possessed when they were first painted. That occasion also provided the opportunity to determine exactly the part played by Dieric Bouts himself. It confirmed the assumption that *Ordeal of the Countess* is by the master's own hand, whereas *Execution of the Count* was not quite finished—the upper half rather more, the lower half rather less—when he died. In all probability, what happened was that Bouts did the preliminary drawing on the panel, for it was certainly based on a sketch by his own hand, and the workshop took over the execution of the painting except for a few areas, such as, perhaps, the upper part of the Franciscan friar, that were painted by the master himself. It was not until early in the seventeenth century that the last touches were added by a rather heavy hand; the disfigurements thus perpetrated were removed only quite recently.

23 Hugo van der Goes
(c. 1440–1482)

The Adoration of the Magi
(Monforte Altarpiece)

Detail: The Moorish King
State Museums, Berlin-Dahlem
See also figure 34

If Hugo van der Goes saw Rogier van der Weyden's *Columba Altarpiece* (fig. 29) when still a young man, he cannot have failed to note a certain pedantry and a rather diffuse abstraction, which he probably ascribed to the master's advanced age. Be that as it may, when Hugo tackled the same theme he introduced something entirely new. First of all he avoided all trace of symmetry in the center panel (fig. 34). In his view what was essential was to make the scene an expression of real life. The Virgin Mary sits, as if by chance, slightly off-center before the ruined wall that stretches back into the distance. All there is to set her off is the vertical molding of the pilaster and the little angel hovering above her head, who was sacrificed in part when four or five inches were lopped off the panel. The Infant Jesus, far from offering Himself for worship, turns away from the kneeling king so that His mother has to hold Him by the arm: perhaps He is frightened of the king's big hands. The latter, clad in a brocade robe covered by a bright-red surcoat, is a vigorous, virile figure. In comparison, Joseph in light reddish violet with dark hood, who has doffed his cap and hardly dares even to glance at the splendid gifts that undoubtedly delight him, makes a feeble impression.

The second king, in dark, mink-trimmed robe and fiery red cap topped by a golden crown, plays a fundamental part in heightening the effect of depth. His right foot rests on the rising floor on which the scene is set. With his left hand he receives from a page the precious cup that is his gift to the Infant Christ; his right hand lies on his heart in a gesture of reverence. But what really gives the impression of distance is the hilly landscape with shepherds tending their flocks. We view it above a breast-high parapet behind which stand two youths (perhaps apprentices) and two bearded men. One of the latter is presumed, not without reason, to be a self-portrait of the artist.

The task of the third, Moorish, king is to give the picture balance. His majestic figure might very well have stepped out of an Italian quattrocento fresco. The solemn gravity of his stance, the noble carelessness with which he plucks up his moss-green surcoat at his thigh, the grand manner with which he wears his splendid gold-brocade robe, the apparent independence of the left leg from the rest of his body—in the Low Countries nothing of the sort had ever been seen before. Nor had the motif of the two secretive heads we can glimpse over his shoulder been previously employed, not even in the works of Dieric Bouts, which lack the spatial tension typical of Italy.

The bright cobalt blue of the Virgin's mantle is repeated in the irises on the left-hand edge of the picture, in the narrow strip visible of the Moorish king's undergarment, and in the cap worn by the man behind him.

The wings with *The Nativity* and *The Circumcision* preserved in Antwerp are copies by the Master of Frankfurt.

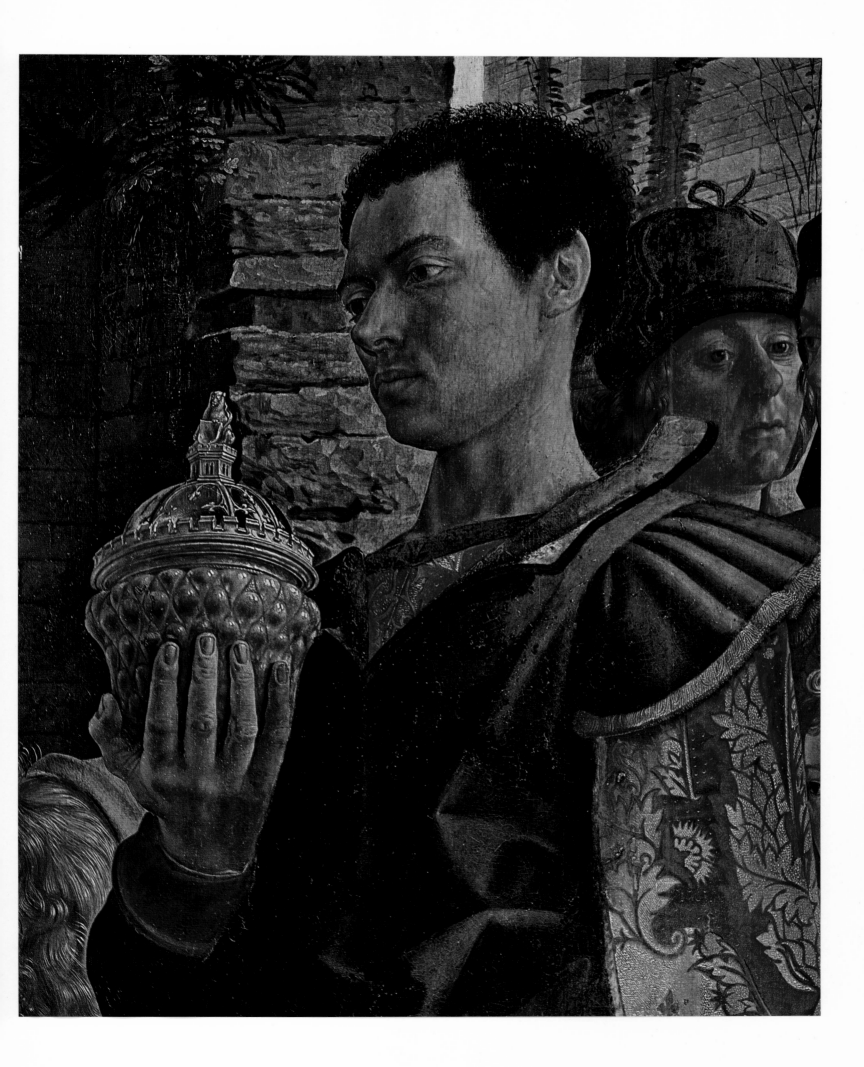

24/25 Hugo van der Goes

The Adoration of the Shepherds
(Portinari Altarpiece)

Right wing
Detail of center panel
Uffizi Gallery, Florence
Reproduced in full in figure 35

The *Portinari Altarpiece* set Hugo van der Goes a difficult task, not only because of its unusually large size, but also because the Nativity and the Adoration of the Shepherds are themes that provide small opportunity for monumental treatment. For this reason the artist must have found the composition of the center panel a harder problem to solve than that of the wings, on each of which he had to make room for two gigantic figures of saints as well as for the donor or his wife and their children. Hugo took the kneeling figure of the Virgin Mary as the focal point of the picture, though she is placed slightly left of center. Instead of the stylized beauty that had formerly been typical of madonnas and saints, he gave her a well-defined individual character—what one might almost call portrait treatment. The Child lying naked on the ground before her is a very precise study of a newborn babe. He is surrounded by a group of angels who, together

with the major figures, form a rough triangle. This does not eliminate all risk of fragmentation, which the artist evaded by introducing the massive Romanesque column that backs up Joseph and gives the whole picture stability. The manger with the ox and the ass and the timber framework of the stable achieve an effect of perspective on either side. Like the second and third kings in the *Monforte Altarpiece* in Berlin, here the shepherds who hurried in when they heard the glad tidings introduce an element of disorder into the idyllic scene. They gaze at the miracle, from which they seem kept at a distance by an invisible barrier, with curiosity and shy reserve. The angels on the ground are dressed in white, pale blue, and brocades of shades of gold green, and red. Those that hover above the Virgin Mary (in deep blue) and Joseph (in full-bodied vermilion) wear light-colored brocade, whitish green and pale lilac. The shepherds form an earth-hued

contrast with a little red and green here and there. They have become famous for their realistic treatment and, it is true to say, such an assortment of types exists nowhere else.

The ceramic vase with white and blue irises and a bright red lily, and the glass with columbines in the foreground at the lower edge of the center panel have a symbolic significance. Van Mander was particularly struck by these flowers, as by the charming modesty of Hugo's female figures with their demure and lovely faces.

The wings are static factors in the overall composition. Saint Anthony in a dark monastic habit and Saint Thomas in red robe and green cloak call to mind the old men in Van Eyck's *Ghent Altarpiece* (fig. 18). On the right wing the towering figures of Saint Margaret in vermilion and Mary Magdalene in a cream-colored, gold-em-

broidered gown stand in front of an early spring landscape in which tall, still leafless trees serve the same purpose as Saint Thomas's lance on the opposite wing. The female saints with their high, rectangular foreheads display Hugo's unconventional ideal of beauty. The donor and his wife are dressed in elegant black; only the children are permitted a little more red and green. The artist also lavished the utmost care on the little scenes in the background. They represent the Virgin Mary and Joseph on the road to Bethlehem and the progress of the three Magi, who have sent a servant ahead to ask the way.

The Annunciation, painted in grisaille on the outside, is distinguished by the grandiose motion of the angel who sweeps in with raised hand and scepter. The Virgin's attitude is utterly convincing: she rests one hand humbly on her breast.

26 Hugo van der Goes

The Lamentation

13 3/8 × 9″ (33.8 × 23 cm.)
Kunsthistorisches Museum, Vienna

No painter seems to have identified himself so closely with the theme of the Lamentation of Christ as did Rogier van der Weyden. In contrast to Petrus Christus, who did not even imagine the possibility of a visible contact between mother and Son (fig. 22), Rogier felt that only by depicting her tenderly embracing the dead Christ could the subject be treated as it deserved. His most famous rendering of the theme is in the *Mary Altarpiece,* which is assumed to be the original, but there is also another version, known only from a copy in the Ittersum Collection, Amsterdam, which has provided the basis for further copies and derivatives. Rogier's invention was so masterful that even as great a painter as Dieric Bouts could find nothing really new to set against it. A version in The Hague (Mauritshuis), though extraordinarily close to the master, is not generally considered to be an authentic work of Rogier. It must, however, have made a decisive impression on Hugo van der Goes, even though the touching embrace is lacking there and the Virgin's hands are merely held together in front of her.

In the small Vienna picture reproduced here, the body of Christ, marked and exhausted by suffering, is very reminiscent of the work in The Hague. But whereas there the figure of Joseph of Arimathea, who supports the body under the armpits through a shroud, is much

in evidence, in Hugo's version greater stress is laid on the body itself. It is only gradually that one notices that here too Joseph is performing the same important task while Nicodemus, splendidly arrayed in blue velvet, shows his grief merely by placing his hand to his breast with a woebegone expression. In the Mauritshuis picture, instead, the painter could find nothing better for him to do than to press one hand to his head. Hugo was anxious to allot once again a more active role to the mother. She bends forward in order to get closer to her Son, so far forward indeed that John is obliged to hold her to prevent her losing her balance. Their movement is echoed by the second Mary, who, with streaming eyes, receives the nails from another woman. By piling his figures one above the other instead of placing them behind each other, Hugo gives the impression of reverting to the flatness of the Gothic style. The movement in the opposite direction is started by a male figure and dramatically stressed by the gesticulation of a fourth woman. The Magdalene kneeling in the lower left-hand corner might be a sister of the one in The Hague, but she too has been given a more personal attitude: clasping her hands in her lap, she stares mournfully into the void. This is far more expressive than the relatively conventional hand-on-heart gesture in the Mauritshuis painting.

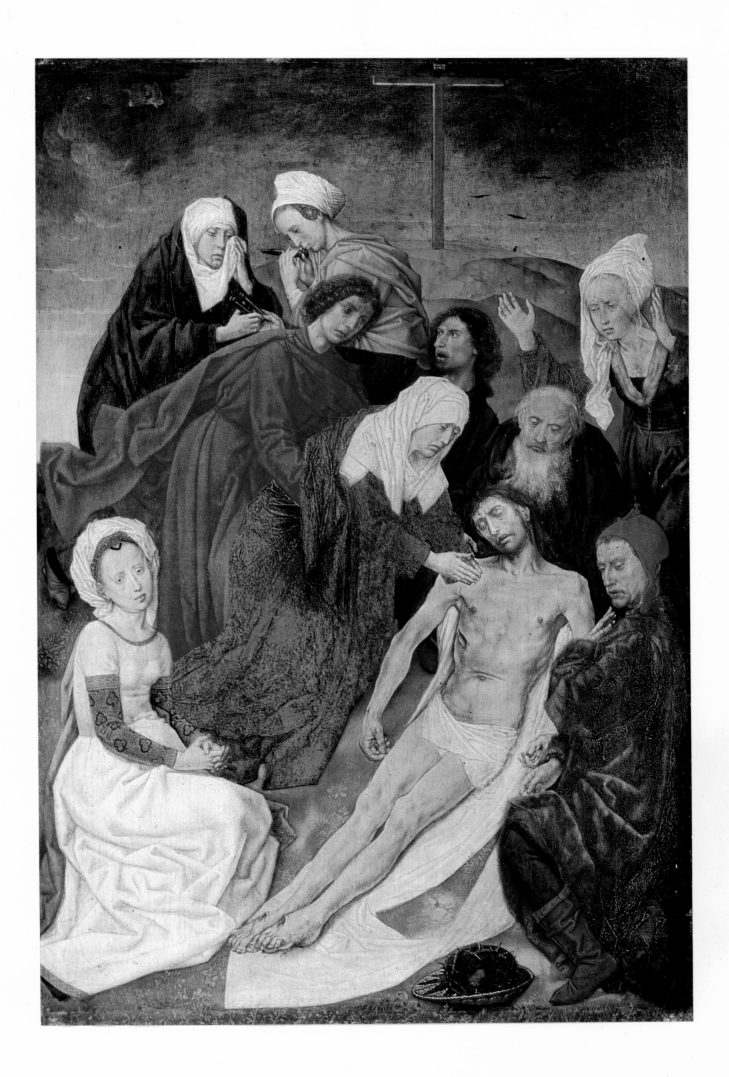

27 Hans Memling

(c. 1433–1494)

Saint John Altarpiece

Center panel
1479
67 3/4 × 67 3/4" (172 × 172 cm.)
Hôpital Saint-Jean, Bruges

It would be a mistake to see in Memling merely the obedient pupil of his master, Rogier van der Weyden. That was true only at the start. After a short time he succeeded in producing two works of considerable artistic importance: the little *Donne of Kidwelly Altarpiece,* formerly at Chatsworth and now in the National Gallery, London; and a decade later the large *Saint John Altarpiece* in the Hôpital Saint-Jean in Bruges, dated 1479. The second work is to the first as the blossom to the bud. The great advance was made possible by shifting the figures of the donors from the center panel to the outside of the wings and placing them in Gothic-canopied niches. On one side are two brothers of the hospital, on the other, two of the sisters, backed by their respective patron saints James the Great, Anthony, Agnes, and Clare.

In the center panel of the Bruges altarpiece the male saints (the two Johns) stand in front of marble columns, which may have been derived from Jan van Eyck's *The Madonna of Canon van der Paele* (fig. 19) and which are more numerous than in the earlier London work. The horizon of the landscape extends through the center panel and both the wings. The Virgin sits enthroned before a narrow brocade cloth of honor under a canopy whose vermilion front echoes in a brighter hue the red of her robe. The female saints are arrayed more splendidly. Saint Barbara is the less showy in green gown and brownish mantle; and the two Johns are simply attired. This allowed the painter to clothe Saint Catherine in red velvet, ermine, and magnificent gold brocade and to add a geometrically patterned oriental rug without running the risk of excessive richness.

As in the earlier London picture, the spectator's attention is attracted by two different actions. On the one hand, the Infant Jesus, accompanied on a portative organ by a little angel, puts the ring on Saint Catherine's finger. On the other, the Virgin turns the pages of a prayerbook held by a kneeling angel. The composition shows a certain dependence on a work by Hugo van der Goes, preserved only in a copy (drawing W 856 at Bayonne), in which Dürer too found inspiration in his later period.

It was no easy task to combine the center panel with scenes from the lives of John the Baptist and John the Evangelist, and Memling proved incapable of treating the vision of the apocalyptic horsemen as it deserved.

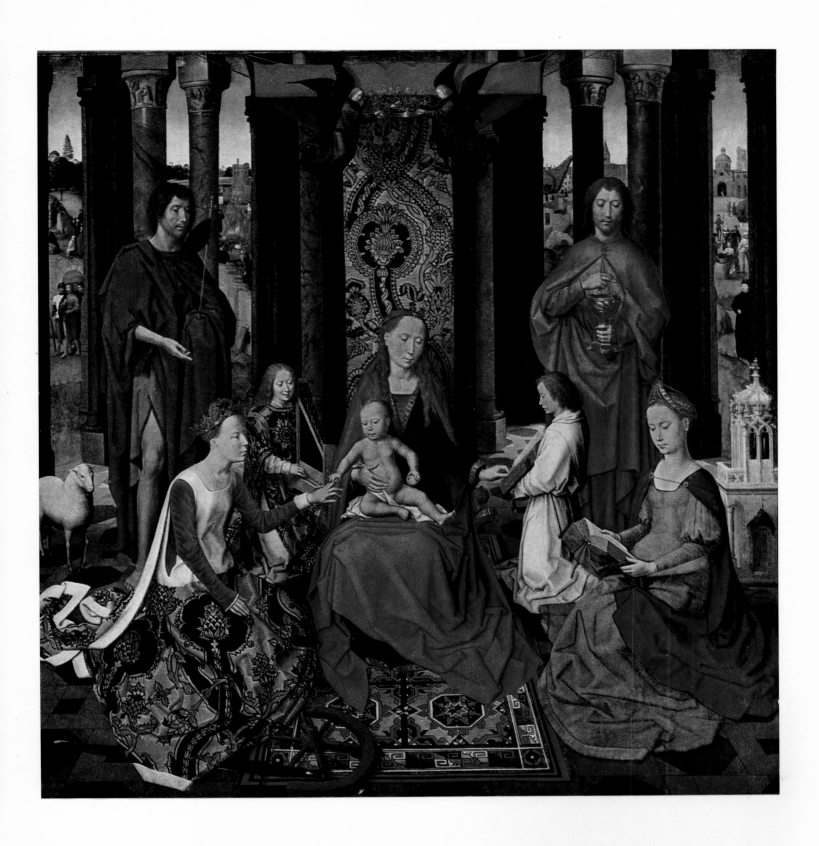

28 Hans Memling

The Seven Joys of the Virgin

Detail: A Troop of Horsemen
1480
Alte Pinakothek, Munich
Reproduced in full in figure 38

Twice Memling combined scenes from the lives of Christ and the Virgin Mary in so individual a way that the medium-sized panels came to be considered typical of his art. The first work, which is preserved in Turin, chiefly comprises scenes from the Passion represented synoptically in and before Jerusalem, whose houses are opened up to reveal the various events that take place inside. It is believed to have been commissioned by Tommaso Portinari and his wife, who were also the donors of Hugo van der Goes's huge altarpiece in Florence (fig. 35). This would justify the early date (c. 1470) ascribed to the Turin work. About ten years elapsed before the execution of the second panel of the same kind (fig. 38), a detail of which is reproduced here.

This time the panorama is more extensive. It comprises not only Jerusalem but also the hilly country around the city. The horizon is formed by the sea, whose shore is dominated by towering peaks. In the foreground is the stable of Bethlehem. The three Magi have just dismounted and reverently approach the Infant Jesus, who lies cradled in His mother's arms. Their attendants hold the horses; some men mounted on camels are still arriving. The kings and their suite appear at other points of the picture. In the middle distance we see them at a crossroads; within the city itself they are received in audience by Herod. One of the finest sections (reproduced in this detail) shows

them entering a defile after leaving Bethlehem, clad in brilliant colors (red, white changing to bluish, bright cobalt blue) set off by the neutral tones of the ground. The same colors are scattered throughout the entire picture and bestow on this wonderfully well-preserved panel from the Boisserée Collection its painterly beauty.

The left-hand side of the panel shows the Annunciation, the Proclamation to the Shepherds, the Massacre of the Innocents, the Flight into Egypt, and, in the far distance, Christ Tempted by the Devil. In the foreground to the left, on a larger scale, is the Nativity. Here the painter has portrayed the donor, Pieter Buyltink (his small son is behind him), in an unconventional pose, kneeling with folded hands before the iron-barred window of the stable, but quite unable to see what is going on inside; he does not have to see, for he knows. Buyltink donated the panel to the Tanners' Chapel in the Church of Our Lady in Bruges in 1480. His wife, Catharina von Riebecke, is depicted, also with her coat of arms, in the opposite corner.

The right-hand side of the panel is occupied by scenes of the Passion—the Resurrection, Christ Appearing to Mary Magdalene and His Mother, the Road to Emmaus, the Ascension, the Death of the Virgin, the Assumption, the Descent of the Holy Ghost, and, on a very small scale in the far distance, Peter on the Lake.

29 Hans Memling

Young Man at Prayer

Wing of a small folding altar
15 1/4 × 10" (39 × 25.5 cm.)
The National Gallery, London

No other painter of his time has preserved among his oeuvre so many portraits as Hans Memling. About a dozen independent portraits, mostly of men, and more than three times as many likenesses of donors, both men and women, are still extant. Even this does not take children into account, on whom he lavished no less care.

A certain number of these portraits, all in half-length, were originally combined with a Madonna to form a diptych or triptych. The "young man" in London reproduced here is believed to have been the left wing of a triptych that had a Madonna on the center panel and a portrait of his wife on the right wing, though indeed he looks almost too young to be a married man. The work is so closely related to the dated small diptych with Saint Benedict in Florence that one is justified in dating it about 1487.

Spiritual innocence—the term must be understood without the slightest overtone of disparagement—and physical delicacy are con-sidered the chief characteristics of Memling's art. They are particu-larly in evidence in this comely youth who kneels before a book of hours with hands joined in prayer. The room and its perspective are defined by two marble columns with crocket capitals. The painter has placed his sitter—believed to be a duke of Cleves—between them and somewhat left of center of the panel. He is backed by a dark-green wall instead of the landscape found in most of Memling's portraits. The large dark eyes, the finely chiseled features, the careful-ly tended hair that covers his ears like a page's match his extremely elegant apparel to perfection. Over a dark-red velvet vest laced with narrow ribbons, he wears a simple but stylish black doublet slashed at the shoulders. A ring on the thumb, another on the middle finger, a precious pendant set with pearls, hanging on a chain from his neck, complete a painting whose preliminary drawing could itself be called a work of art.

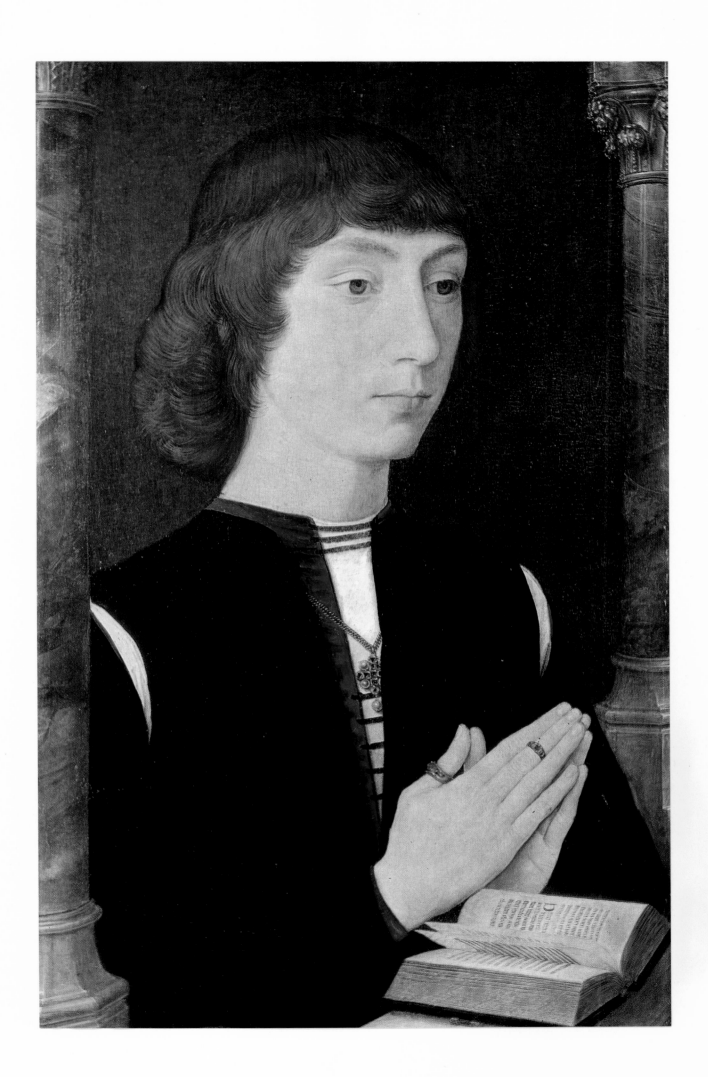

30 Geertgen tot Sint Jans

(before 1470–before 1495)

The Holy Kinship

Detail: The Head of Saint Elizabeth
Rijksmuseum, Amsterdam
Reproduced in full in figure 40

Christ's family—insofar as we know it from tradition—can be rather confusing at first glance. This is due to the fact that Saint Anne, after her marriage with Joachim had produced Mary, the mother of Jesus, gave the same name, Mary, to the daughters born of her second marriage (to Cleophas) and of her third (to Salomas).

The first Mary married Joseph (if at all), the second Alpheus, the third Zebedee. This third union was particularly important because it produced both John the Evangelist and James the Great. No wonder such complicated family relationships are not always set forth correctly. Even when names are mentioned, there is still no guarantee against error.

By analogy with Van der Weyden's *Seven Sacraments* in Antwerp—a work perhaps not painted entirely by the master's own hand—Geertgen has set the scene somewhat asymmetrically in the nave of a church with marble columns, capitals, and Gothic-arched interties, and with doors wide open to the world outside. In this "family picture" the child who reaches out toward the Infant Jesus—the two are about the same age—on the Virgin Mary's lap would seem to be the future John the Baptist in the arms of his mother, Saint Elizabeth. Consequently, the older matron seated next to the Virgin should be her mother, Saint Anne. Behind her stand Joseph (holding a lily) and Joachim (the old man with the full white beard). The two women behind Saint Elizabeth are presumably Mary Cleophae (seated with her back toward the spectator) and Mary Salome (standing up). Mary Salome, unlike the mother of Christ (whose hair falls over her

shoulders), wears a hardly less gorgeous Burgundian headdress than Saint Elizabeth, who is, in addition, clad in rich brocade. These two headdresses are the most sumptuous details of this magnificent picture.

The actions in the middle and far distance are very odd: they may be interpreted as signifying rejection of Old Testament thinking. Before the rood screen, which is adorned with two reliefs representing the Fall of Man and the Expulsion from the Garden of Eden, stands an altar with a sculptured group of the Sacrifice of Isaac. While Jewish priests prevent the believers from entering the holy of holies, a boy with a snuffer on a long pole is putting out the candles on top of the screen. This can mean only one thing: the sacrificial cult which was performed here is coming to an end; the barriers that separate sinful man from God are falling. A group of children in the middle distance before the altar symbolizes the path indicated by the members of "Christ's family" in the foreground and by the Infant Jesus Himself. Little James the Great holds a tiny flask from which he pours wine into the chalice held out by his brother John, the future Evangelist (son of Mary Salome and Zebedee)—an allusion to Christ's expiatory sacrifice—while little Simon (son of Mary Cleophae and Alpheus), who later became an apostle, holds the saw which is his attribute. The boy to the left of Saint Anne is Simon's brother, James the Less; we can recognize him by the club with which he was beaten to death.

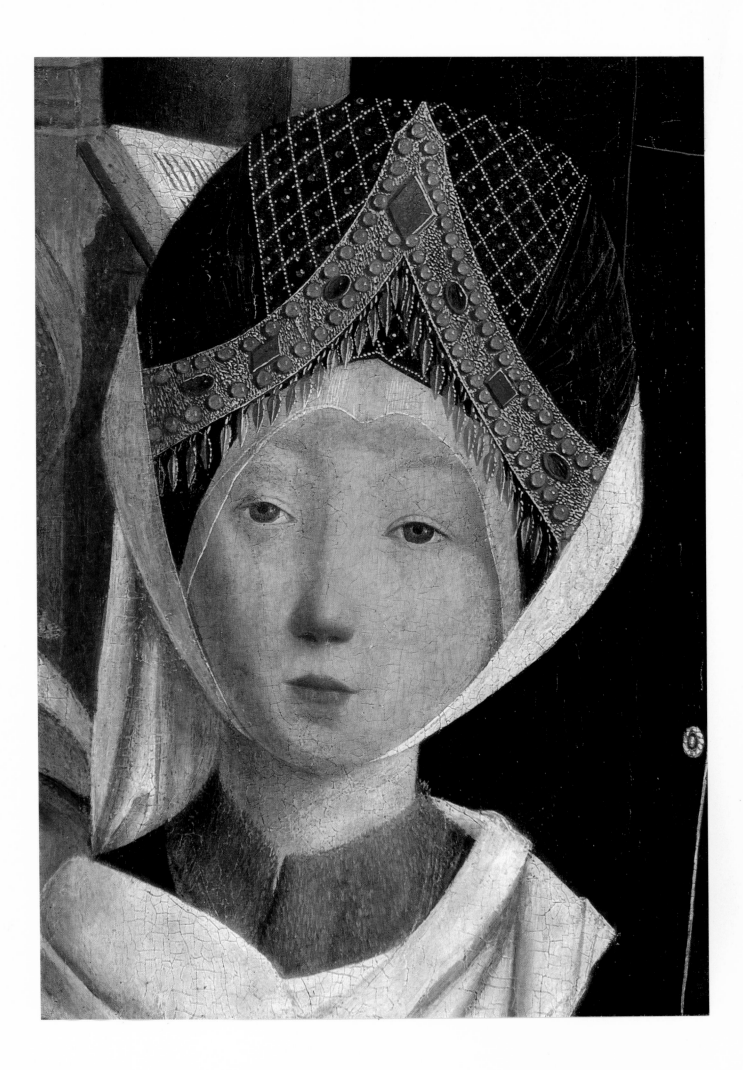

31 Geertgen tot Sint Jans

Saint John the Baptist
in the Wilderness

16 1/2 × 11″ (42 × 28 cm.)
State Museums, Berlin-Dahlem

The synoptic Gospels tell us that John the Baptist preached in the "desert," but the region cannot have been too desolate even if the ascetic lived there on locusts and wild honey. They were, in fact, alluding to the desert of the land of Judah, and immediately afterward state that the whole country and the people of Jerusalem went to be baptized in the Jordan. Nevertheless, it was a daring act for a painter at the end of the Middle Ages to disregard the Gospels entirely and represent instead an extremely pleasant scene as the Baptist's abode. That is exactly what Geertgen did on his panel in Berlin, not merely interpreting the Bible text to suit himself, but anticipating a far later day when it would be considered a matter of course for a painter to treat landscape as a subject for his art. If Geertgen, who died so young—he was only about thirty years old at the time of his death—cannot be denied a touch of genius, it is largely due to the bold unconventionality and foresight he displayed in this work.

It might be pointed out that Geertgen had some predecessors: for instance, Robert Campin with his early spring landscape in the Dijon *Nativity* (colorplate 4) and Jan van Eyck with the view of the river and the distant Alps in his *The Madonna of Chancellor Rolin* (fig. 20). But one must admit that both were bird's-eye views, whereas Geertgen seems to have been the first, with Hugo van der Goes in the Vienna *Fall of Man* (Kunsthistorisches Museum), to depict nature in the wild state with its animals, its grasslands (through which flows a winding stream in this painting), its tall, isolated trees, its woods

from so close up that the beholder can feel that he is a part of it.

Dürer was the first artist to consider that scenery was worth depicting for its own sake (see the watercolors executed on his first journey through Italy). But it should also be pointed out that one of his earliest drawings—*Holy Family* (W 30, in Berlin), with Joseph resting his head on his right hand—shows so many affinities with Geertgen that one can hardly deny the existence of a connection with Geertgen's work. This means that the latter was partly responsible for Dürer's innovation. In both cases it is the unusual empty space above the human figures and the use of isolated tree trunks that give space depth and make it accessible. By depicting his bearded Baptist, who for all his austerity wears a spreading cloak over his shirt (which looks more like wool than hair), seated in meditation on a grassy bank, Geertgen has once again foreshadowed future developments. Does he not seem to apostrophize or anticipate the *deus sive natura* of his fellow countryman Spinoza? The Lamb gives the impression of a little plaything, like a small dog accompanying a philosopher. The Baptist, resting his cheek on his right hand, assimilates the beauty of the parklike landscape without actually looking at it. Such emancipation from the tradition of Biblical and ecclesiastical conceptions was a tremendous intellectual achievement. No wonder Dürer's *Melencolia I (Melancholia)* has been viewed as deriving from Geertgen's melancholy John the Baptist. In fact, the German artist may have seen it on his early travels, which in that case took in the Low Countries.

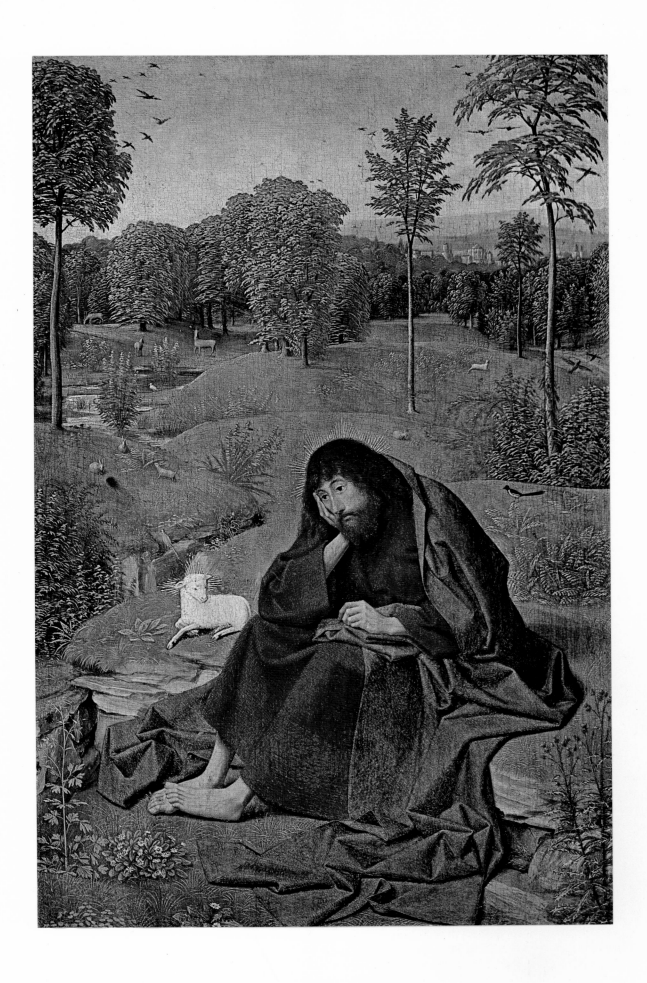

32 Master of the Virgo inter Virgines

(active c. 1470–1490)

The Lamentation

21 1/2 × 21 1/2″ (54.5 × 54.5 cm.)
Walker Art Gallery, Liverpool

The genius of the Master of the Virgo inter Virgines is revealed by his totally new, personal treatment of the theme of the Lamentation. Previously, painters were almost invariably convinced that there was no avoiding an arrangement of Christ's body parallel to the edge of the picture. But that in itself raised certain problems: first, the difficulty of displaying the body in all its length; secondly, the absolute necessity of introducing one or more figures as repoussoirs.

This unnamed painter risked all by placing Nicodemus and Joseph of Arimathea diagonally in such a way that Joseph's reddish cap lies almost in the main axis of the picture, while the dead Christ's drooping head occupies roughly the point where its diagonals intersect. The upper and lower parts of Joseph's body are turned in different directions, as if he had twisted round to let the Virgin Mary see her Son. Joseph holds the body under the armpits with a shroud; Nicodemus, with straddled legs, holds the shroud farther down to give it stability. He is an old man with thin white beard and hair, fantastically dressed in bright-red skullcap; long, mink-trimmed, salmon-colored gown held by a belt made of metal disks; and slit gold-brocade undergarment edged with ermine. His long, wide, draped sleeves are in jade-green silk, and a piece of black material with gold border,

apparently attached to his cap, covers his shoulders. Mary Magdalene wears a crownlike headdress adorned with pearls on her shaven forehead—something never seen before. Her pale face towers above the group as she gazes entranced—a queen, but a queen of pain and grief—at the dead Christ.

The group of figures that occupies the left-hand third of the picture comprises the Virgin Mary, who kneels with clasped hands, supported by Saint John, and the two other Marys. One has assumed the same attitude as the Virgin; the other, also in the throes of grief, presses her hand to her breast. Her pearl-set cap is copper-colored like her gown, which we can see under her dark-olive-green mantle. The third Mary's headdress is a reddish-yellow Burgundian cushion with a scarf of the same color. A daring little inverted coronet juts out above it.

The rocky, mountainous landscape, in which we can see a man with the ladder used for removing Christ's body from the cross, is bare and bleak. It makes the gorgeously appareled and bejeweled men and women appear all the more colorful and stresses the ineffable pain concentrated in the face of the dead Redeemer.

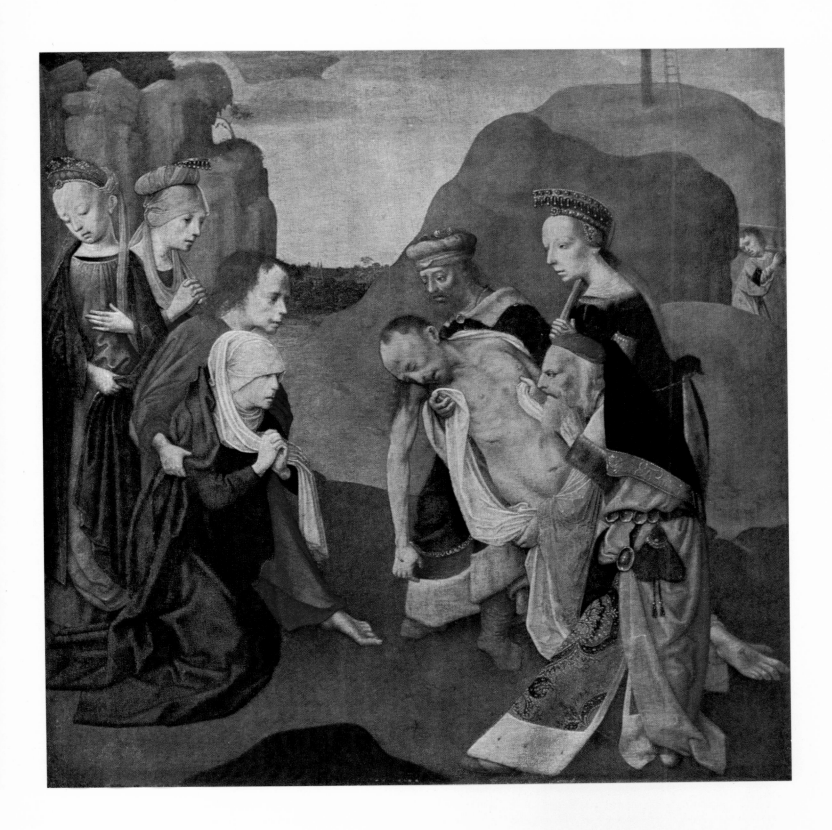

33 Gerard David
(c. 1450/60–1523)

The Virgin and Child
("Virgin with a Milkbowl")

13 3/4 × 11" (35 × 28 cm.)
Musées Royaux des Beaux-Arts, Brussels

Gerard David's *"Virgin with a Milkbowl"* well deserves the universal popularity it enjoys. It is considered authentic by the Brussels museum where it is on view, but most critics disagree. And that is unfair, for there can be no doubt whatever that the Brussels picture is the genuine original. True, so experienced a connoisseur as Sturla Gudlaugsson has reproduced the version in the Von Pannwitz Collection as the original, although there is another in Genoa that more closely resembles the one in Brussels. The very fact that in the Von Pannwitz picture the Child is painted in the nude proves that it is later. The original is less revealing, more subdued. In it one still finds the reserve and inwardness inherited from the pious Middle Ages, which contrast with the more mundane, rounded plasticity introduced by the dawning Renaissance.

The painter has lavished enormous care on the young mother's flowing hair, which is half covered by a transparent veil. Her figure is slender; her features are delicate, as are the little head and body of the Child. The bread and apple on the small table in the foreground are a humble meal. But the girlish mother, spooning pap from the bowl for the Child on her knee does not merely serve a decorative function. It was also a good idea, pictorially, to make the Child the center of the picture and set Him full front in contrast to His mother's three-quarter profile. There is a special charm in the fact that the rolled-up cuff of the Virgin's dress with its pale-blue lining lets us glimpse a bright-red sleeve. These two colors are repeated in the view through the window.

The depth of the room in which the scene is set is made palpable by two pieces of furniture: the second table, behind the Child, carrying a book with its pouch beside it and a basket, and the sideboard with pitcher and vase of flowers behind the Virgin on the left. The view through the window of trees, pond, wood, house, and yard (slightly restored) enables the spectator to form an idea of what the house in which the mother and Child are seen looks like from the outside. All these details combine to make this delightful painting an image of happy bourgeois life at the end of the Middle Ages.

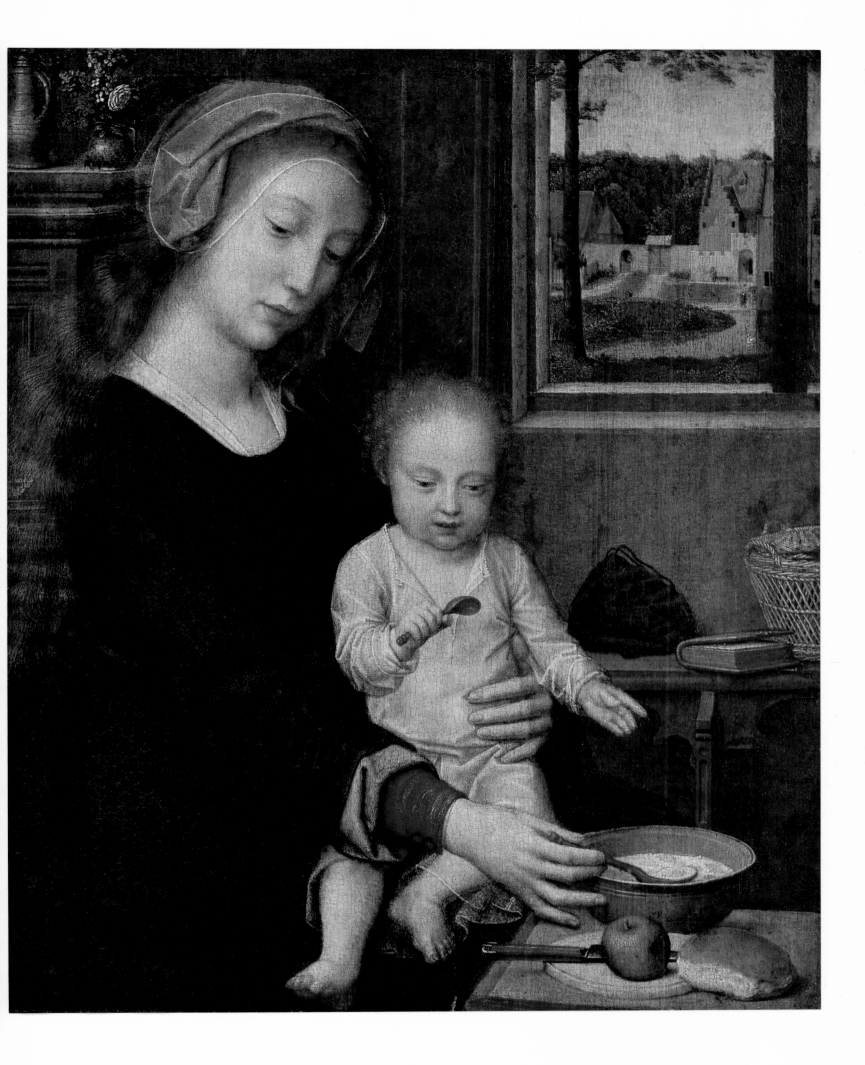

34/35 Hieronymus Bosch
(c. 1450–1516)

The Garden of Delights

Detail of the center panel
Detail of the right wing
The Prado, Madrid
Reproduced in full in figure 41

The triptych in the Prado, Bosch's largest work, is traditionally known as *The Garden of Delights*. This is, however, a rather vague, even misleading, designation for a work for which it is, in truth, hard to find a title because it comprises an entire universe and has not yet been elucidated satisfactorily in all respects.

The large center panel, which is linked with the left wing by a continuous horizon, is filled with a bewildering throng of nude figures both male and female. This is the more astonishing in that the representation of the naked body was taboo throughout the Middle Ages. Obviously what the artist wanted to express was the idea of a new earthly paradise. As a gigantic illustration of a life of gentle eroticism and sexuality that leads unavoidably to difficulties, the disorder is by no means lacking in formal organization. One can distinguish an upper zone where the odd mountainous forms of the left wing are continued by various retort-like pink and blue forms: what is indulged in here seems to be the pleasure of gliding, swimming, and making love. A middle zone is occupied by a circus of riders, depicted on a smaller scale, mounted on strange steeds that chase around a central pond. The lowermost, slightly larger, zone may be divided by its diagonals into roughly triangular areas which are not strictly defined and provide the stage for a wide range of amorous exercises. One is surprised to see a wedge of powerful, oversize birds—most of them keenly observed—break in from the left. Beginning our review of the details from the lower left-hand corner, our eye is caught by a black woman with a bright red apple on her head, whose almost identical twin appears in the group on the opposite side of the panel. As has been the case in Christendom from the earliest times, racial differences seem to have no importance whatsoever. The naked man by her side, around whom a few others are pressing, sets a bird free. The one next to him holds a testicle-shaped bag; farther back, another carries a huge blackberry. In the group on the right (not shown here) we can make out, besides the black woman, two beautiful, white, female nudes, one of whom still has what looks like a nun's knotted cord around her thighs. They are being initiated into the new cult to which a monument in the shape of a stylized phallus rises behind the group. To their left, naked figures nibble and snuff at fruits. Above them, topped by a fruitlike object with a window, stands an initiation chamber from which a naked woman emerges carrying a big fish under her arm. Like the strawberries, raspberries, and blackberries, some of them oversize, that are scattered through the picture, the fish is a fertility symbol, for its roe contains a myriad spawn. In front of this structure an Adamite tenderly strokes the shoulder of a girl who sits on the ground in the same pose as Adam on the left wing. The scene next to them must be viewed as a homosexual act euphemistically embellished with flowers. Higher up on the right a couple—one of whom has a berry for a head—lie on a grassy mound. Above them a wedding is being celebrated under a glass bell. Farther back (on a smaller scale) people amusing themselves by picking oranges call to mind the idylls of the Florentine Neoplatonists. Near the right-hand edge of the panel we spy a strange group; it has been interpreted as a couple trying in vain to escape from the pink fruit in which they are imprisoned while an owl, the symbol of wisdom, witnesses the proceedings. It might be more correct to view the scene as a wild, orgiastic dance that common sense, personified by the owl, is subduing and trying to halt. Lower down a solitary youth holding a red fruit in his hands lies on his back and plays with a bird perched on his toes. At the bottom right-hand corner we can see a man and a girl peeping from behind a glass tube. He has been viewed as the *spiritus rector* of the entire proceedings, the grand master of the Adamite sect. Near the center of the panel is a small red tent, which is important as a touch of color and as an element of the composition, but is actually too small to warrant the associations that have been suggested. Perched on a branch of the tent is a jay, the protector of conjugal love, which holds in its beak a fruit eagerly awaited by an onrushing mob.

Turning our eyes to the left, toward the wedge-shaped pond, we see floating on its surface a gigantic pink fruit with an opening through which a pair of lovers gaze. Another couple can be seen enclosed in a glass ball or a soap bubble which sticks to a thistle-like flower that grows out of a pink fruit. Nearby, a drowning man clings to a large owl: does it mean that he is acting wisely? On the bank a naked man labors under a huge mussel shell that produces pearls while it serves a couple as a love nest. Between these two groups, a masturbator, head down, has drowned himself in the pond; his legs stretch up in the shape of a Y. The leader of the gigantic birds, a goldfinch (symbol of sex and vanity), carries a sad-looking man on its back and holds in its beak a blackberry toward which three naked figures crane their necks. Another man is drowning in a barrel, while nearby a

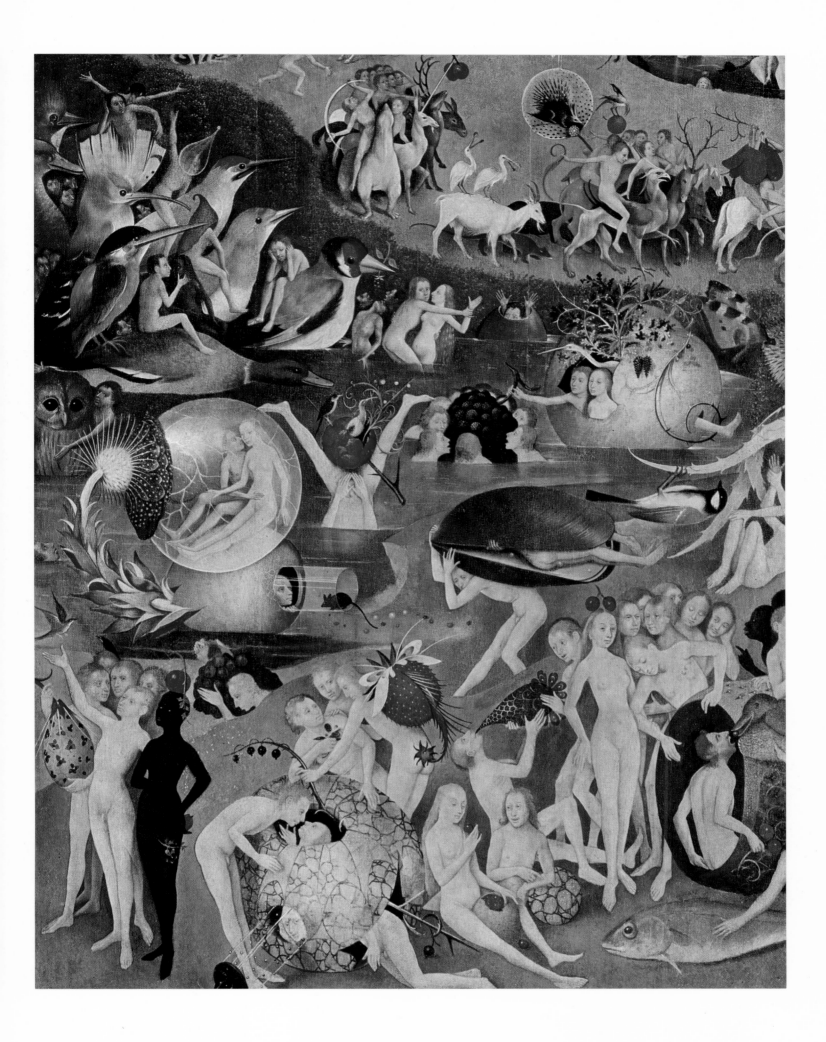

youth catches hold of a golden-haired girl as if to dance. The other birds, including the woodpecker and the hoopoe (with fantastic crest), have their riders; only the long-beaked kingfisher has none. A gigantic mallard—the duck at the edge of the panel is probably its mate—flies horizontally into the picture, carrying on its back a white man caressing a black girl.

The middle of the lower zone still remains to be examined. There, if the interpretation is correct, life and death meet. A dying man in the mouth of an upset urn receives a last morsel from a gray duck that is apparently perched on the knees of a headless creature whose body is concealed by leaves or petals, beside another swathed in a cocoon of silk. They are turning cartwheels and are poised on their hands. Behind the urn is a womblike gourd topped by a huge mulberry for which a girl violently craves. It is the fruit of the tree that feeds the silkworm, symbol of the hope of resurrection, which is realized in the butterfly on the thistle above. An arm from the urn stretches out toward an outsize fish. A particularly well-built young woman surrounded by a group of naked figures of both sexes is designated as leader of the revels by the twin cherries on her head. Some seated on the ground feed greedily on fruits; one drinks from a pointed bag. A girl inside a huge, veined, womblike gourd offers her lips to her lover for a kiss. Farther back a man carries a sort of red bug on his back, probably as an instrument of sexual excitement. Above and to the right of this group, in the vertical axis of the picture, homosexual activities have apparently been taking place, with lethal results, in the hollow of a rolled-up thistle: plant and bodies are pale as death. A titmouse perches upside down on a twig; the position is typical of the bird, but in this case might also be symbolic.

The lower main section of the center panel shows us Adamite life in the Garden of Eden chiefly as a motionless idyll, though it does not escape sexual aberrations and death. In the middle section, on the other hand, which is framed by trees, all is movement. The endless circle of life on earth is seemingly symbolized by a round dance, a triumphal procession without beginning or end, that moves round the central pool. In the pool itself young women stand or swim, some crowned with fruits, others with white spoonbills or black crows, offering themselves as future mothers. Most of the women are white, some are black; one of the latter bears a peacock (the symbol of vanity) on her head. The round dance comprises various troops of naked mounted men. It also swarms with birds—spoonbills, herons, and storks, among others—and with fruits and other symbols of fertility and sensuality; a porcupine appears on a fan. Among the bewildering multitude of birds and beasts one can recognize horses, unicorns, and a griffin, the model for which seems to have been an etching by Martin Schongauer. Since Schongauer died in 1491 and the etching was a late work, one can calculate that *The Garden of Delights* could not have been painted before about 1485–90. There are also a lion, panther, ox, goat, camels, bears, donkeys, stags, pigs, and fish—these last carried in the men's hands because, of course, they cannot run. The riders are arrogant and obstreperous. In the axis of the picture a man balances a white egg, symbol of the harmonious world, on his head; behind him on a white saddle horse a pair of lovers half hidden by a red cloak flourish the rod of life; and one man even carries the pagan crescent. At the sides, groups of figures bring a gigantic lobster's tail, fish, birds, and other fertility symbols to join the "carrousel."

In the upper zone of the central panel, like harbingers of the sputniks of our own day, rise the metallic stabiles of the human habitus—blue for the male, pink and differently shaped for the female. An important detail is the couple embracing in the hollow sphere located in the axis of the picture while naked figures perform gymnastic feats on its equator. The water that springs from the fountain of life is greedily swallowed by those who swim in the pool, which is full of creeping and fishlike beasts. A black man in a little boat makes a sexual approach to a white woman. A crowd of people worm their way into an egg on the shore; others nearby encircle a huge berry. These are games for the blessed with fruits as prizes. Finally, the apotheosis of idolized life symbols is heightened to the point of incongruity: their triumphal progress continues in the sky.

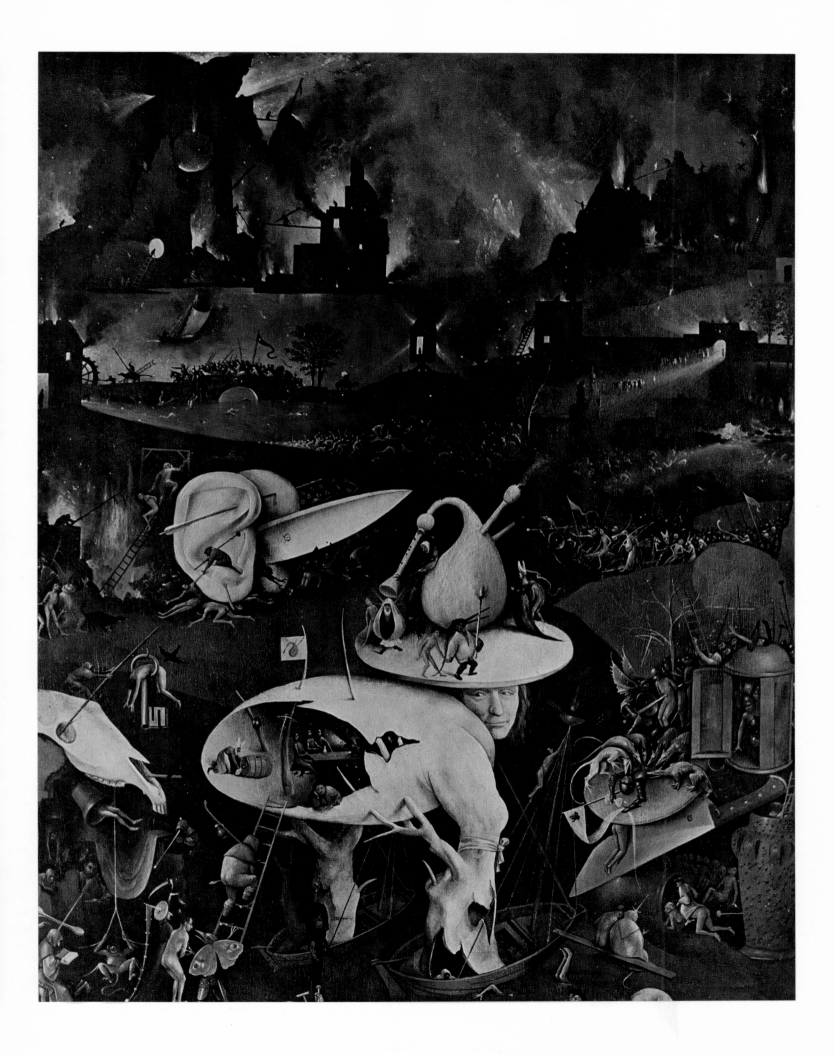

36 Hieronymus Bosch

The Temptations of Saint Anthony

Center panel
52 1/2 × 46 7/8" (133.5 × 119 cm.)
Museu Nacional de Arte Antiga, Lisbon
Reproduced in full in figure 42

The wonderful painted triptych entitled *The Temptations of Saint Anthony* is the focal point of the Lisbon museum. It is far finer as a painting than *The Garden of Delights* and even takes pride of place over Dürer's *Saint Jerome,* on view in the same room, and the important panels attributed to the Portuguese painter Nuño Gonsalves. Perhaps a more appropriate title would be "The Intimidation of Saint Anthony." The saint has outlived physical temptation, so his achievement does not consist in giving up pleasures but in resisting the torments caused by experience of evil in many different shapes and forms.

The center panel represents a Black Mass read from an infernal blue missal by a hideous heretical bishop attended by two gruesome animal forms. His chasuble is slit up the back to show blood flowing from his skeleton into the Stygian morass where strange fish live and weird boats ply; one of the latter has a ray on its sail. Other ceremonies linked with the horrid Black Mass take place on the platform beneath which the water flows through a culvert. The celebrants, fashionably dressed women with headdresses decorated with snakes or thistles, busy themselves at a round table. One wears reddish yellow, the other is sinisterly yellow in face and garb. Behind them stands a creature half bird, half fantasy with a snipe's head and long, trumpet-shaped beak which puffs nauseous fumes in the direction of the ruined chapel in the middle distance. One of the priestesses reaches out for the Host that lies near the wine vessel; the other offers a small cup of wine. To whom? To a capering lute player with a pig's head on which perches an owl, leading a little dog and followed by a cripple. Slightly farther back, heralded by a pair of armor-plated hellhounds, comes in all haste the pack of the avenging spirits—a willow-witch accompanied by a strange, pale-colored monster and a monkey-faced man with a broken flower vase for a hat. As a trophy he carries a torturer's wheel from which hangs upside down the trussed carcass of a pig. Behind him is a sinister apparition in full armor with closed visor.

An equally fantastic throng of horrible creatures moves through the stagnant water toward the right-hand edge of the picture. A grotesque falconer rides a horse whose hindquarters have been changed into an earthen jug. A willow-witch cradles a swaddled infant in her arms; she is seated on a steed that has turned round and changed into a rat. Behind her are a man carrying a red disk on his back, and a figure—seemingly a portrait—whose scalloped Burgundian headdress carries a red pharmaceutical berry (the fruit of the mandrake) topped by a shape that resembles the sound hole of a violin; he is escorted by a man-at-arms. According to Fraenger, the poisonous berry—an aphrodisiac that causes hallucinations, illusions, and delirium—explains the confusion of the cavalcade. The major color accent on the panel is provided by a gigantic scarlet berry in the left foreground, from which issues a curious harpist with a horse's skull for a head mounted on an indescribable beast, followed by a demon swinging in a basket and brandishing a sword. Behind a timber partition lies a crippled man in a tall hat who, like so many things in Bosch's pictures, has yet to be explained. Returning to the Mass table, there are other important details to be mentioned. A handsome black woman in a reddish robe holds up a plate on which stands a mysterious, froglike manikin which raises an egg above its head. The most conspicuous figure is an elegantly dressed woman in front of the table. She wears a towering, white Burgundian headdress and an authentic *cul de Paris* gown, which, sad to say, ends in a lizard's tail. She has squeezed between the table and the kneeling bearded saint to offer a bowl of consecrated wine to an aged nun; an armless, trunkless man squatting in front of the nun has already received a small goblet.

The saint looks out of the picture toward the spectator, making the sign of the cross. His gaze is parallel to that of Christ, who makes the same gesture as He stands before the image of Himself crucified in the dimly lit chapel. The zone of the holy of holies is cut off from the outside world by a beam of light that comes from the brightly lit wooded landscape (painted in an amazingly modern manner) on the horizon behind the burning houses. This beam is parallel to the trumpet-beak of the snipe-headed creature.

The chapel occupies the interior of a ruined tower that constitutes a necessary stabilizing element of the composition. It is divided outside into several horizontal strips adorned with symbolic scenes, mostly from the Old Testament. Farther back, on the right, is a tentlike structure where a monk and a nun are dallying, while naked figures, equipped with bathing towels just as they might be today, climb down the steps or dive into the water. Is this a pool for reviving revelers or for purifying sinners?

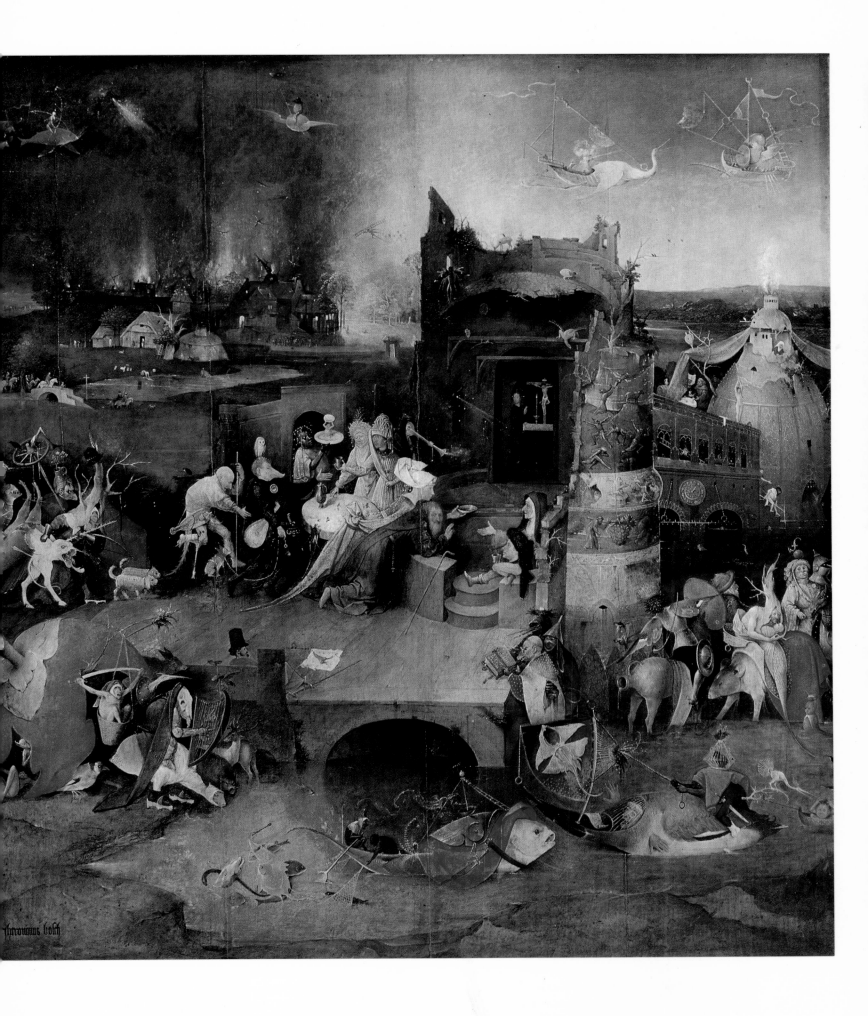

37 Hieronymus Bosch

Christ Carrying the Cross

Detail: Saint Veronica
Museum voor Schone Kunsten, Ghent
Reproduced in full in figure 43

Bosch was one of the first artists to paint pictures full of heads, an idea that he may have borrowed from Italian models. In the Vienna *Last Judgment* he wanted to indicate this trend and used an upright panel so that he could divide the picture into an upper and a lower part. Here, at the end of his life, he merely filled the picture plane with heads which, except for those of Christ and Veronica, are wildly expressive and starkly caricatured. Unlike *The Crowning with Thorns* in London, where the treatment may still be termed gentle, here the savage vulgarity of the scene is stressed to the limit. At Princeton there is a *Christ Before Pilate* that must have belonged to the same series. It is rather larger than the Ghent panel, which is an argument in favor of the hypothesis that a piece was sawn off the latter. Here, still more clearly than in his earlier works, Bosch has not hesitated to employ abstract, surrealistic coloring. Some of the heads are ash gray, not because that was their actual hue, but because it suited the painter's temperament and his overall color scheme, in which yellow, blue, and red play an important part.

The beam of the cross on Christ's shoulder coincides with one of the diagonals of the picture. It calls attention to the Savior's head, which would otherwise have been submerged in the throng of superposed and juxtaposed faces, strongly contrasted in shape and expression, but all equally hideous. At the lower right they form a group that taunts one of the thieves, who turns his head to snarl a savage retort. Almost at the point where the diagonals of the picture intersect, next to Christ, who is portrayed with closed eyes and haloed by a few sparse rays, there is a particularly revolting type. His huge mouth is wide open and from his bristling mustache hangs a thin chain. (A man in the Princeton picture has one like it and has added a ring through his nose and another through his lower lip, evidently modish extravagances of the period.) To the right of him a bloated figure in armor carrying a shield presses forward. Higher up, near the top right-hand corner of the picture, the Good Thief is berated by a raving friar while a third head in right profile—perhaps a local worthy—wears a Burgundian turban and a skeptical pout. The space between him and the cross is filled by a row of three heads that put one in mind of Leonardo; the nearest of the three carries a mace and chain. Just below them a foreshortened figure grips the cross with both hands, adding his own weight to the burden that the tortured Christ is forced to bear.

To the left of Christ are two other horrible male heads and, in the lower left-hand corner, two women—Veronica, with an attendant, holding the cloth on which Christ's face is already imprinted. It seems as if Bosch used their heads to indicate that the world is not all brutality. Veronica is not weeping: her averted face expresses grief beyond tears.

38/39 Quentin Matsys

(1465/66–1530)

The Lamentation

Detail of the center panel: The Grotto of the Sepulcher
Portion of the left wing: Herod's Banquet
1511
Koninklijk Museum voor Schone Kunsten, Antwerp
Reproduced in full in figure 44

When Quentin Matsys turned to the task of designing a Lamentation for the large center panel of a painted altarpiece, he disregarded, from the very start, some possible models: Rogier van der Weyden, who had had the splendid idea of showing the Virgin embrace her dead Son; Petrus Christus and Geertgen tot Sint Jans, who placed the body almost isolated on the ground; Hugo van der Goes, who adopted an upright format for his little picture in Vienna. He may instead have derived a certain inspiration from *The Lamentation* now in the Hague. In any case, whatever Matsys may have seen, he produced something entirely new. He had, of course, to display the body at full length and the composition of the rest of the painting was a necessary consequence of that. Nicodemus reverently holds the upper part of the body, while Joseph of Arimathea, with all the care of a doctor, extracts a piece of skin from the hole left by a thorn in Christ's head. An assistant, having removed the crown of thorns, holds it in his hands and at the same time looks all agog, yet with profound sympathy, at what is happening. The artist has rendered the unseeing eyes of the dead Christ with tender feeling and has delicately distinguished the emotions expressed in the faces of all those present. The other figures, with the exception of Saint John, are women. They are arranged in the picture plane as in a relief and, despite the landscape background, put one in mind of a carved reredos. Mary Salome holds Christ's left hand and receives a sponge and a pot of ointment from a fashionably dressed woman. Mary Magdalene once again attempts to anoint His feet. The Virgin has sunk to her knees: all she can do is fold her hands in a gesture of prayer and she has to be supported by John, the beloved disciple, to whom Matsys has given an unconventional type. Mary Cleophae, her mantle drawn over her head, has taken almost exactly the same pose as the Virgin. The colors are subdued: the only bright notes are the Virgin's blue mantle and John's red robe. The hill with the crosses is cleverly utilized to integrate the composition in the foreground. In front of the women who are gathering the nails with which Christ was crucified sit two genre figures. One is eating from a basket; the other, in a tall hat, is tying his shoe.

And now comes something quite out of the ordinary which is significant for a Netherlander. Looking into the grotto of the sepulcher we see a maidservant sweeping it with a broom, while another holds a candle to provide light; an old man stands ready at the entrance with a freshly pressed towel. What we have here is one of the sources of genre painting produced in abundance in The Netherlands during the following centuries.

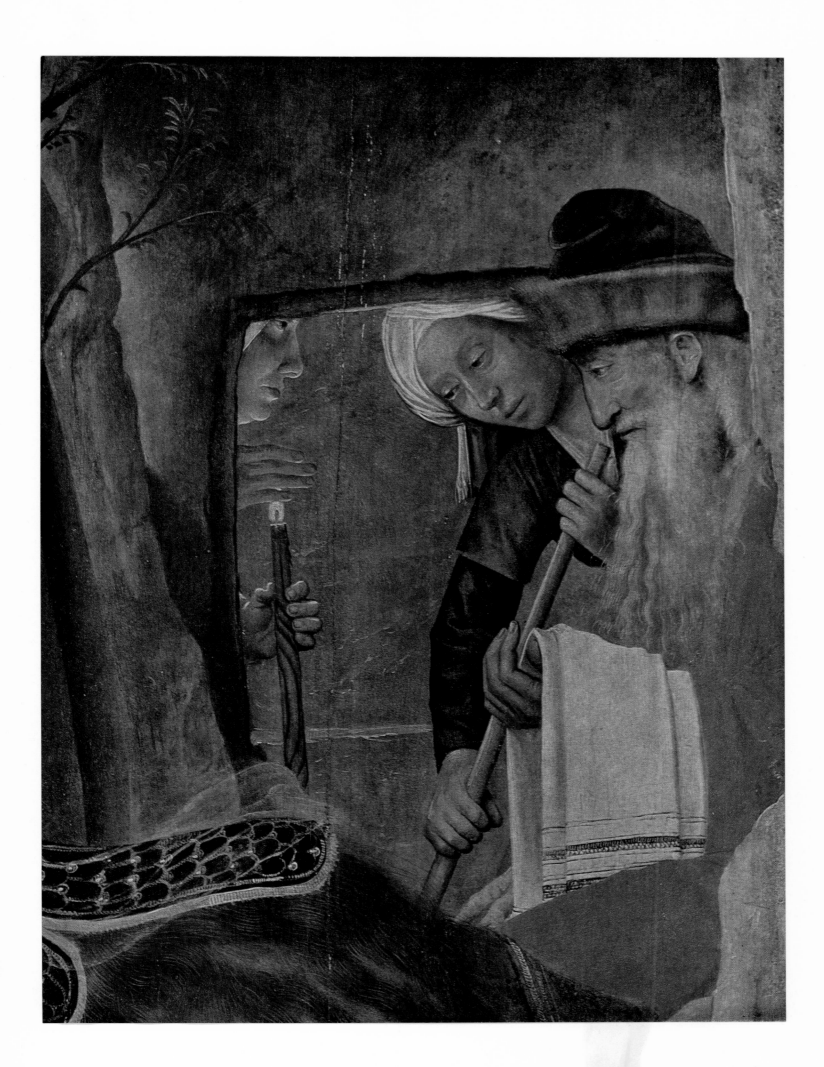

The scenes on the wings are painted in a very lively manner. Psychologically they count among the most advanced and interesting productions of the period. On the left wing the almost bare table, covered with a white cloth, is utilized to give an impression of depth and to lead the eye toward the center panel. On the right wing (fig. 44) the composition is divided into two parts by the horizontal rim of the ill-defined caldron of oil in which the unfortunate Evangelist is being boiled. On the left wing Herod, a huge, bearded figure, sits at the table in front of a wall covered with dull-red-and-gold brocade. By his side Herodias, looking fresh and youthful with splendidly bejeweled hair, snuggles up to him with a slight smile on her lips as she coyly pokes the Baptist's head with a knife, as if to make sure that he is really dead. Salome, a pretty, saucy little wench with roses and a veil on her auburn hair, wears a precious pendant (like her mother's) on her breast over a flower-patterned silk brocade gown tied round the hips with a green scarf. She slips the salver with the Baptist's noble head onto the table toward Herod. Her left hand is raised as if to forestall a scolding and her questioning eyes seem to ask: "Haven't I done a good job?" Herod raises his right hand in a gesture that may be taken as expressing surprise and disgust rather than approval. He is clearly shocked. Astonishment has reduced to silence the trumpeters in bright red behind the green-draped balustrade of the gallery. Through the arched doorway we can see the courtyard where Salome receives the Baptist's head from the executioner. The page dressed in golden-yellow doublet and bright-red hose restraining a dog behind the wine cooler in the foreground is depicted on a slightly smaller scale. The painter is justified in taking this liberty to make the major figures more impressive, as he is justified in applying the opposite principle to the right wing, where the coarse, vigorous figures poking the fire in the foreground—on whom Matsys, with his feeling for realism, has lavished special care—are also those largest in scale. Yet they do not distract our attention from the shining eyes of the martyred Evangelist, who spreads out his arms as if in wonder at a supernatural vision. Nor from the Emperor Diocletian who, with the crown on his turban and the scepter in his hand, has approached quite close on his white charger; he is surrounded by a yelling, gesticulating throng of mounted men who, like him, are separated from the saint only by a timber barrier. Some have strikingly original, well-characterized heads. Above them a boy has settled himself in a tree to watch the proceedings; farther back, the city gate forms the perspective pendant to the left wing.

40 Quentin Matsys

Portrait of Petrus Aegidius

1517
22 7/8 × 17 3/4" (58 × 45 cm.)
Collection the Earl of Radnor, Longford Castle, Salisbury

The double portrait of Desiderius Erasmus of Rotterdam (Palazzo Corsini, Rome) and Petrus Aegidius (Longford Castle; in addition, there is an excellent replica, perhaps by the artist's own hand, in Antwerp) is one of the handsomest testimonies to the level of culture among Humanist men of letters. Petrus Aegidius, born at Antwerp in 1486, was Erasmus's pupil, and was about twenty years younger than the author of *Praise of Folly*. They were close friends and also shared a common friendship with Thomas More, author of *Utopia* (which was dedicated to Aegidius), and the double portrait was executed as a gift to him. More was so pleased with it that he expressed his gratitude in a Latin poem that is still extant. It bears the superscription: "Verses on the double panel on which Erasmus and Petrus Aegidius are portrayed together by the excellent artist Quentin, in such a way that Erasmus begins his paraphrase of the Epistle to the Romans and the painted books by his side show their titles, whereas Petrus holds a letter with the address written in More's hand which the painter has imitated too."

Quentin's portrait of Erasmus was subsequently surpassed by those of Hans Holbein the Younger, but it is extremely interesting to have a likeness of the great man when he was a few years younger, and painted by another hand. Perhaps we would appreciate the Matsys portrait more if we did not have Holbein's. True, Aegidius is de-

picted as so fresh and likable that the picture of the younger man surpasses the other in liveliness and, one is tempted to say, in charm. Compared with that of Erasmus, his black gown is made more attractive by a wide mink collar painted with admirable skill.

The Humanist writer and theologian Pierre Gilles (always known by the Latin form Petrus Aegidius, in the manner of scholars of that time) passed a quiet life in Antwerp, dividing his time between his duties as town clerk and his studies. His friends Erasmus and More both describe him in highly flattering terms: he seems to have been learned and modest, cheerful and friendly, witty without malice. Erasmus was a constant guest in his house, and he entertained both More and Dürer when they visited the Low Countries. Aegidius produced many works of his own, and was also responsible for the publication of the first edition of Erasmus's *Epistolae*.

Erasmus, his gaze rather fixed, pauses from writing to listen to what his friend has to say. The latter turns briskly toward his companion, a sly smile in his eyes; his sensual mouth seems on the point of uttering a clever remark or jest. The two men are seated in the same room: the writing table and bookshelves extend through both panels. Aegidius was a living proof that the transition to the Renaissance did not demand a revolutionary break but could also be achieved as natural growth.

Notes

1 The "Master of Flémalle"—a makeshift name that is fated to disappear—provides one of the most difficult, and at the same time most interesting, chapters of the history of art considered as a science, and it continues to stimulate research. The question of the existence of the Master of Flémalle was first raised toward the end of the last century. Those in favor (Hugo von Tschudi, Wilhelm von Bode, Henri Hymans, Hulin de Loo, Winkler, Charles de Tolnay, Panofsky) enjoyed, and still enjoy, no less prestige than their opponents (Ludwig Scheibler, Eduard Firmenich-Richartz, Renders, Max J. Friedländer), who insisted on viewing the works attributed to him in the main as early works by Rogier van der Weyden. The same is true of his identification with Robert Campin, which was upheld by Jules Destrée, Tolnay, Winkler, and others.

If the author of this book started out by siding with Friedländer, the decisive reason for his doing so was not only the apparent presence of obvious elements of both masters in a single work but rather the difficulty, which even Panofsky had not yet overcome, of finding a dividing line between Campin—to quote his name instead of the Master of Flémalle, which Panofsky, oddly enough, never brought himself to do—and Van der Weyden. Each scholar drew that line differently.

The opinion now adopted by the author rests on two grounds. For the first he is indebted to Panofsky, who in turn can refer back to Paul Rolland and Hulin de Loo. It is proposed in his standard work, *Early Netherlandish Painting,* which will be hard to improve on as regards thoroughness in stylistic criticism and, still more, in iconographic scholarship, knowledge, and interpretation of symbols, as well as scrupulous accuracy. He suggested that the *"maistre rogier de la pasture"* so signally honored by the city of Tournai in 1426 was not an artist and had nothing but his name in common with the *"rogelet de la pasture"* who entered Campin's workshop for a five-year apprenticeship in 1427 and later became famous. This theory eliminated complications that even clever dialectic had previously failed to set aside entirely. "Van der Weyden" was a common name, and Rogier's father, Henry van der Weyden, a master cutler, was for a long time confused with a sculptor called Henry van der Weyden who lived at Louvain. The famous Rogier van der Weyden presents a natural parallel with Jacques Daret, who had been admitted to Campin's workshop as an apprentice as early as 1418. The altarpiece he was commissioned to paint in 1434—it used to be at Saint-Vaast, near Arras—is full of borrowings from Campin's works.

The second ground was the fact that the *Werl Altarpiece* is dated 1438 and therefore cannot be incorporated in the sequence of Rogier van der Weyden's work, extrapolated to comprise that of Campin.

Nonetheless, the close stylistic affinity between the two great masters, which Renders so insistently emphasized and so thoroughly demonstrated with numerous photographs of details, is a remarkable, indeed extraordinary, phenomenon. But no less out of the ordinary and worthy of note is the fact that Campin must have been able not only to ring the changes on his own works (e.g., his Annunciations in Brussels and in the Cloisters, New York; his Visitations in Leipzig, formerly at Lützschena, and in Turin), but also perhaps to copy them (e.g., *Robert de Masmines* in Berlin and Castagnola near Lugano, formerly in Ponthoz Castle). The same is true of others, including Rogier van der Weyden: let me mention merely the copy of *The Deposition* in the Escorial, which differs hardly at all from the original in Madrid, the replicas of *Saint Luke Painting the Virgin,* and of the *Mary* and *Saint John* altarpieces. Either the masters of that period were capable of repeating a work over and over again or else the copyists of that period were capable of an accuracy that was practically never equaled. These two possibilities may also have existed side by side. In any case, there are replicas dating from the fifteenth and sixteenth centuries that are very difficult to distinguish from the originals. This is still true of the work of Dürer, who is known to have executed the replicas himself. The term "replica" is employed in the literature chiefly for works by the artist's own hand, but that is not always clearly stated. Since, however, it is nearly always impossible to say with certainty whether or not a replica was executed by the artist in person, it would be well to abandon the term and to speak only of copies, holograph copies, or variants.

Robert Campin's works were frequently copied and many of them are known to us only through such old copies. Unlike Jan van Eyck, he was at the head of a workshop—this brings him closer to Van der Weyden—which made its influence felt far beyond the frontiers of the Low Countries even after his death (1444). In keeping with the custom of his day, he too was quite unashamed to borrow from his fellow painters. Thus we find, for example, the washbasin from Van Eyck's *Ghent Altarpiece* in his *Mérode Altarpiece* and the circular looking glass from *The Marriage of Giovanni Arnolfini and Giovanna Cenami* in his *Werl Altarpiece.* In so doing Campin differed in no way from his pupil Rogier van der Weyden, who, for his picture of *Saint Luke Painting the Virgin,* borrowed her sitting posture and the townscape from his master and the distant view above a balustrade with two figures from Van Eyck, to mention but a few examples out of many. Whether the same thing occurred in the opposite direction, as is often assumed, is far from certain.

Charles de Tolnay, more than any other author, has insisted on Jan van Eyck's dependence on Campin. I am convinced that he is mistaken. In his eyes an important point is the "toilet niche" which, he says, was borrowed by Jan from the *Mérode Altarpiece.* He seems to underestimate the fact that in the *Ghent Annunciation* the details are set in an ingenious composition planned on a grand scale and divided into four compartments; they must have made an enormous impression on Campin. Consequently, it was Campin who borrowed the toilet niche from Van Eyck, and not vice versa as Tolnay believes. This shifts the dating of the *Mérode Altarpiece* from the region of doubt to that of relative certainty. One may set it earlier or later depending on whether one assumes that Campin had an opportunity to see the *Ghent Altarpiece* in Van Eyck's workshop before it was finished or only after it had been installed in St. Bavo in 1432.

I attribute to Robert Campin the following works which in Panofsky's book are mentioned either under Rogier van der Weyden or not at all. They are arranged below in what I presume to be approximately the chronological order of their execution:

> the small *Madonna in a Niche,* Thyssen-Bornemisza Collection, Castagnola,
> the small *Saint George,* National Gallery of Art, Washington, D.C. (fig. 10),
> *Portrait of a Young Woman,* State Museums, Berlin-Dahlem,
> *The Mass of Pope Gregory,* Musées Royaux des Beaux-Arts, Brussels,
> *The Annunciation,* Musées Royaux des Beaux-Arts, Brussels (colorplate 8),
> *Portrait of G. van Zluyten,* Collection Wildenstein & Co., New York,
> *Portrait of a Man in Prayer,* The Metropolitan Museum of Art, New York,
> *Portrait of a Man with a Pointed Nose,* Philadelphia Museum of Art, John G. Johnson Collection,
> *The Madonna Standing Before the Throne in a Niche* (with Saint Catherine on the reverse), Kunsthistorisches Museum, Vienna,

Portrait of a Man (Guillaume Fillastre), The National Gallery, London (on loan from Lady Merton),

Visitation, Museum der Bildenden Künste, Leipzig (formerly Lützschena),

Annunciation, The Louvre, Paris; left wing, Turin (with another portrait in place of the donor's wife, the latter perhaps still extant in the Heseltine-Rothschild Collection, Paris; see Panofsky's skeptical attitude, pp. 484–85. Like the author, he failed to obtain a viewing of the fragment); right wing, with the *Visitation,* also Turin (Galleria Sabauda).

2 Hugo von Tschudi has found a curious explanation for the position of the Virgin's hand in the Leningrad *Madonna at the Fireside*: he says that she "wants to spank the Child." The correct interpretation is that the mother wants to make sure that the heat of the fire is not too fierce for the baby. Panofsky suggests that she is warming her hand before swaddling Him. See also Vladimir Levinson-Lessing and Nicolas Nicouline, *Les Primitifs Flamands: Le Musée de l'Ermitage, Leningrad,* (Brussels, 1965, p. 10), where the various interpretations are discussed.

3 The *Ghent Altarpiece* has been restored several times in the course of the centuries. In our own day the Laboratoire Central des Musées de Belgique under the direction of Paul Coremans carried out physical and chemical researches of a precision never seen before, with the help of X-rays and other types of radiation. He did not, however, express an opinion as to how the work is divided between Hubert and Jan. That was quite as it should be, for stylistic criticism is not a job for technicians. Overpaintings were removed with the utmost care wherever it seemed suitable to do so. As a result, the dove of the Holy Ghost at the upper edge of *The Adoration of the Lamb* (which has been given a wider frame so as to combine more exactly with the wings) in a glory and surrounded by a rainbow is considerably closer to the original state than it was before the treatment. The greensward, shrubbery, and grove to the left of the group of virgins have gained greatly and are now visible for the first time. The mantle of the enthroned Virgin and that of the second kneeling figure to the left of the fountain have been restored. It was found that the state of the singing and musical angels left much to be desired. Only the brocade mantle of the one who plays the organ is, fortunately, well preserved. The face of God the Father (not Christ, as it formerly seemed), His robe, the crown placed at His feet, and the inscription behind it are overpainted. It was already realized that the steeple on the horizon (apparently that of Utrecht Cathedral) had been added later (presumably when the work was restored by the painters Lancelot Blondeel and Jan van Scorel about 1550); this has now been confirmed. The orange trees and the other exotic plants on the lower right wing as well as the face of the gigantic Saint Christopher (whose eyes were originally wide open) are overpainted—in 1430–32 according to Coremans, who took a skeptical view of the cypresses.

How should we visualize the production of the *Ghent Altarpiece*? It may be presumed that at the start the project provided only for *The Adoration of the Lamb,* which may have existed in the shape of a sketch by Hubert van Eyck. Perhaps the idea of turning it into a polyptych developed at a later stage, for the lower wings on each side make sense only if the outer faces matched them; in other words, only if the two Saint Johns, the portraits of the two donors, and the upper register had already been decided on. We must bear in mind that Jan continued the work at Vydt's request and therefore it was presumably only at that point that the question arose of introducing the portraits of Vydt and his wife, namely how the outer faces of the wings should be treated. True, we do not know whether or not Vydt was concerned from the very start. Since Jan's journey to the south is an accepted fact, it is not unwarranted to presume that the orange trees and other southern plants, which the artist must have studied thoroughly, were painted after that journey, and consequently after 1429. It is seldom sufficiently stressed that Hubert died as early as 1426, which means that six years elapsed between his death and the completion of the altarpiece by his brother. Modifications and *pentimenti* do not by themselves provide

proof as regards the authorship of the original picture, for if due to Jan they might just as well concern his own work as Hubert's. For this reason no agreement has been reached—and probably never will be—on the dividing line between the two brothers. Attempts by Max Dvořák, Beenken, and Panofsky at apportioning the work between the two remain full of problems.

If one can anywhere recognize the hand of a second artist, namely Hubert—quite apart from the existence of the quatrain—it is in the lower center panel. The kneeling figures grouped around the fountain, whose abruptly foreshortened heads depicted in profile put one in mind of Giotto, and the patriarchs on the left give an archaic impression compared with the group of red-clad martyrs on the right (mostly popes and bishops), which is so rich in contrasts that it recalls the compositional principles of the Renaissance. Some of these heads, that of John the Baptist for instance, seem more antiquated than the rest. This is not a decisive argument in favor of attributing them to Hubert since Jan, who was obviously the younger of the two—it is not known exactly when either was born—on accepting the task of continuing the work, would naturally have done his best not to make the difference too visible; he must, indeed, have sought to eliminate it altogether and imitate his brother's manner at least where he thought he could do so without disavowing his own personality altogether. Since it is impossible to fix a dividing line on the original, we should perhaps attribute to Hubert (if we accept the testimony of the quatrain, though its authenticity is not absolutely certain) nothing more than the preliminary drawing or sketch for *The Adoration of the Lamb* on the lower center panel.

The outer faces of the wings, painted basically in gray or brownish tones with only a few touches of color or slight tints here and there, do not present a problem: they are generally attributed to Jan. Here too the treatment by the Laboratoire made some improvements (e.g., in Elisabeth Borluut's head).

It is a pity that lack of time—the altarpiece had to be returned to St. Bavo—and the caution induced by respect for so unique a work prevented Coremans, who died meanwhile, from making his restoration as extensive as might have been desirable.

4 Rogier van der Weyden's name covers some works whose authenticity is so evident that it silences all doubts. But there are others that, though extraordinarily close to the master, do not quite attain his level. Rogier's workshop must have been larger than Campin's or was run on different lines, so that in his case it is hard to decide whether those works whose quality is not entirely satisfactory should be attributed to the master himself or to his circle. Hermann Beenken was the first to compile a list of workshop products and replicas as well as of erroneous attributions under the title *Rogier-Apokryphen*. It comprises in the main works that must not necessarily be viewed as by the master's own hand. Worthy of mention among them are the following, which were formerly praised as being of outstanding excellence:

Seven Sacraments, Koninklijk Museum voor Schone Kunsten, Antwerp,

The Lamentation, Mauritshuis, The Hague,

The Crucifixion with the Virgin Mary and Saint John, John G. Johnson Collection, Philadelphia,

Altarpiece of the Crucifixion, Kunstmuseum, Bern (Abegg Stiftung),

Portrait of a Lady, The National Gallery, London,

Portrait of a Man in a Turban, The Metropolitan Museum of Art, New York.

Doubts have been cast also on the authenticity of the splendid *Annunciation* in New York. I personally am skeptical about the *Saint John Altarpiece* in Berlin. The questions raised by the *Mary Altarpiece*—for instance, whether the wing in New York must absolutely be considered as belonging to the mutilated compartments at Granada—cannot be answered without further research. The sections at Granada give the impression of a higher painterly quality.

I am convinced that the not unusual oblong versions of the *Lamentation* derive from the *Mary Altarpiece* or from an upright picture known only through a copy (Ittersum Collection, Amsterdam) and several half-length Madonnas from the original of *Saint Luke Painting the Virgin*.

5 Despite the fact that we have a clear idea of the style of Dieric Bouts the Elder, there are irregularities concerning which complete agreement will perhaps never be reached.

It is now customary to view the four panels in the Prado with scenes from the life of the Virgin as the work of Dieric Bouts. Only one voice has apparently been raised in dissent: the catalogue of Early Flemish, Dutch, and German paintings in The Metropolitan Museum of Art, New York, compiled by Harry B. Wehle and Margaretta Salinger, hints at the possibility of their having been executed by Ouwater. This does not make sense to me and I reject both Bouts and Ouwater for the following reasons. The relationship between figure and space is more highly developed than in Bouts's work (even during his last phase), for instance the lofty vaulted ceiling of *The Annunciation* and the contrast between the distant landscape and the group of buildings in *The Visitation*. The author of the Prado pictures was already familiar with central perspective foreshortening (see the sideboard in *The Annunciation*), whereas Bouts himself still kept to top view in his *The Justice of Emperor Otto III*. In *The Last Supper* from the *Altarpiece of the Sacrament* (fig. 30), the Gothic windows on the left are similar in structure to, but more awkwardly drawn than, the window in the Madrid *Annunciation*. By and large, one notes what might be termed a certain prettiness and innocence compared with the models (Van der Weyden and Campin), a comparatively commonplace clarity that eliminates all mystery. The type of the Virgin is uncharacteristic of Bouts. *The Adoration of the Magi* is crammed with figures, which is unexampled in his oeuvre. The motif of Joseph holding his cap, though it occurs on a very small scale in Van der Weyden, is not compatible with Bouts's conception of dignity and decorum. The obstinate repetition of the stable roof and the landscape in *The Nativity* and *The Adoration of the Magi* is equally inconceivable in Bouts. For these reasons the four pictures must have been executed after his day.

Wolfgang Schoene, whose analyses of Bouts's works count among the best writings devoted to that artist, made great efforts to distinguish between what was authentic and what was produced by his workshop and his successors. Strange to say, however, no serious attempt has been made so far to determine which works Bouts actually alluded to in his will when he bequeathed those that were "finished or nearly finished" to his wife and the "unfinished" ones to his two sons. The author of this book does not consider it his duty to deal with this tough problem in greater detail. He prefers simply to draw attention to it.

We know the manner of the second son, Aelbert Bouts, which is not very close to his father's, so it does not seem unwarranted to attribute to the first, Dieric Bouts the Younger, the pictures that, while displaying a particularly close resemblance to the father's, make a rather equivocal impression. It is no easy matter in works which in part are perplexingly like those of the elder Bouts to distinguish clearly between the contributions made by the father and those made by the son. Probably it was for such reasons that Schoene proposed the "Master of the Munich Taking of Jesus." The "Master of the Pearl of Brabant," isolated by Karl Voll over sixty years ago in what Friedländer termed an "inexcusable error," has often been identified with Dieric Bouts the Younger. This thesis was adopted even by the catalogue of the Munich Alte Pinakothek. But it is truly amazing to find such a scholar as Horst Gerson, in *Kindlers Künstlerlexikon*, not only reattributing the little altarpiece to the father but going so far as to print a full-page color reproduction of the whole work, in spite of the fact that shortage of space put him under the necessity of using it most sparingly.

The small triptych *The Martyrdom of Saint Hippolytus* in Bruges (Musée de la Cathédrale Saint-Sauveur) was rejected by Schoene, although it apparently displays all the father's qualities. Gerson, instead, recognized its authenticity, as he did that of the Munich *Taking of Jesus* and consequently of the Munich *Resurrection* too. This means that we are back again where we started so far as research on marginal Boutsian products are concerned.

When judging *The Martyrdom of Saint Hippolytus* one must not forget that the Christian ideology was capable of sublimating even the worst atrocities and thus making them an object of aesthetic enjoyment. So we can appreciate as a painting the saint being torn apart by four horses, and admire the skillful way that the slope's inclination was executed; there is no undesirable foreshortening. One must also admire the way in which the martyr's shirt and cloak are spread out on the ground. The spectators are grouped as in *The Martyrdom of Saint Erasmus;* by placing them frontally the artist introduced a stabilizing factor in the group. As in the same work, the potentates on the right wing are treated as if wafer-thin, while the emperor and the man kneeling before him are again placed in frontal-profile position; the man on his knees may be undergoing an ordeal, but the scene has not yet been elucidated. The left wing was left unfinished, perhaps because it offered no opportunity for portraiture. It was taken in hand after the death of the elder Bouts by Hugo van der Goes, who performed his task with perfect tact and skill.

In spite of this, Schoene put forward serious arguments against the authenticity of the work. Yet one must admit that Hugo would hardly have accepted the task of finishing a workshop product. Consequently, I am inclined to believe that *The Martyrdom of Saint Hippolytus* is one of those mentioned in Bouts's will and that, since it differs so little from what the name of Dieric Bouts the Elder conjures up before our eyes, it will soon be universally classified among his authentic works.

6 Tolnay points out that there is no proof that either Bosch or Almangien belonged to the "Adamite sect" or that Almangien commissioned the triptych. But he seems to have overlooked the fact that the sect was a clandestine organization whose first duty was to maintain the most absolute secrecy: it would have spelled disaster for any of its activities to have become public knowledge. He is also wrong in stating that Fraenger restricts the artist's role to that of a mere mechanical illustrator, thus implicitly denying his creative genius. All one can say in this connection is that Fraenger could not have been more totally misunderstood.

In my opinion, to give *The Garden of Delights* a late date is a fundamental error into which all recent authors (Tolnay, Fraenger, Bax, Baldass) have fallen, although formerly there was a diametrically opposite trend. Ludwig Baldass quotes Tolnay's reasons: the simplified handling, the landscaping (in comparison with the Prado *Adoration of the Magi*), the individual forms, and the renewed emphasis on local coloring. But these arguments are far from decisive.

7 It is also customary to set a late date for *The Itinerant Peddler,* though it has really nothing in common with, for instance, *The Last Judgment* in Vienna or *Christ Carrying the Cross* in Ghent. It is certainly later than the outside of *The Hay Wain,* but the time that elapsed between the two works was not necessarily very great.

Bibliography

Arranged in chronological order

1604 MANDER, CAREL VAN. *Het Schilder-Boeck.* Haarlem

1857 CROWE, J. A., and CAVALCASELLE, G. B. *The Early Flemish Painters.* London. (German edition revised by Anton Springer, Leipzig, 1875)

1898 TSCHUDI, H. VON. "Der Meister von Flémalle," in *Jahrbuch der Kgl. Preuss. Kunstsammlungen,* vol. 19, pp. 8ff., 89ff. Berlin

1904 MÂLE, É. "Le Renouvellement de l'art par les 'Mystères' à la fin du moyen âge," in *Gazette des Beaux-Arts,* vol. 31, pp. 289–90. Paris

1905 BODENHAUSEN, E. FREIHERR VON. *Gerard David und seine Schule.* Munich

1906 VOLL, K. *Die altniederländische Malerei von Jan van Eyck bis Memling.* Leipzig

1908 WEALE, W. H. *Hubert and John van Eyck.* London and New York

1909–1912 FIERENS-GEVAERT. *La Peinture en Belgique: Les Primitifs flamands.* Brussels

1910 HEIDRICH, ERNST. *Altniederländische Malerei.* Jena. (Reprinted 1924)

1913 ALLEN, P. S. *Opus Epistolarum Des. Erasmi Roterodami,* vol. 3, p. 103ff. Oxford

WINKLER, FRIEDRICH. *Der Meister von Flémalle und Rogier van der Weyden.* Strasbourg

1918 JÄHNIG, K. W. "Die Beweinung Christi vor dem Grabe von Rogier van der Weyden," in *Zeitschrift für bildende Kunst,* vol. 53, p. 171ff. Leipzig

1921 CONWAY, W. M. *The Van Eycks and Their Followers,* New York

1922 DURRIEU, P. *Les Très-Belles Heures de Notre-Dame du Duc Jean de Berry.* Paris

1923 MARTIN, H. *La Miniature française du XIIIᵉ au XVᵉ siècle.* Paris and Brussels

1924 HUIZINGA, J. *The Waning of the Middle Ages.* London
WINKLER, FRIEDRICH. *Die altniederländische Malerei.* Berlin

1924–1935 DELEN, A. J. J. *Histoire de la gravure dans les anciens Pays-Bas.* Paris

1924–1937 FRIEDLÄNDER, MAX J. *Die altniederländische Malerei.* Vols. I–II, Berlin; vols. 12–14, Leiden

1925 DVOŘÁK, M. *Das Rätsel der Kunst der Brüder van Eyck.* Munich

1926 STEIN, W. "Die Bildnisse von Rogier van der Weyden," in *Jahrbuch der Preuss. Kunstsammlungen,* vol. 47, p. 1ff. Berlin

1927 WINKLER, FRIEDRICH. *Neues von Hubert und Jan van Eyck.* Festschrift for Max J. Friedländer's 60th birthday, p. 91ff. Leipzig

1930 DESTRÉE, JULES. *Roger de la Pasture—van der Weyden.* Paris and Brussels

1931 RENDERS, É. *La Solution du problème van der Weyden—Flémalle—Campin.* Bruges

1932 TOLNAY, CHARLES DE. "Zur Herkunft des Stiles der van Eyck," in *Münchener Jahrbuch der bildenden Kunst,* New Series, vol. 9, p. 320ff. Munich

1933 DUVERGER, J. "Is Hubrecht van Eyck een legendarisch Personage?" in *Kunst, Maanblad voor Oude en Jonge Kunst,* vol. 4, p. 161 ff.

RENDERS, É. *Hubert van Eyck, personnage de légende.* Paris and Brussels

PÄCHT, O. "Gestaltungsprinzipien der westlichen Malerei des 15. Jahrhunderts," in *Kunstwissenschaftliche Forschungen,* vol. 2, p. 75ff.

SCHEEWE, L. *Hubert und Jan van Eyck, ihre literarische Würdigung bis ins 18. Jahrhundert.* The Hague

1935 TROCHE, ERNST G. *Niederländische Malerei.* Berlin

OSTEN, G. VON DER. *Der Schmerzenmann: Typengeschichte eines deutschen Andachtbildes von 1300–1600.* Berlin

RENDERS, É. *Jean van Eyck.* Bruges

1936–1947 HOOGEWERFF, G. J. *De Noord-nederlandsche Schilderkunst.* The Hague

1936 LAVALLEYE, J. *Juste de Gand.* Louvain

1937 OERTEL, R. "Die Verkündigung des Hugo van der Goes," in *Pantheon,* vol. 20, p. 377ff. Munich

KERBER, O. *Hubert van Eyck.* Frankfurt

1938 TOLNAY, CHARLES DE. *Le Maître de Flémalle et les Frères van Eyck.* Brussels

SCHOENE, W. *Dieric Bouts und seine Schule.* Berlin

HULIN DE LOO, G. "Roger van der Weyden," in *Biographie Nationale de Belgique,* vol. 27. Brussels

OETTINGER, K. "Das Rätsel der Kunst des Hugo van der Goes," in *Jahrbuch der Kunsthistorischen Sammlungen in Wien,* New Series, vol. 12, p. 43ff. Vienna

BURROUGHS, ALAN. *Art Criticism from a Laboratory.* Boston

1939 SCHOENE, W. *Die grossen Meister der niederländischen Malerei des 15. Jahrhunderts.* Leipzig

1940 BRAGG, W. H. *From the National Gallery Laboratory.* London

1941 BAZIN, G. *L'École franco-flamande XIV et XV siècles.* Geneva

BEENKEN, HERMANN. *Hubert und Jan van Eyck.* Munich

1942 BALDASS, LUDWIG. *Hans Memling.* Vienna

1943 BRAUN, JOSEPH. *Tracht und Attribute der Heiligen in der deutschen Kunst.* Stuttgart

ROSENBERG, J. "Early Flemish Painting," in *The Bulletin of the Fogg Museum of Art,* vol. 10(2), p. 47ff. Cambridge, Mass.

1944 DOERNER, M. *Malmaterial und seine Verwendung im Bilde.* Stuttgart

BAUCH, KURT. "Ein Werk Robert Campins," in *Pantheon,* vol. 32, p. 30ff. Munich

1945 DAVIES, MARTIN. *National Gallery Catalogues: Early Netherlandish School.* London

1946 COMBE, J. *Jheronymus Bosch.* London

ROLLAND, P. *La Peinture murale à Tournai.* Brussels

1947 WEHLE, H. B., and SALINGER, M. *The Metropolitan Museum of Art: A Catalogue of Early Flemish, Dutch and German Paintings.* New York

1948 PUYVELDE, LEO VAN. *The Flemish Primitives.* Brussels

1949 BAX, D. *Onteigtering van Ieroen Bosch.* The Hague

RING, G. *A Century of French Painting 1400–1500.* London

MAQUET-TOMBU, J. "Les Tableaux de justice de Roger van der Weyden à l'Hôtel de Ville de Bruxelles," in *Phoebus,* vol. 2, p. 178ff. Dresden

WESCHER, P. "Eine unbekannte Madonna von Rogier van der Weyden," in *Phoebus,* vol. 2, p. 104ff. Dresden

1950 KAUFFMANN, H. "Jan van Eycks 'Arnolfinihochzeit,'" in *Vierteljahresschrift für Kultur- und Geisteswissenschaften,* vol. 4, p. 45ff.

WINKLER, FRIEDRICH. "Rogier van der Weyden's Early Portraits," in *Art Quarterly,* vol. 13, p. 211ff. Detroit

GERSON, H. *Van Geertgen tot Frans Hals: De Nederlandsche Schilderkunst.* Amsterdam

FRAENGER, WILHELM. *Die Hochzeit zu Kana. Ein Dokument semitischer Gnosis bei Hieronymus Bosch.* Berlin

1951 BEENKEN, HERMANN. *Rogier van der Weyden.* Munich

SALINGER, M. "An Annunciation by Gerard David," in *The Metropolitan Museum of Art Bulletin,* New Series, vol. 9, p. 225. New York

KOCH, R. A. "Geertgen tot Sint Jans in Bruges," in *Art Bulletin,* vol. 32, p. 259ff. New York

1952 MEISS, M. "Nicholas Albergati and the Chronology of Jan van Eyck's Portraits," in *Burlington Magazine,* vol. 94, p. 137ff. London

HARTLAUB, G. F. "Besprechung von Wilhelm Fraenger 'Die Hochzeit zu Kana. Ein Dokument semitischer Gnosis bei Hieronymus Bosch,' Berlin 1950," in *Zeitschrift für Kunstgeschichte,* vol. 15, p. 82ff. Munich

SCHRYVER, A. P. DE, and MARTIJNISSEN, R. H. *De Oorspronkelijke Plaats van het Lam Gods-Retabel* (Les Primitifs Flamands, Contributions à l'Étude des Primitifs Flamands, vol. 1). Antwerp

BALDASS, LUDWIG. *Jan van Eyck.* Cologne

POST, P. " 'Pictor Hubertus eyck maior quo nemo repertus': Eine Untersuchung zur Genter Altar-Frage auf Grund des Tatsächlichen," in *Zeitschrift für Kunstgeschichte,* vol. 15, p. 46ff. Munich

MUSPER, H. T. "Die Brüsseler Gregorsmesse ein Original," in *Bulletin des Musées Royaux des Beaux-Arts,* p. 89ff. Brussels

FRAENGER, WILHELM. *The Millennium of Hieronymus Bosch.* London

1953 BRAND PHILIP, LOTTE. "The Prado Epiphany by Jerome Bosch," in *Art Bulletin,* vol. 35, p. 267ff. New York

PANOFSKY, ERWIN. *Early Netherlandish Painting.* Cambridge, Mass. (Discussed by Friedrich Winkler in *Kunstchronik,* 1955, p. 9ff. Leipzig)

COREMANS, P. *Les Primitifs flamands* (Publications of the Centre National de Recherches Primitifs Flamands under the direction of P. Coremans and with the collaboration of H. Adhémar, Aru, Janssens de Bisthoven, Davies, Eisler, de Gerardon, Lavalleye, Levinson-Lessing, Nicouline, Parmentier, van Schoute). Antwerp

1955 DIEBOW, HANS. "Original und nicht Kopie!" in *Die Weltkunst,* vol. 25, 15.5, p. 11 ff. Berlin

ROTHE, HANS. *Hieronymus Bosch, Garten der Lüste.* Munich

BRAND PHILIP, LOTTE. *Hieronymus Bosch.* New York

1956 FRIEDLÄNDER, MAX J. *From Van Eyck to Bruegel.* London

BAX D. *Beschrijving en poging tot Verklaring van het Tuin der onkuisheid drielnik van Ieroen Bosch.* Amsterdam

1957 MUSPER, H. T. "Eine Madonna in Gent," in *Bulletin des Musées Royaux des Beaux-Arts,* vol. 6, p. 81ff. Brussels

CUTTLER, CHARLES D. "The Lisbon Temptation of St. Anthony by Jerome Bosch," in *Art Bulletin,* vol. 39, p. 109ff. New York

PHILIPPOT, PAUL. "À propos de la 'Justice d'Othon' de Thierry Bouts," in *Bulletin des Musées Royaux des Beaux-Arts,* vol. 6, p. 55ff. Brussels

1958 FISCHEL, LILI. "Die 'Vermahlung Mariae' des Prado zu Madrid," in *Bulletin des Musées Royaux des Beaux-Arts,* vol. 7, p. 3ff. Brussels

1959 BUSCH, GÜNTER. *Die Madonna des Kanonikus Paele* (Reclams Universal-Bibliothek). Stuttgart

BALDASS, LUDWIG. *Hieronymus Bosch.* Vienna

MENZ, H. "Freilegung einer Inschrift auf dem von Eyck-Altar der Dresdner Gemäldegalerie," in *Jahrbuch der Staatlichen Kunstsammlungen,* vol. 1, p. 28. Dresden

1960 TAUBERT, JOHANNES. "Die beiden Marienaltäre des Rogier van der Weyden," in *Pantheon,* vol. 18, p. 67ff. Munich

1961 MUSPER, H. T. *Gotische Malerei nördlich der Alpen.* Cologne

ARNDT, KARL. "Gerard Davids 'Anbetung der Könige' nach Hugo van der Goes," in *Münchener Jahrbuch der bildenden Kunst,* vol. 12, p. 153ff. Munich

1962 ARNDT, KARL. *Der Columba-Altar* (Reclams Universal-Bibliothek). Stuttgart

1963 FRAENGER, WILHELM. "Das Lied des Moses," in *Castrum peregrini,* vol. 58. Amsterdam

1964 ARNDT, KARL. "Zum Werk des Hugo van der Goes," in *Münchener Jahrbuch der bildenden Kunst,* vol. 15, p. 63ff. Munich

WINKLER, FRIEDRICH. *Das Werk Hugo van der Goes.* Berlin

1965 ARNDT, KARL. *Der Portinari-Altar* (Reclams Universal-Bibliothek). Stuttgart

MALKON, K. "Hugo van der Goes," in *Kindlers Malerei Lexikon,* vol. 2, p. 684. Zurich

TOLNAY, CHARLES DE. *Hieronymus Bosch, Kritischer Katalog der Werke.* Baden-Baden

1966 MUSPER, H. T. "Aus der Werkstatt der Holzschnittforschung," in *Hundert Jahre Kohlhammer,* p. 324ff. Stuttgart

FRINTA, MOJMIR S. *The Genius of Robert Campin.* The Hague

1967–1976 FRIEDLÄNDER, MAX J. *Early Netherlandish Painting.* Translation by Heinz Norden. 14 volumes. Leiden

KIESER, EMIL. "Zur Deutung und Datierung der Rolin-Madonna des Jan van Eyck," in *Städel-Jahrbuch,* New Series, vol. 1, p. 73ff. Munich

CÄMMERER-GEORGE, MONIKA. "Eine italienische Wurzel in der Rahmen-Idee Jan van Eycks," in *Kunstgeschichtliche Studien für Kurt Bauch.* Munich and Berlin

PUYVELDE, LEO VAN. *La Genèse de la forme artistique de Rogier van der Weyden.* Akten des 21. Internationalen Kongresses für Kunstgeschichte in Bonn 1964, p. 46ff.

1968 McGRATH, ROBERT L. "Satan and Bosch: the *Visio Tundali* and the Monastic Vices," in *Gazette des Beaux-Arts,* series 6, vol. 71, p. 45ff. Paris

ARNDT, KARL. "Zur Ausstellung 'Jheronimus Bosch,' " in *KunstChronik,* vol. 21, p. 1ff. Leipzig

MUSPER, H. T. "Das Original der 'Suppenmadonna' von Gerard David," in *Bulletin des Musées Royaux des Beaux-Arts.* Brussels

Chronology

1363 Utrecht Master. *The Crucifixion.* (Koninklijk Museum voor Schone Kunsten, Antwerp.)

1394–1399 Melchior Broederlam. *Altarpiece of the Crucifixion.* (Musée des Beaux-Arts, Dijon.)

1406 Robert Campin becomes a master painter at Tournai.

1411–1416 Paul of Limbourg. *Très Riches Heures.* (Musée Condé, Chantilly.)

1414–1416 *The Book of Hours of Marshal Boucicaut.* (Musée Jacquemart-André, Paris.)

1425 Jan van Eyck is appointed *varlet de chambre* at the court of Philip the Good of Burgundy.

1426 Hubert van Eyck dies.

1427 Rogier van der Weyden enters Campin's workshop.

1427–1429 Jan van Eyck's mission to Spain and Portugal.

1432 Completion of *Ghent Altarpiece* by Hubert and Jan van Eyck. (St. Bavo, Ghent.)
End of Rogier's apprenticeship with Campin.

1434 Jan van Eyck. *The Marriage of Giovanni Arnolfini and Giovanna Cenami.* (The National Gallery, London.)

1436 Rogier van der Weyden. *The Justice of Trajan and Herkinbald.* (Destroyed by fire in 1695.)

1438 Robert Campin. *Werl Altarpiece.* (The Prado, Madrid.)

1439 Jan van Eyck. *The Artist's Wife.* (Groeningemuseum, Bruges.)

1441 Jan van Eyck dies.

1444 Robert Campin dies in Tournai.

1446 Petrus Christus. *Portrait of a Carthusian.* (The Metropolitan Museum of Art, New York.)

1450 Rogier van der Weyden travels in Italy.
Petrus Christus. So-called *Exeter Madonna.* (State Museums, Berlin-Dahlem.)

1452 Petrus Christus. Wings of an altarpiece, a *Nativity* and an *Annunciation.* (State Museums, Berlin-Dahlem.)

1457 Dieric Bouts settles at Louvain.

1462 Dieric Bouts. *Portrait of a Man.* (The National Gallery, London.)

1464 Joos van Gent becomes free master of the Ghent painters' guild.
Rogier van der Weyden dies in Brussels.

1467 Hugo van der Goes becomes dean of the Ghent painters' guild.

1468 Hugo van der Goes is entrusted with the decorations for the marriage of Charles the Bold at Bruges.

1473 Hans Memling's *The Last Judgment Altarpiece* is seized en route to Italy during the war between the Hanseatic League and England and taken to Danzig.

1475 Dieric Bouts dies in Louvain.

1478 Hugo van der Goes enters a monastery near Brussels.

1479 Hans Memling. *Saint John Altarpiece.* (Hôpital Saint-Jean, Bruges.)

1480 Hans Memling. *The Seven Joys of the Virgin.* (Alte Pinakothek, Munich.)

1482 Hugo van der Goes dies.

1484 Gerard David becomes master of the Bruges painters' guild (the Guild of Saint Luke).

1487 Hans Memling. Diptych: *Martin van Nieuwenhove.* (Hôpital Saint-Jean, Bruges.)

1491 Quentin Matsys becomes master of the Antwerp painters' guild (the Guild of Saint Luke).

1494 Hans Memling dies in Bruges.

1498 Gerard David. *The Legend of Cambyses and Sisamnes,* commissioned for the courtroom in Bruges Town Hall. (Groeningemuseum, Bruges).

1511 Quentin Matsys. *The Lamentation.* (Koninklijk Museum voor Schone Kunsten, Antwerp.)

1516 Hieronymus Bosch dies in 's Hertogenbosch.

1523 Gerard David dies in Bruges.

1530 Quentin Matsys dies.

Index

Numerals in roman type refer to pages. Numerals in () signify footnotes to be found on the page preceding the parentheses. Numerals in *italics* indicate pages where plates appear; those preceded by an * designate colorplates.